How to Draw...

Fantasy Creatures

Dragons, fairies, vampires & monsters in simple steps

MW00818157

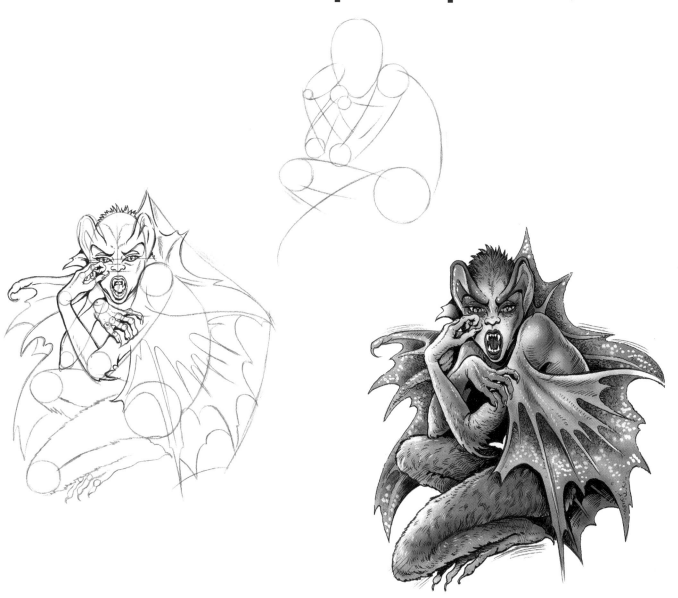

First published in Great Britain 2015 by

Search Press Limited
Wellwood, North Farm Road,
Tunbridge Wells, Kent TN2 3DR

How to Draw Fantasy Creatures is a compendium volume of
illustrations taken from the How to Draw series:
How to Draw Dragons; How to Draw Fairies;
How to Draw Vampires and How to Draw Monsters.

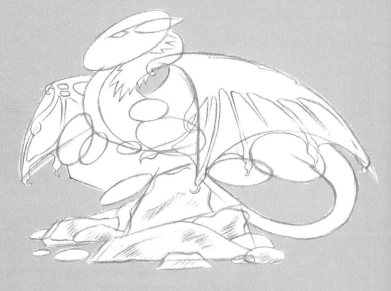

ISBN: 978-1-78221-309-3

Printed in Malaysia

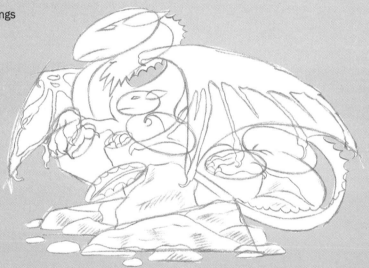

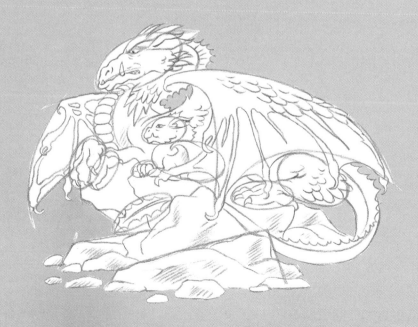

How to Draw
Fantasy
Creatures

Dragons, fairies, vampires & monsters in simple steps

Paul Bryn Davies & Jim McCarthy

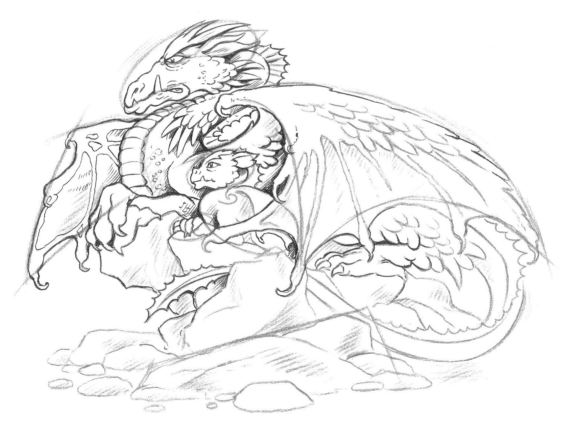

Search Press

Contents

Introduction...8

Dragons...10

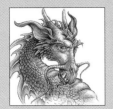

Page 12

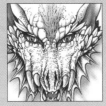

Page 13

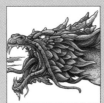

Page 14

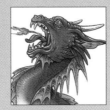

Page 15

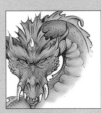

Page 16

Page 17

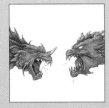

Page 18

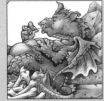

Page 19

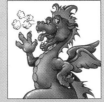

Page 20

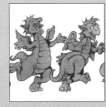

Page 21

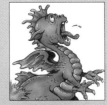

Page 22

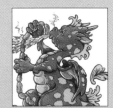

Page 23

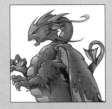

Page 24

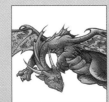

Page 25

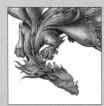

Page 26

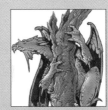

Page 27

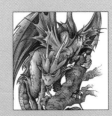

Page 28

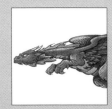

Page 29

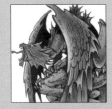

Page 30

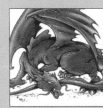

Page 31

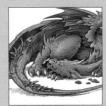

Page 32

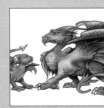

Page 33

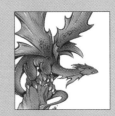

Page 34

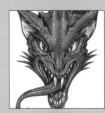

Page 35

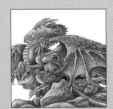

Page 36

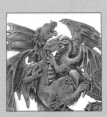

Page 38

Fairies..40

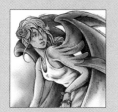
Page 42

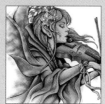
Page 43

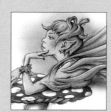
Page 44

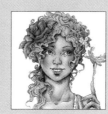
Page 45

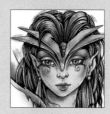
Page 46

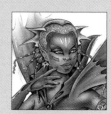
Page 47

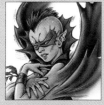
Page 48

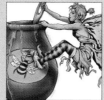
Page 49

Page 50

Page 51

Page 52

Page 53

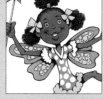
Page 54

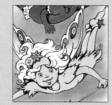
Page 55

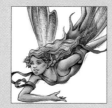
Page 56

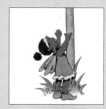
Page 57

Page 58

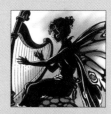
Page 59

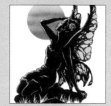
Page 60

Page 61

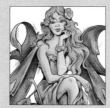
Page 62

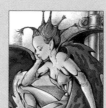
Page 63

Page 64

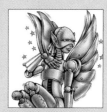
Page 65

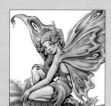
Page 66

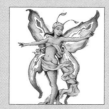
Page 67

Page 68

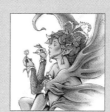
Page 69

Vampires..**70**

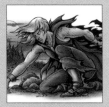
Page 72

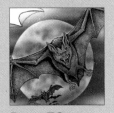
Page 73

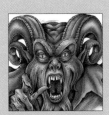
Page 74

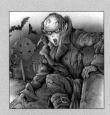
Page 75

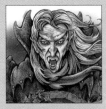
Page 76

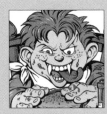
Page 77

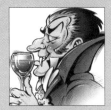
Page 78

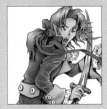
Page 79

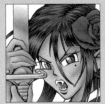
Page 80

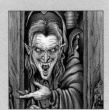
Page 81

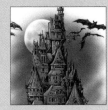
Page 82

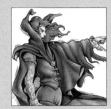
Page 83

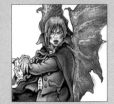
Page 84

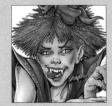
Page 85

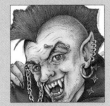
Page 86

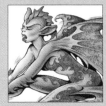
Page 87

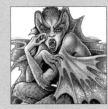
Page 88

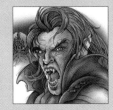
Page 89

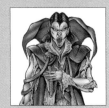
Page 90

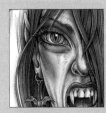
Page 91

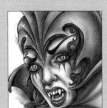
Page 92

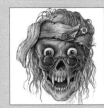
Page 93

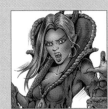
Page 94

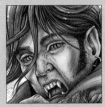
Page 96

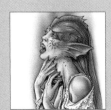
Page 97

Monsters...98

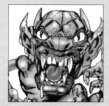

Page 100

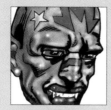

Page 101

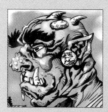

Page 102

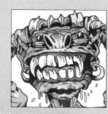

Page 103

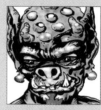

Page 104

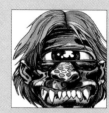

Page 105

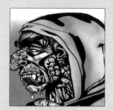

Page 106

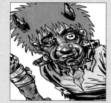

Page 107

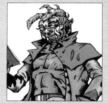

Page 108

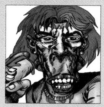

Page 109

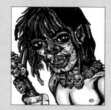

Page 110

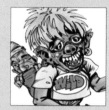

Page 111

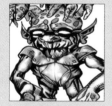

Page 112

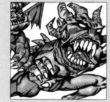

Page 113

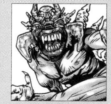

Page 114

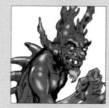

Page 115

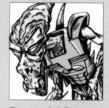

Page 116

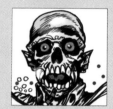

Page 117

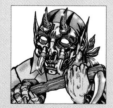

Page 118

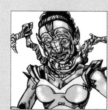

Page 119

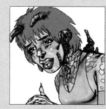

Page 120

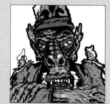

Page 121

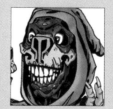

Page 122

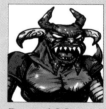

Page 123

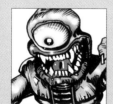

Page 124

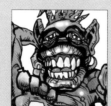

Page 125

Page 126

Page 127

Introduction

Artists Paul Bryn Davies and Jim McCarthy are experts in drawing the wierd and wonderful. This step-by-step collection of their sketches provides you with an exciting range of fun and fictitious characters to draw.

These drawings are designed to inspire and will act as a starting point to help you to capture their unique creative flair. The method of illustration is simple: basic geometric shapes evolve, stage by stage, into the finished forms. In order to make the sequences easier to follow, the artists use different coloured pencils for each of the stages. The colours act as a guide, with new shapes built on to old shapes, and distinguishing features are added as the images develop. The penultimate stages show tonal representations of the fantasy creatures, and the final stage is a full colour image of the finished drawing.

When you are following the steps, use an HB, B or 2B pencil. Draw lightly, so that any intial, unwanted lines can be erased easily. Your final work could be a detailed pencil drawing, or the pencil lines can be drawn over using a ballpoint, felt-tip or technical pen. At this point, gently erase the original pencil lines.

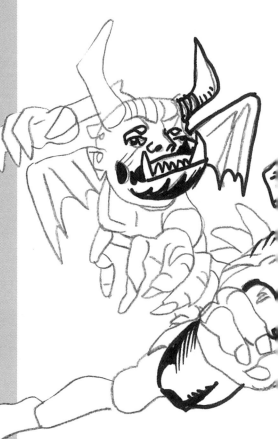

If you want to add colour, you could use pencil crayons, markers, watercolours or acrylics. Alternatively, if you have the equipment and the skills, your drawings can be scanned into a computer and coloured digitally. Watercolours have been applied using an airbrush and opaque white gouache has been added as highlights.

Once you get the hang of it, you may want to try drawing your own fantasy creations; perhaps from your own photographs, using the simple construction method shown here. You can make the process easier if you use tracing paper to transfer shapes and lines to your drawing.

Most importantly, remember to have fun drawing these imaginative (and sometimes terrifying) creatures!

Happy drawing!

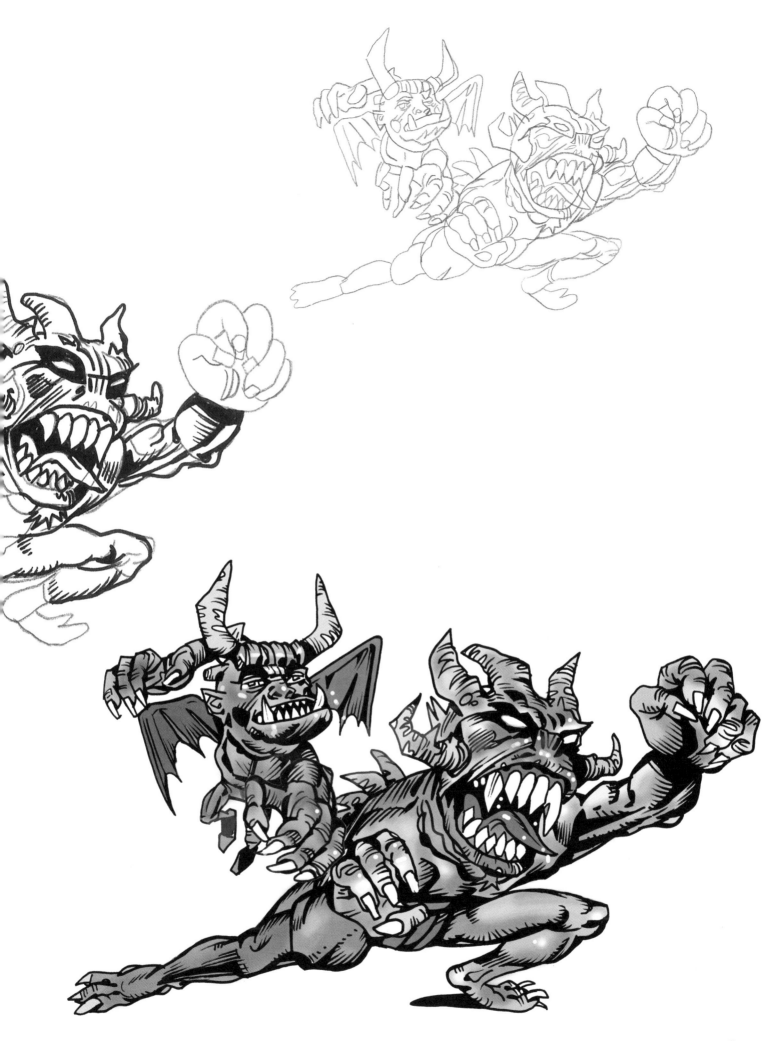

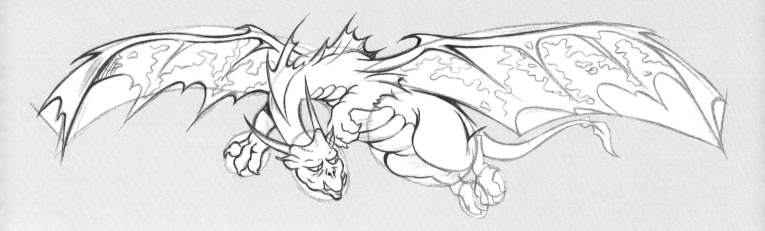

Dragons

Here, you will learn how to create the greatest of all mythical beasts: the dragon. These legendary creatures come in a selection of different styles, from fierce, fire-breathing beasts to friendly, crouching and sleeping dragons.

To create your own compositions, it is a good idea to look at crocodiles, iguanas, lizards and other reptiles for inspiration.

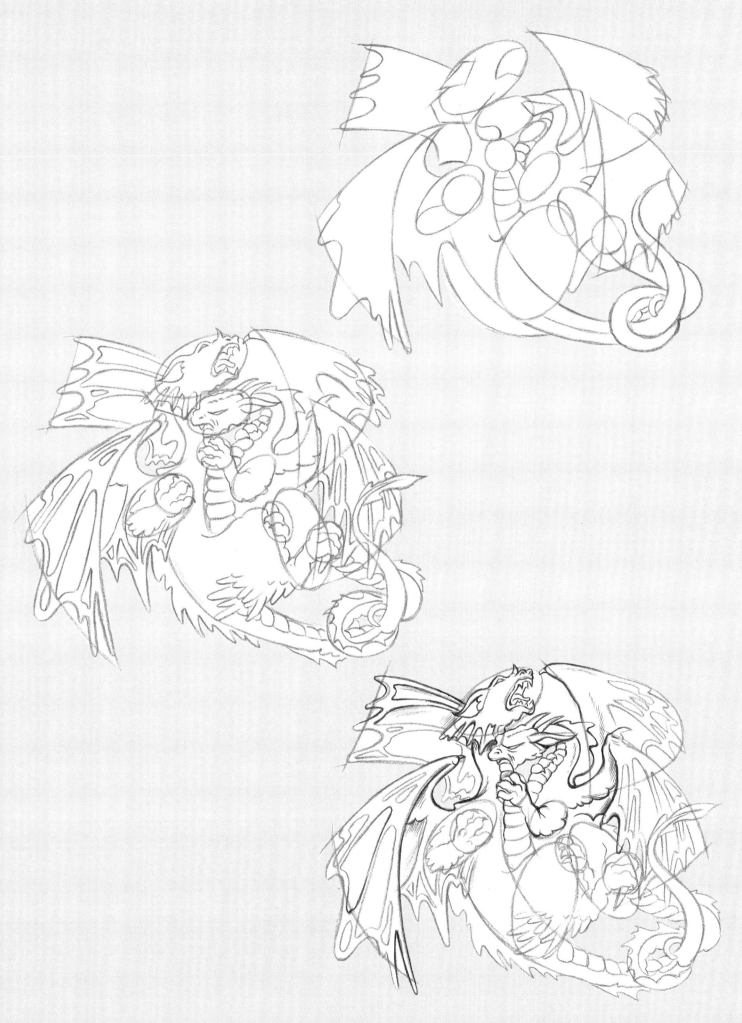

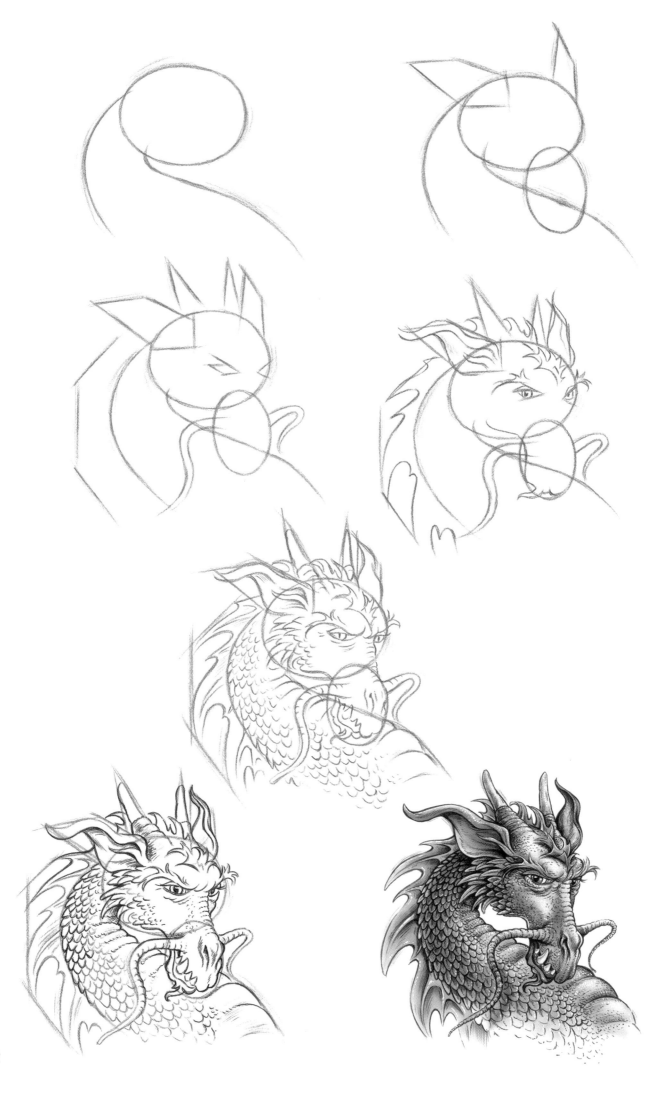

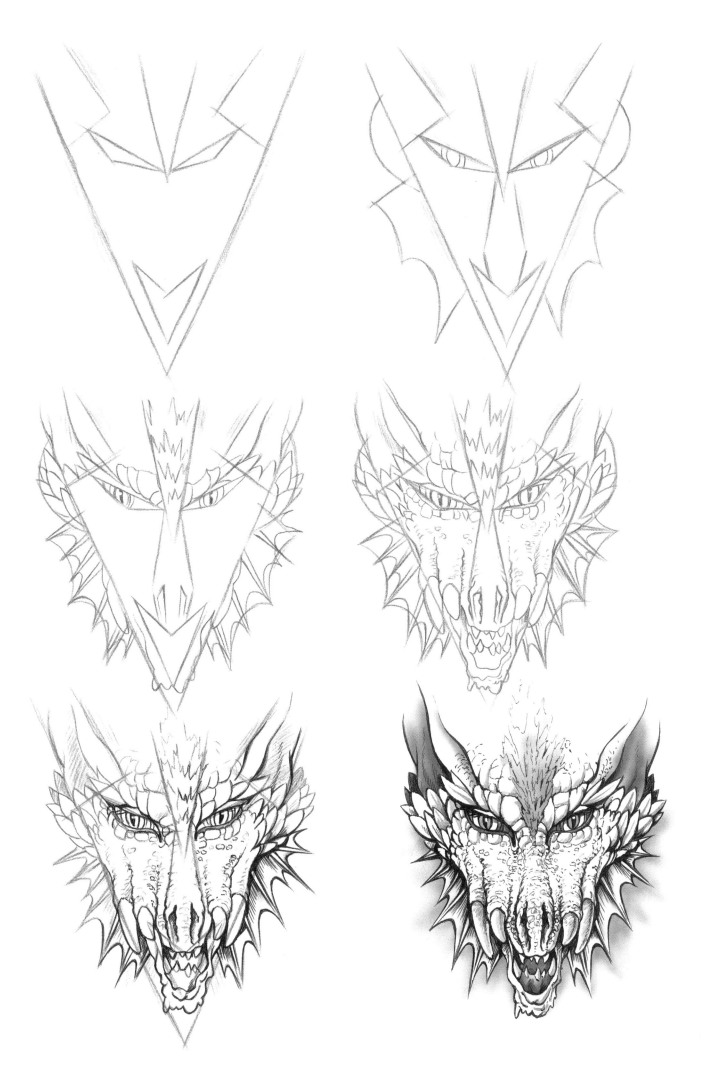

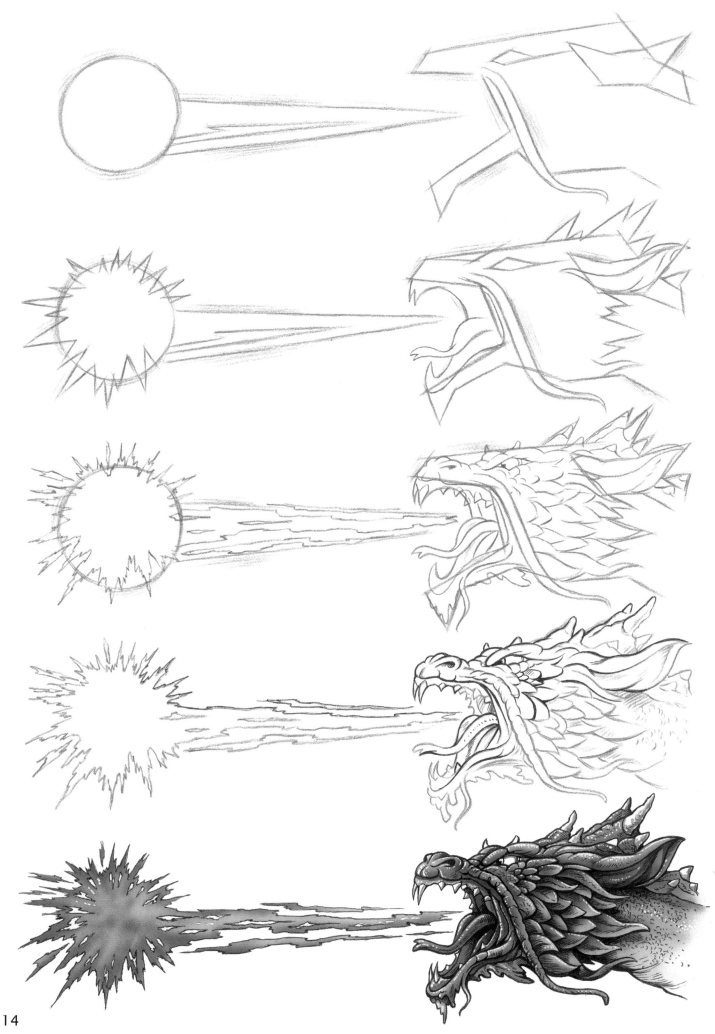

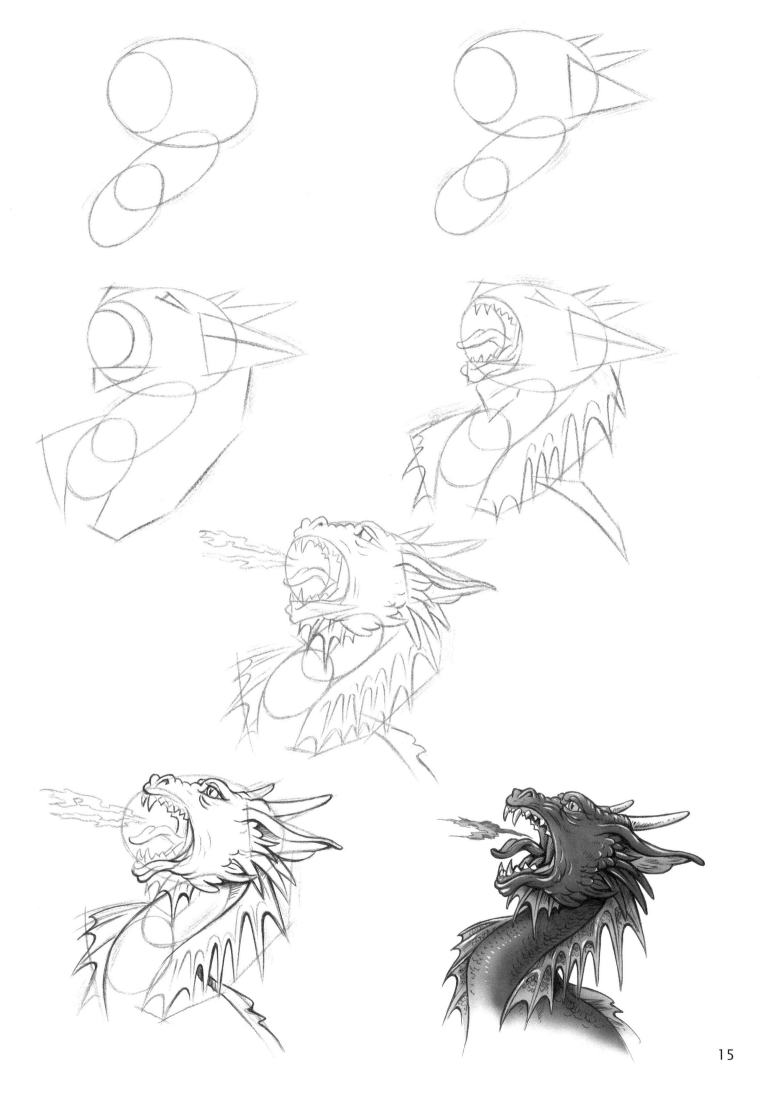

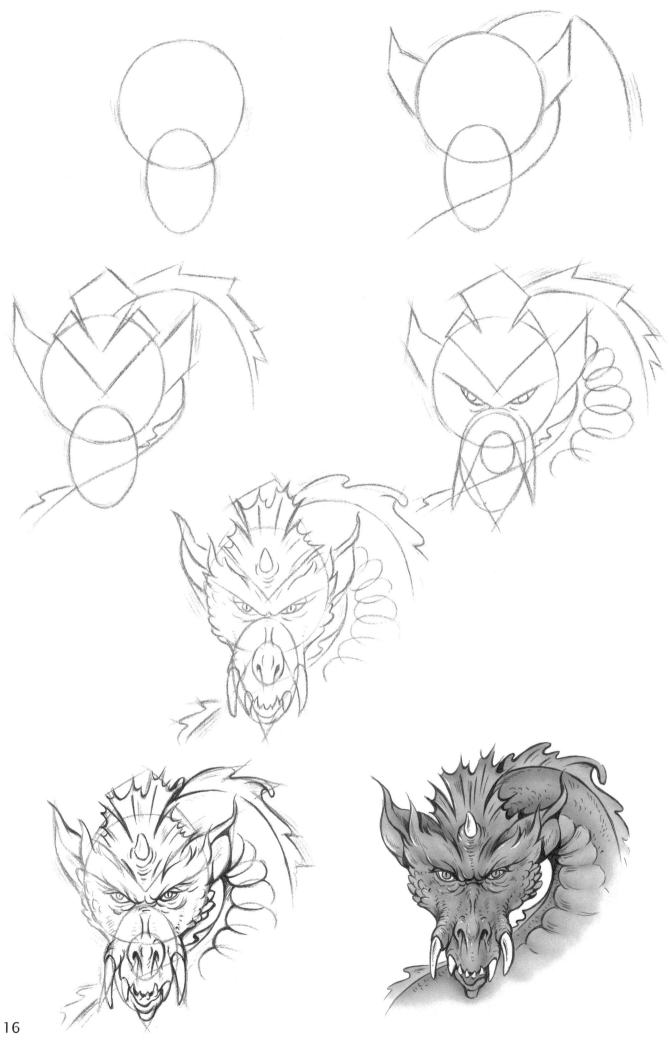

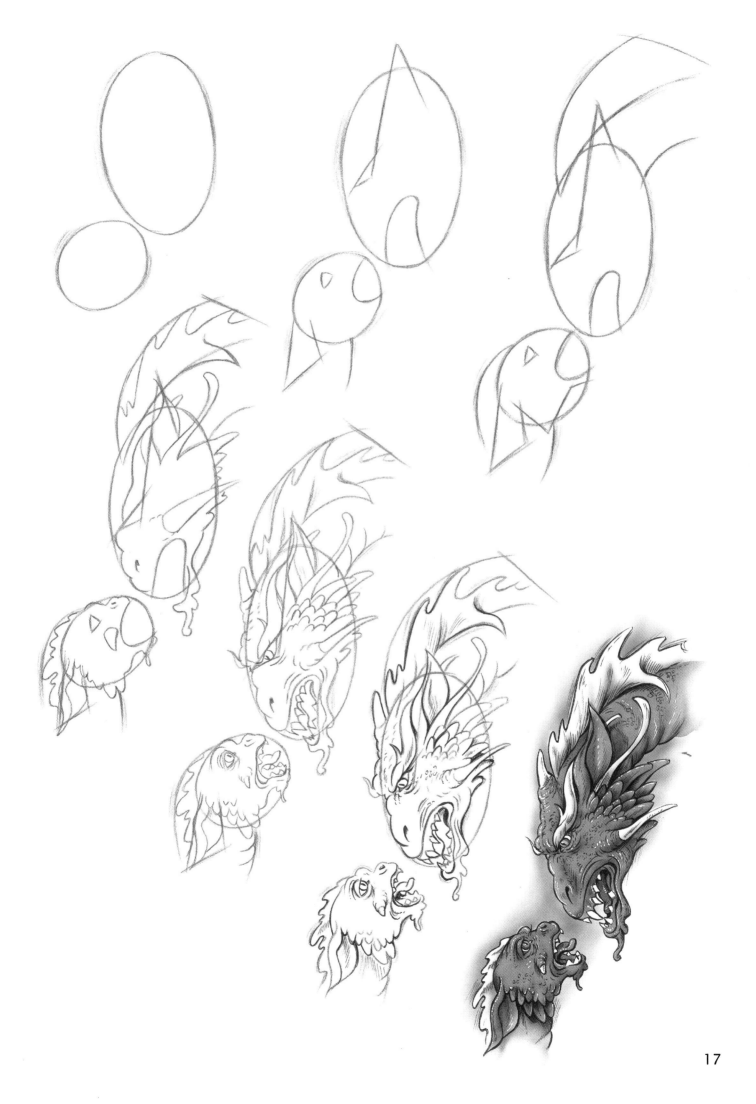

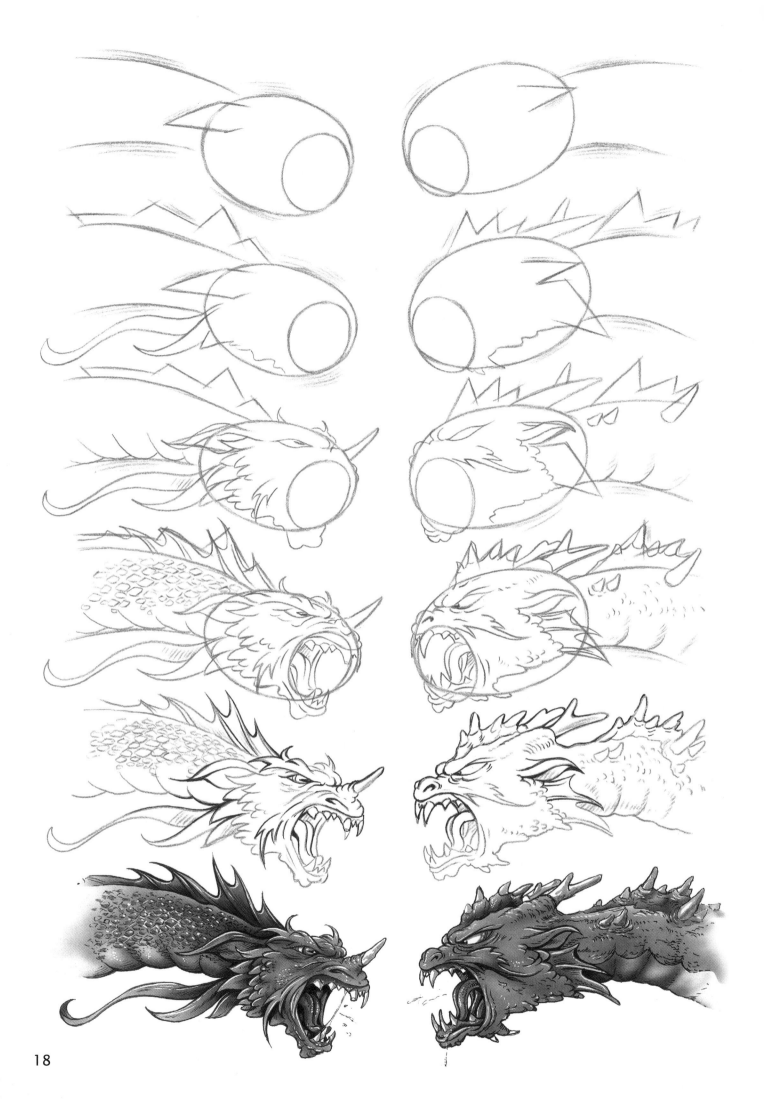

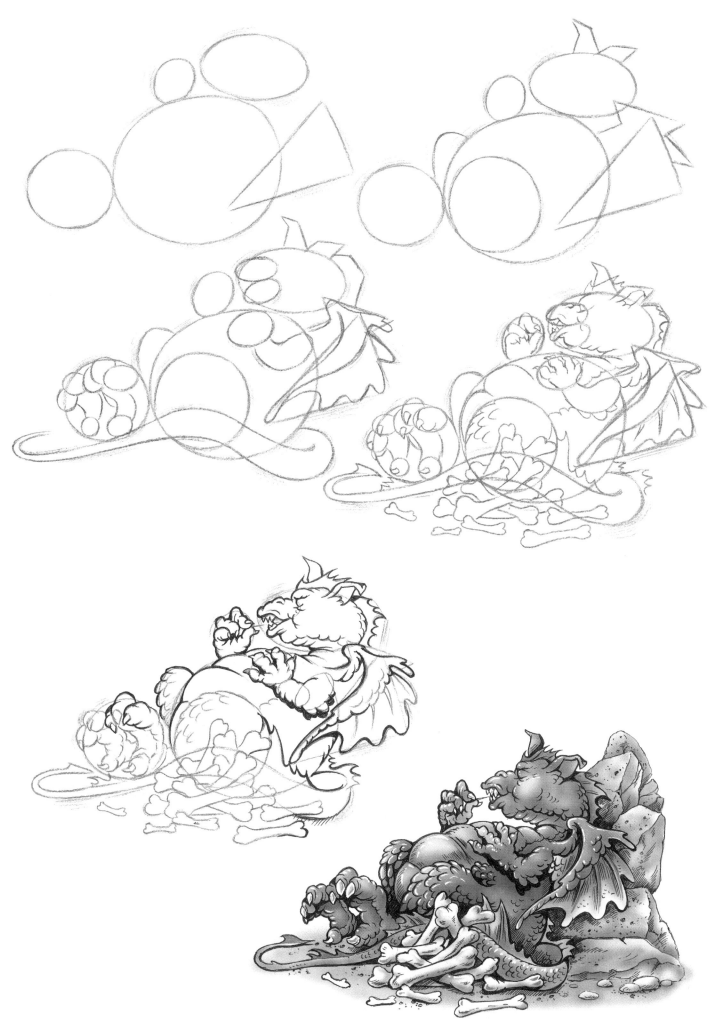

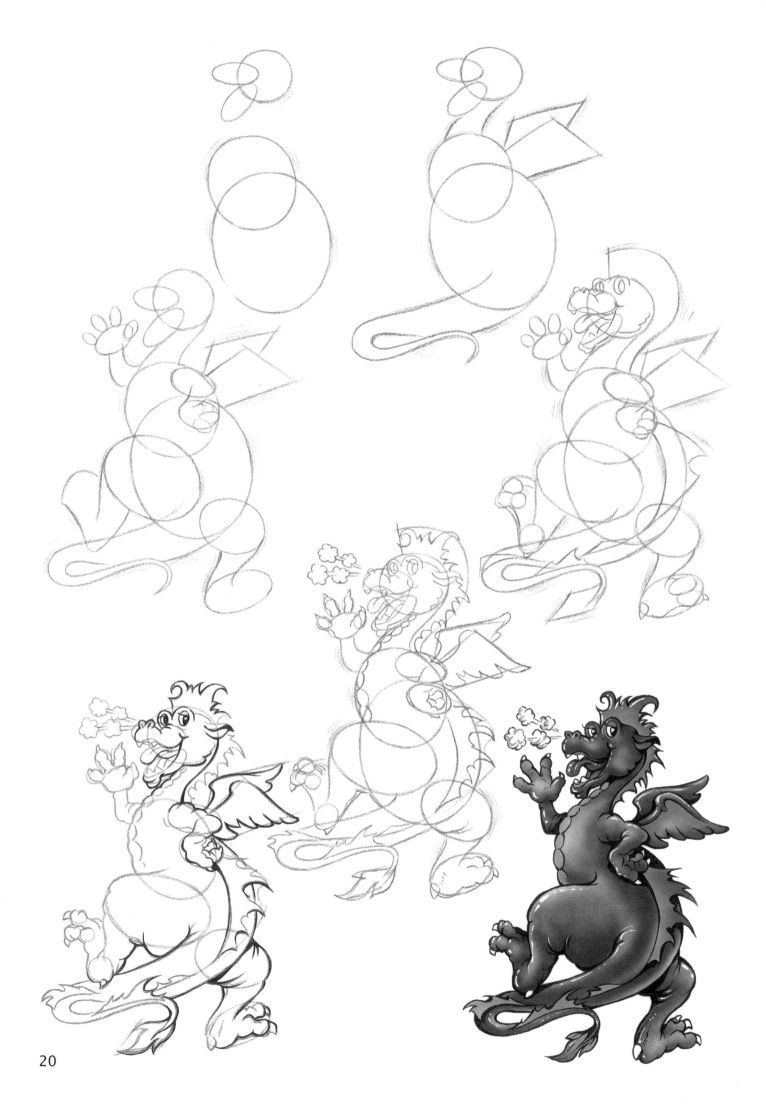

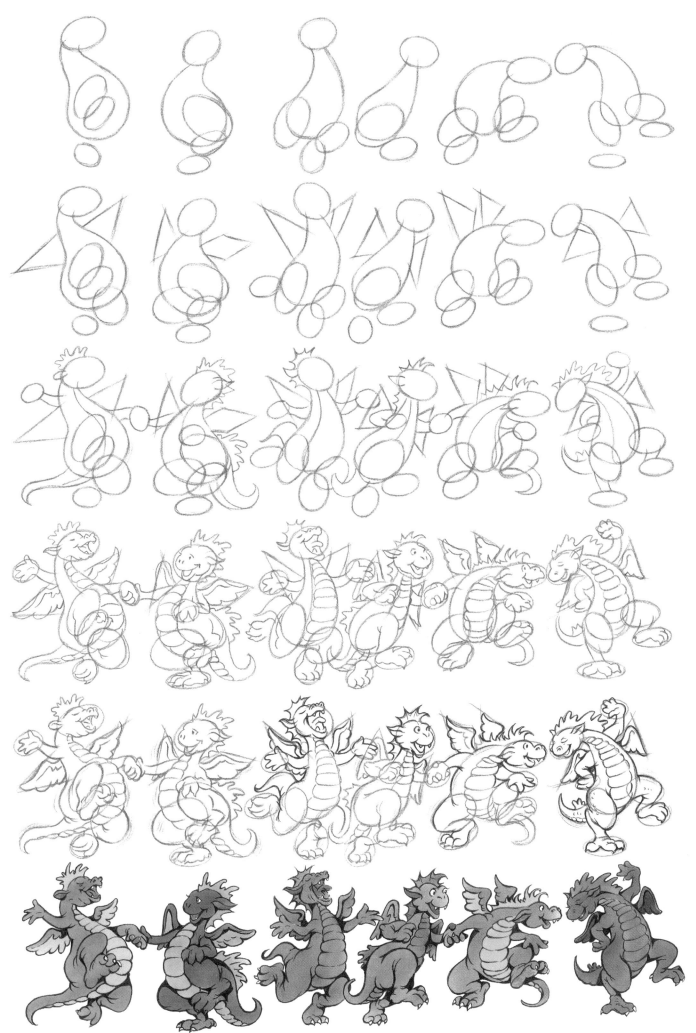

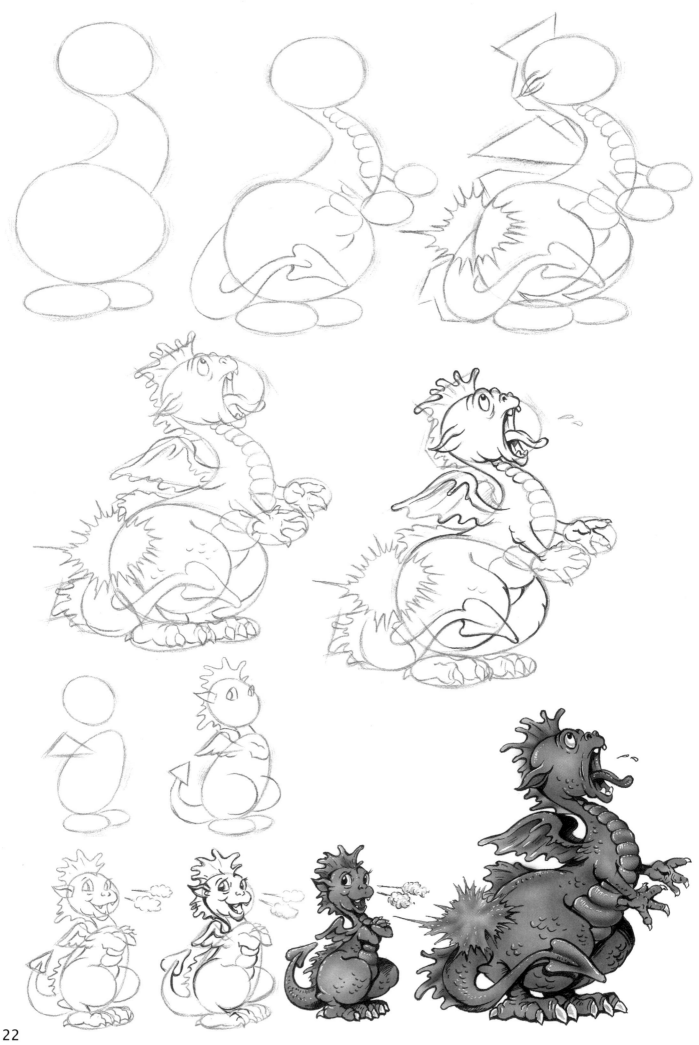

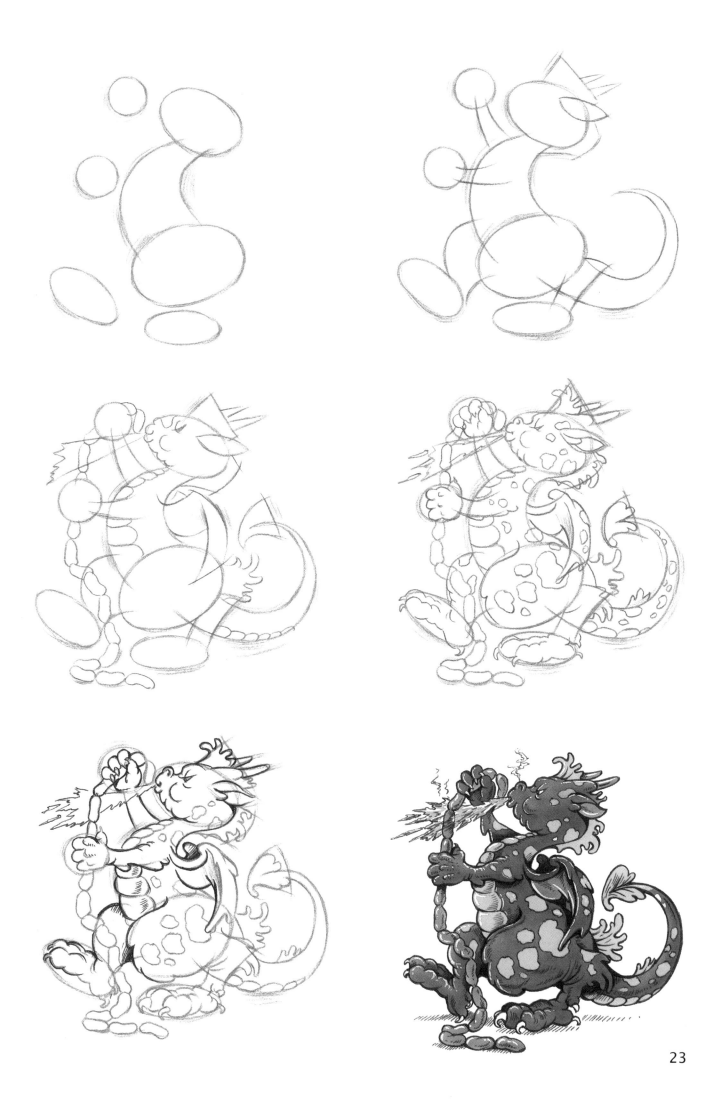

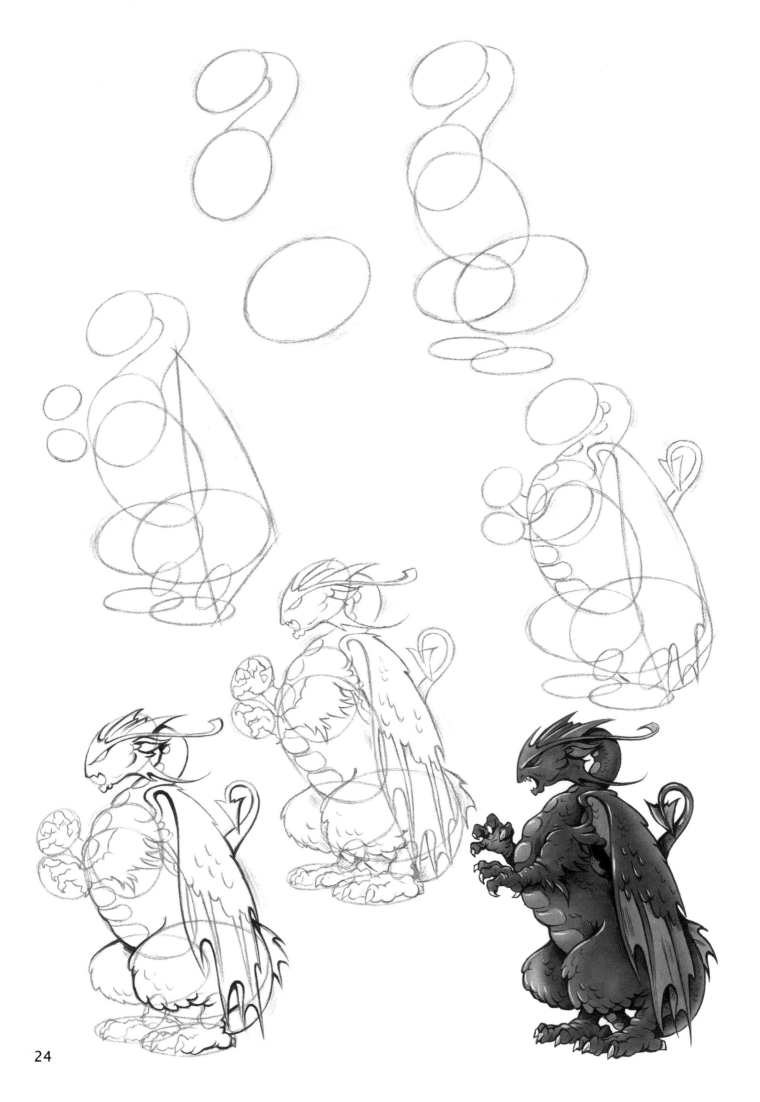

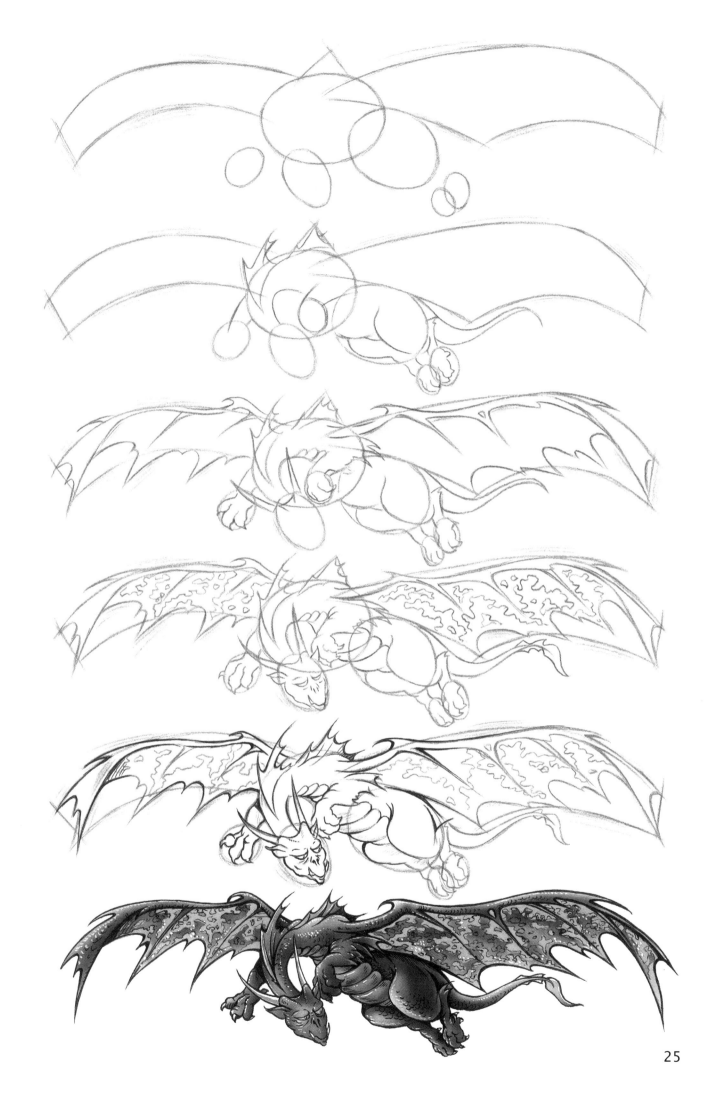

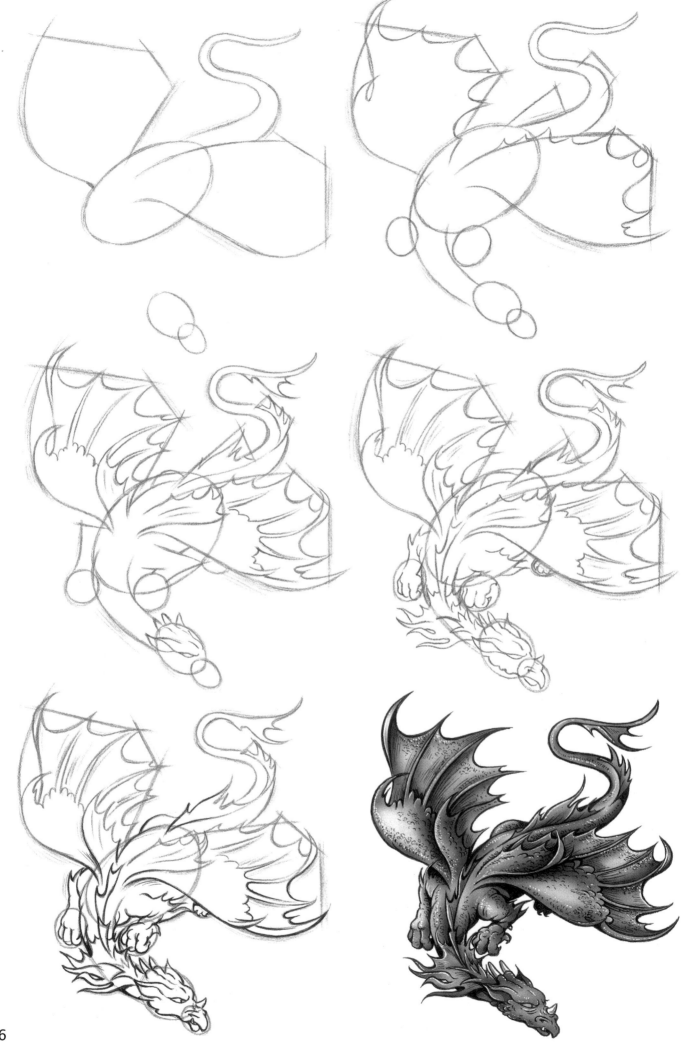

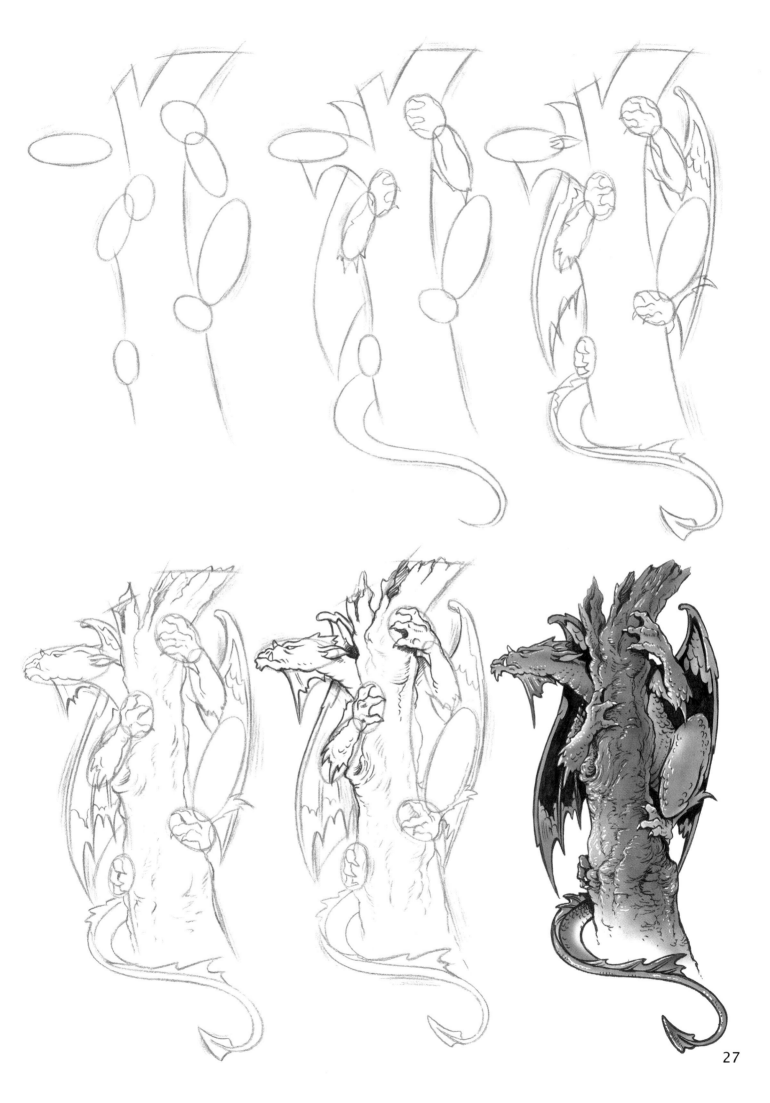

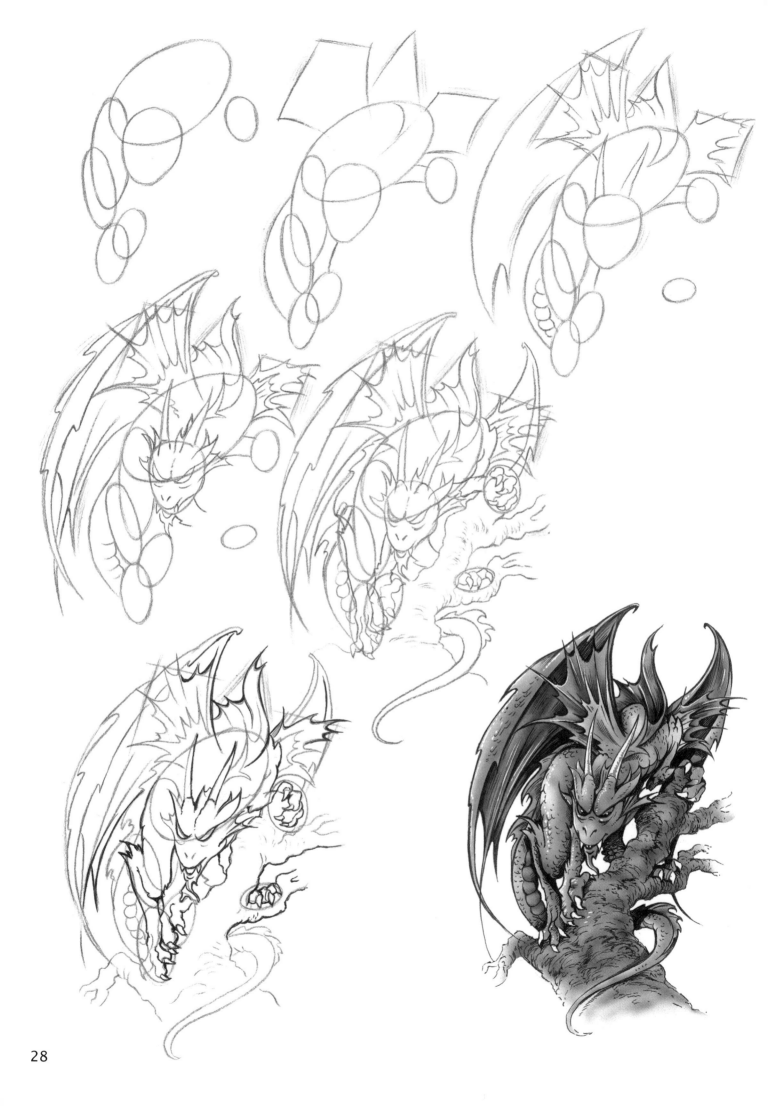

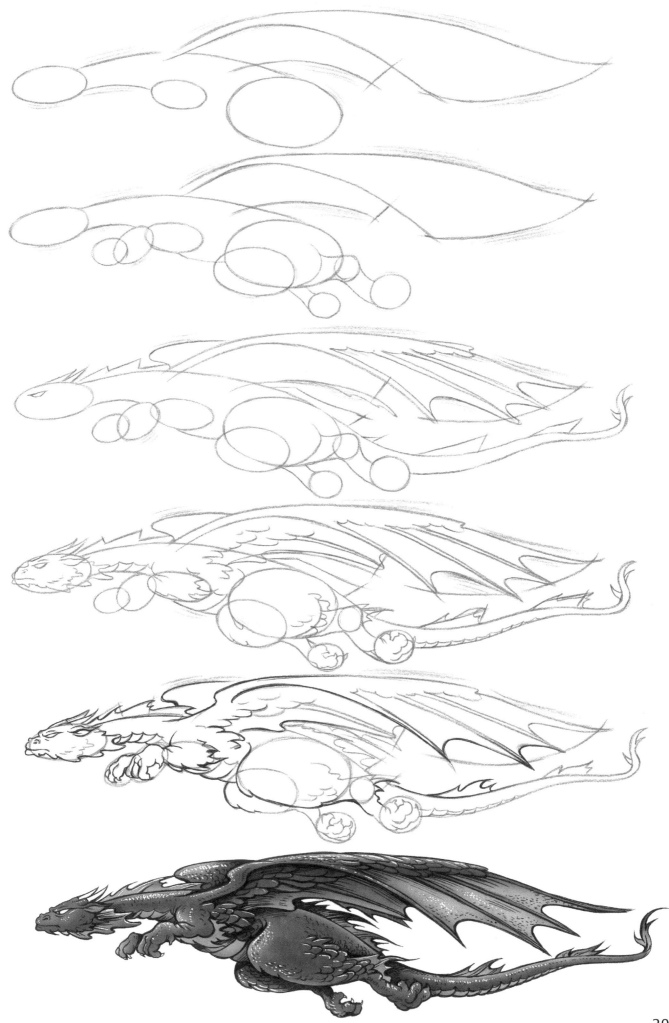

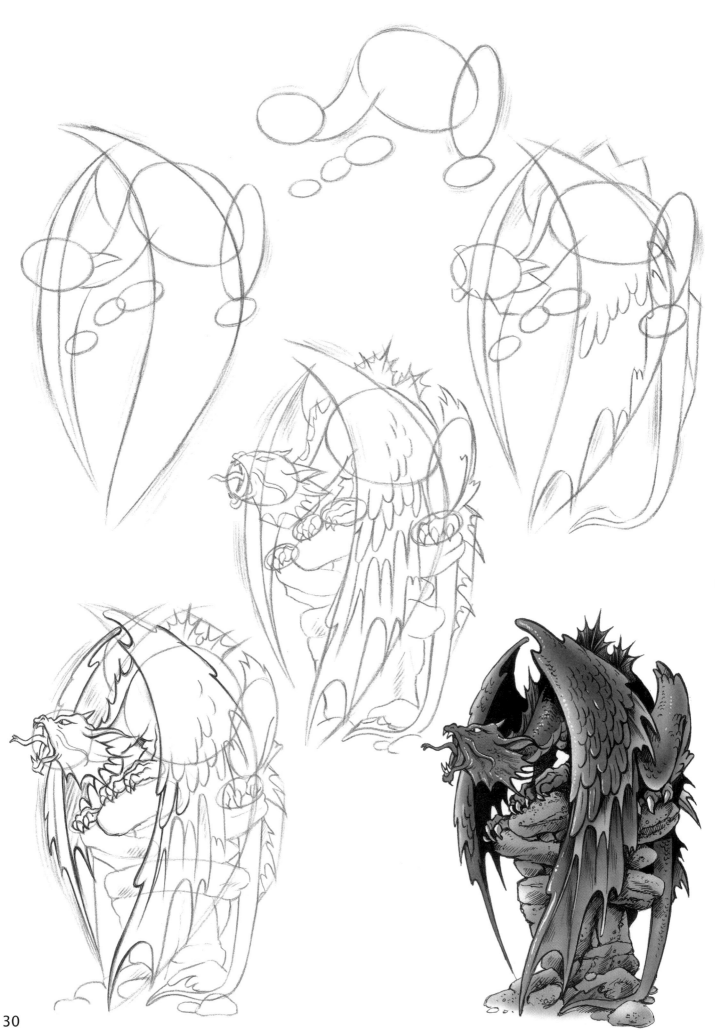

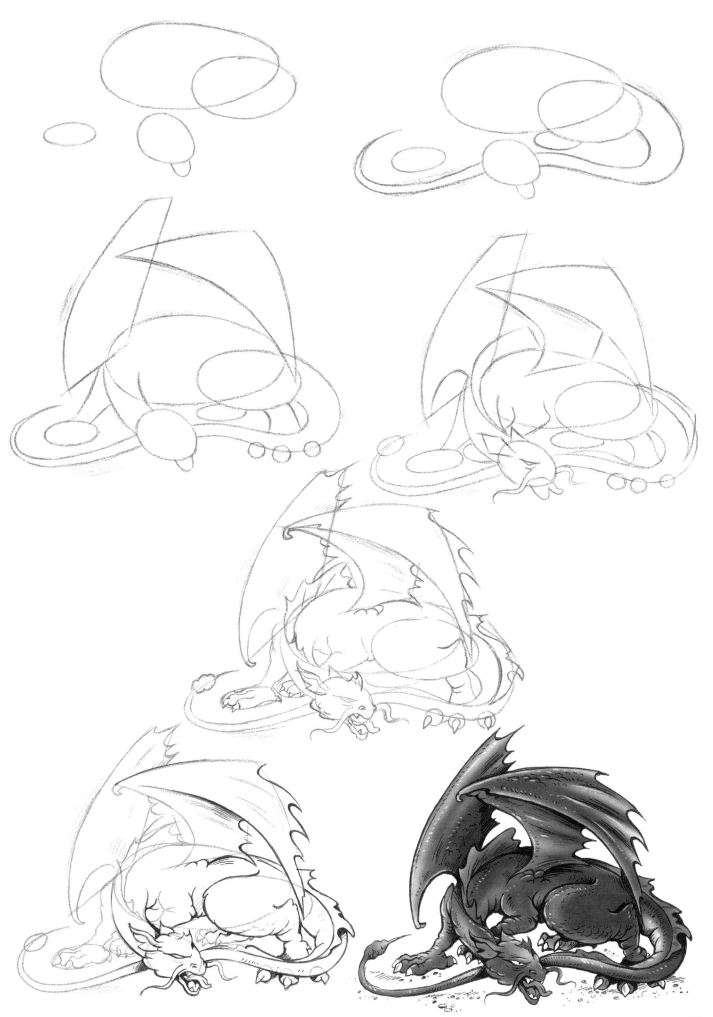

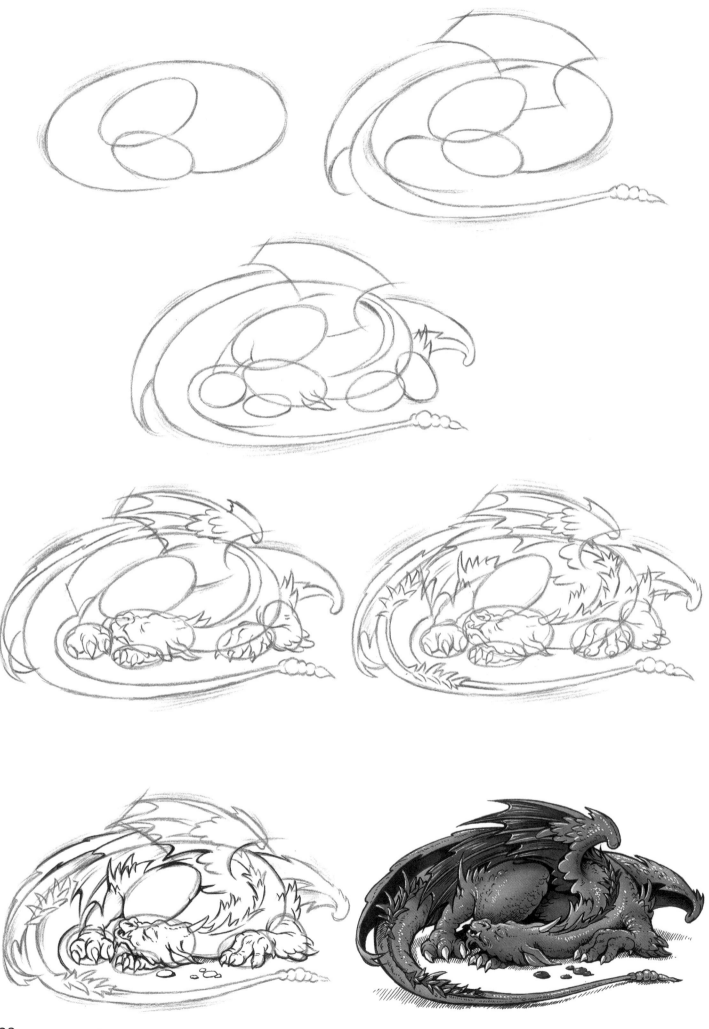

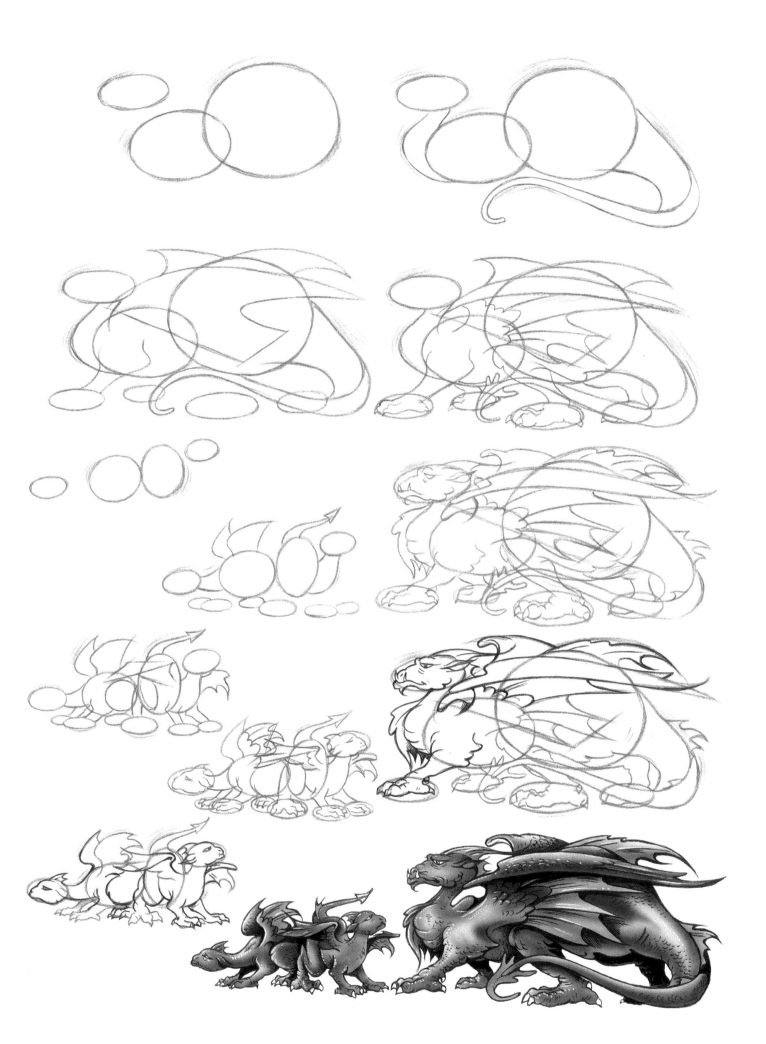

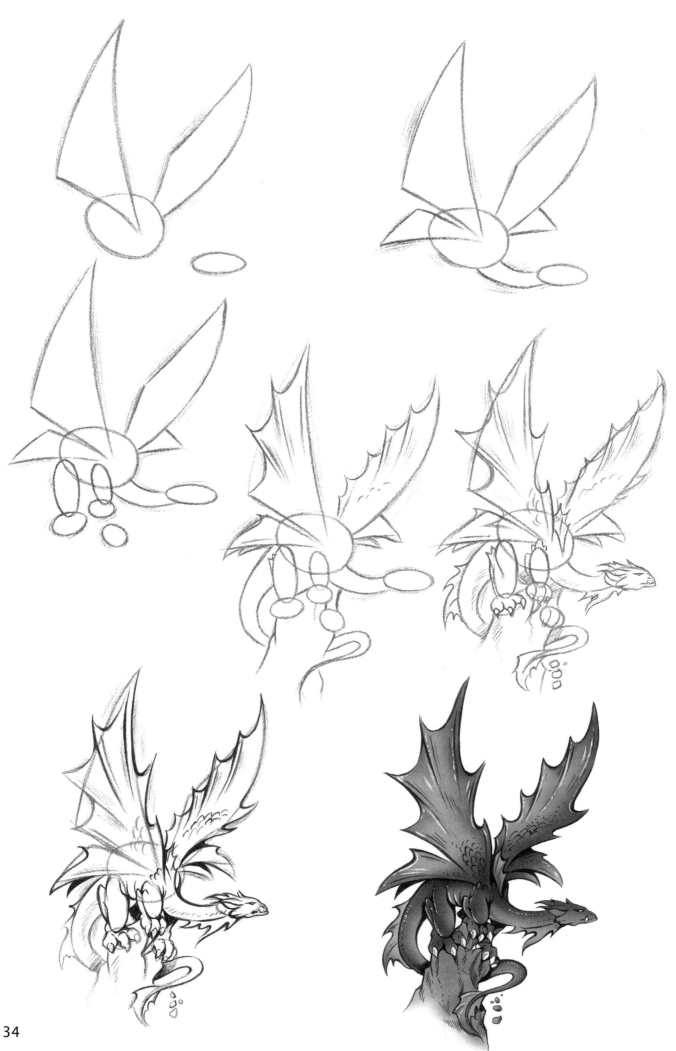

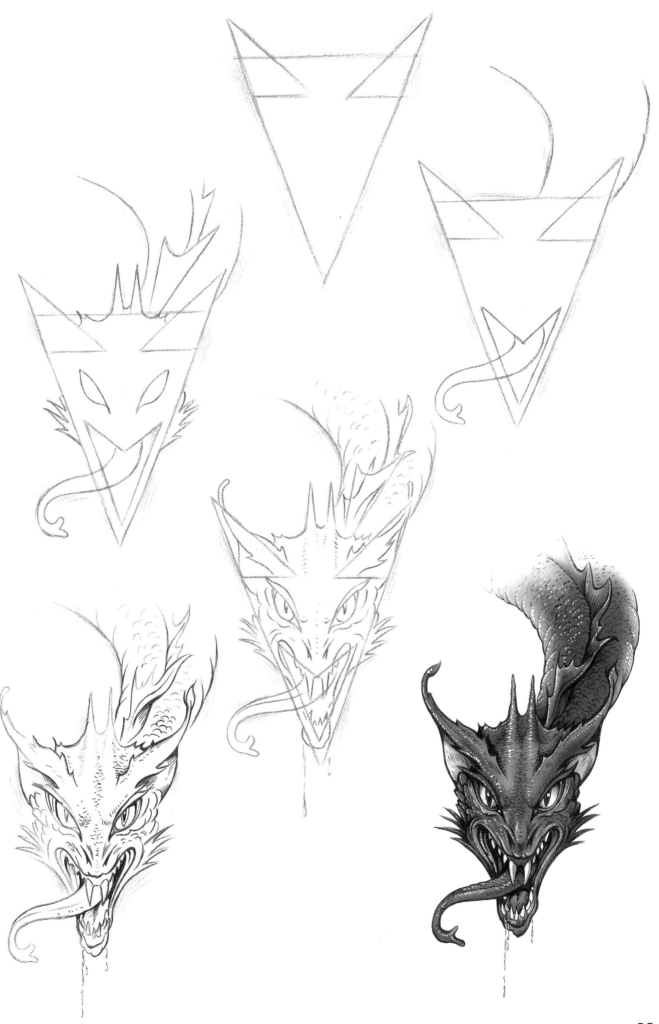

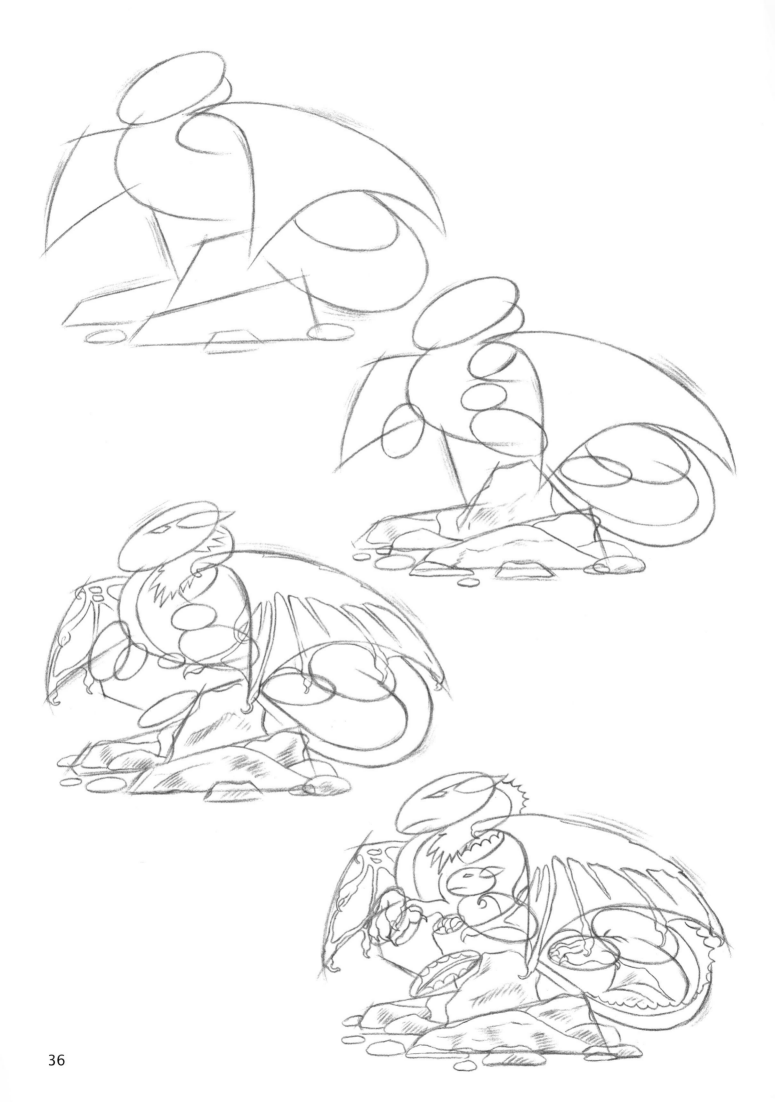

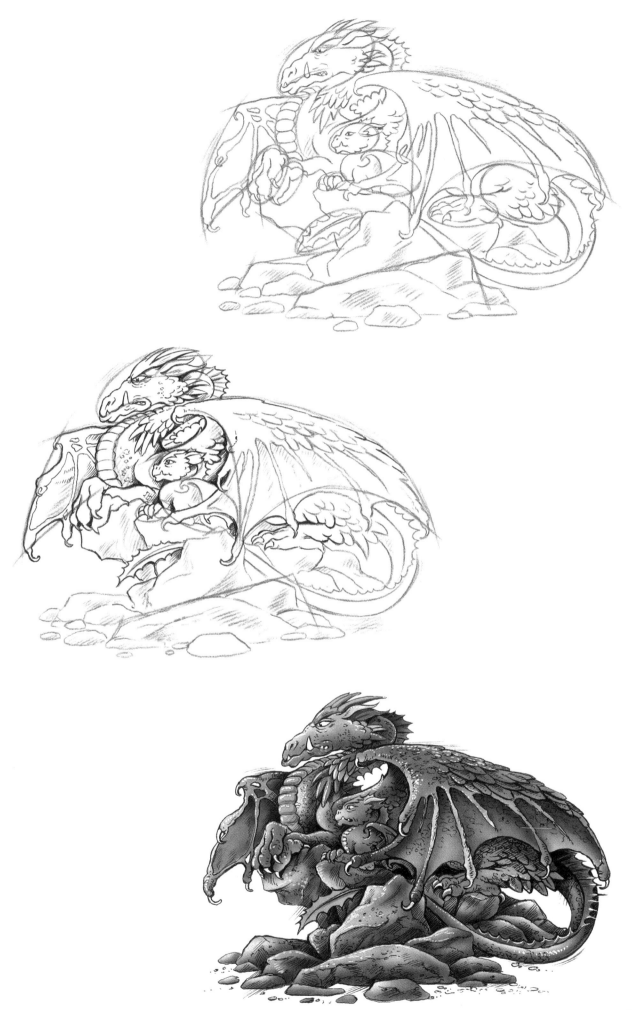

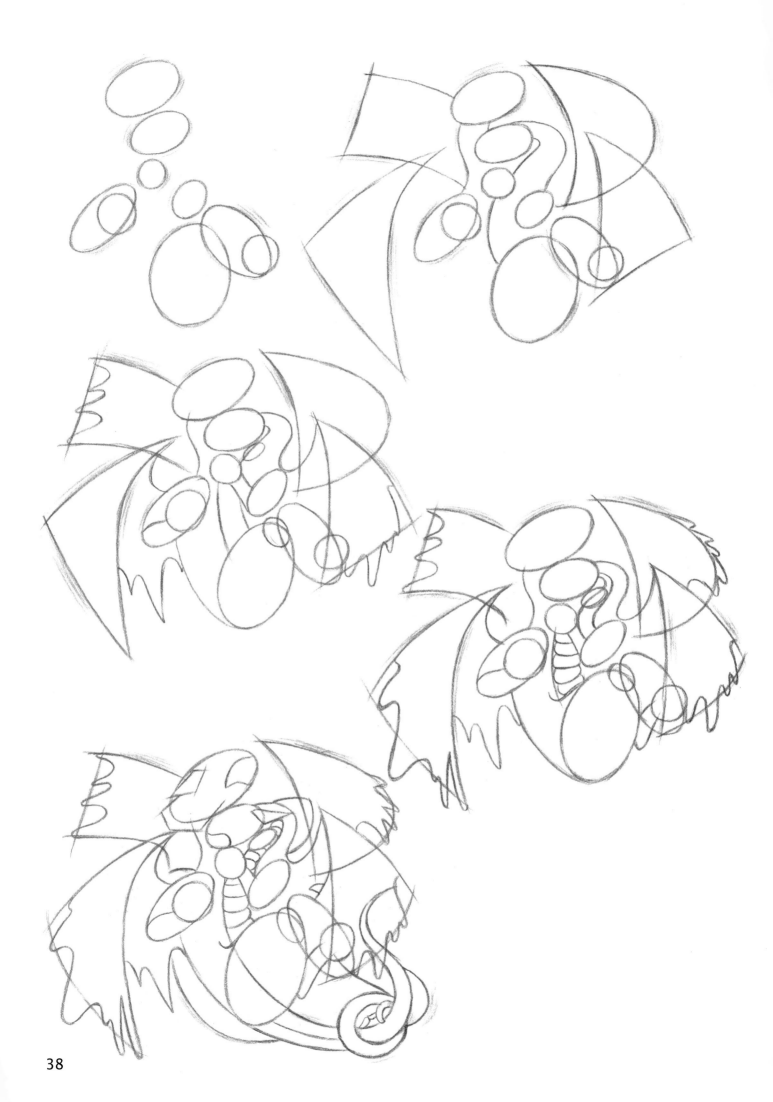

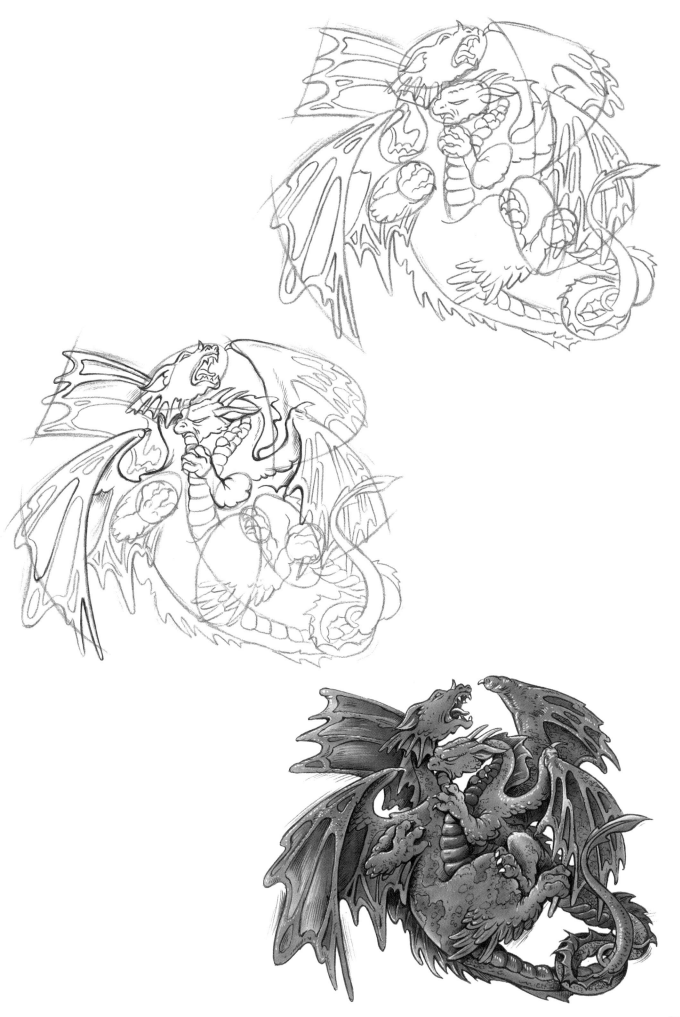

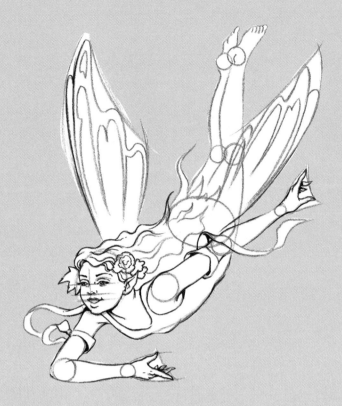

Fairies

Welcome to Fairyland! Paul Bryn Davies has provided a varied collection from cartoon-style winged folk to more realistic fairies; some mischievous, others beguiling, but all of them beautiful.

If you believe in the legends about these elusive creatures, you will know that they are impossible to find, so inspiration must be taken from nature as well as rural and urban environments. Fairies closely resemble humans and understanding the basics of human anatomy will help if you want to progress and draw your own folk. When drawing the wings, try studying the wings of butterflies, lacewings and similar flying insects.

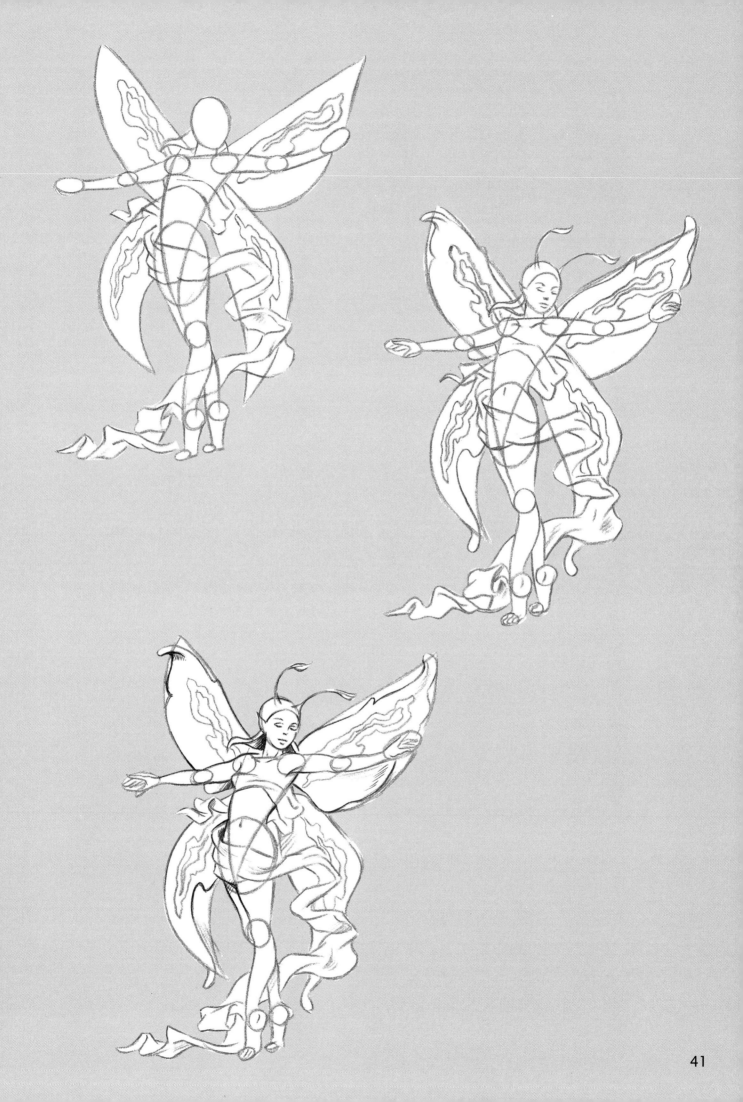

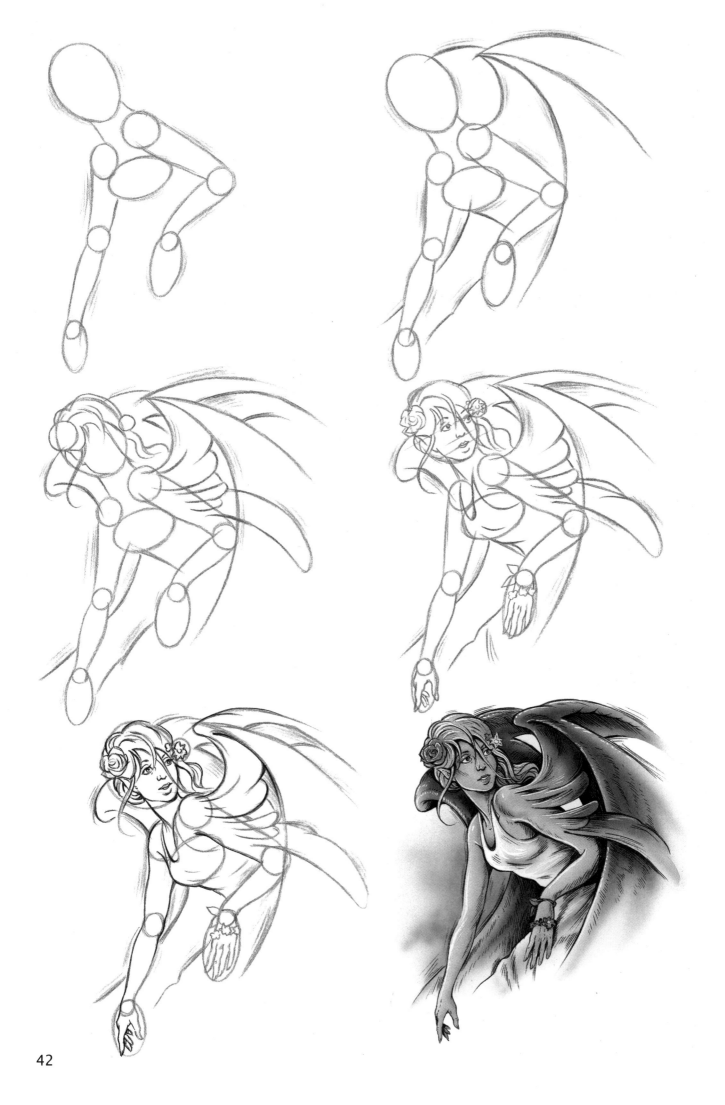

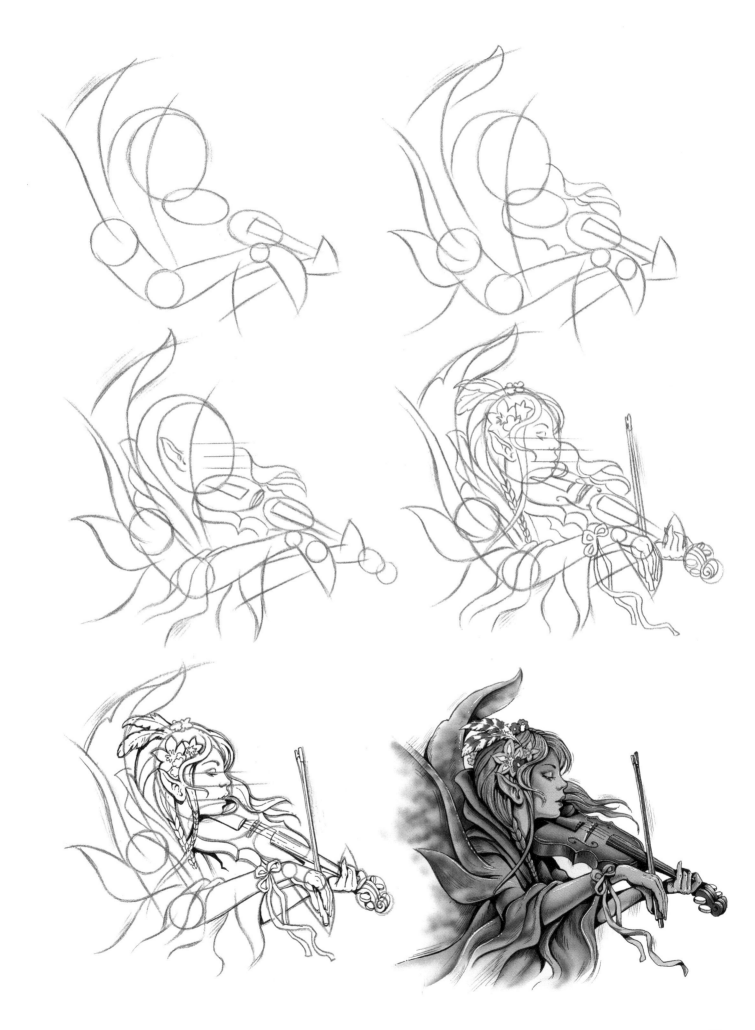

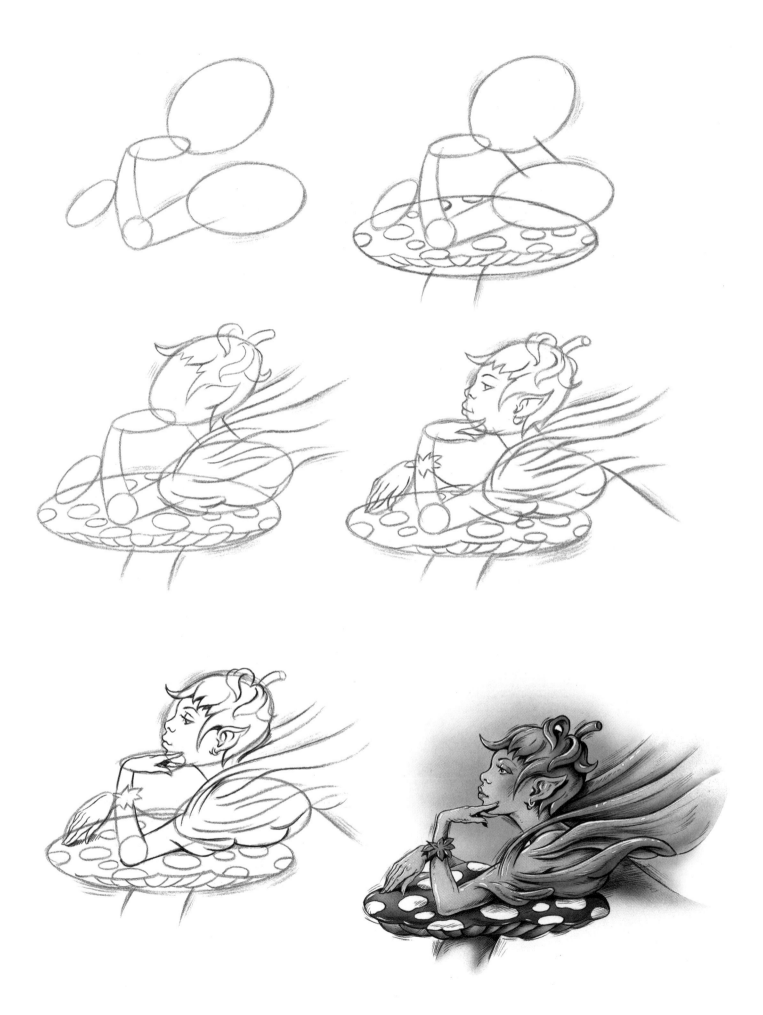

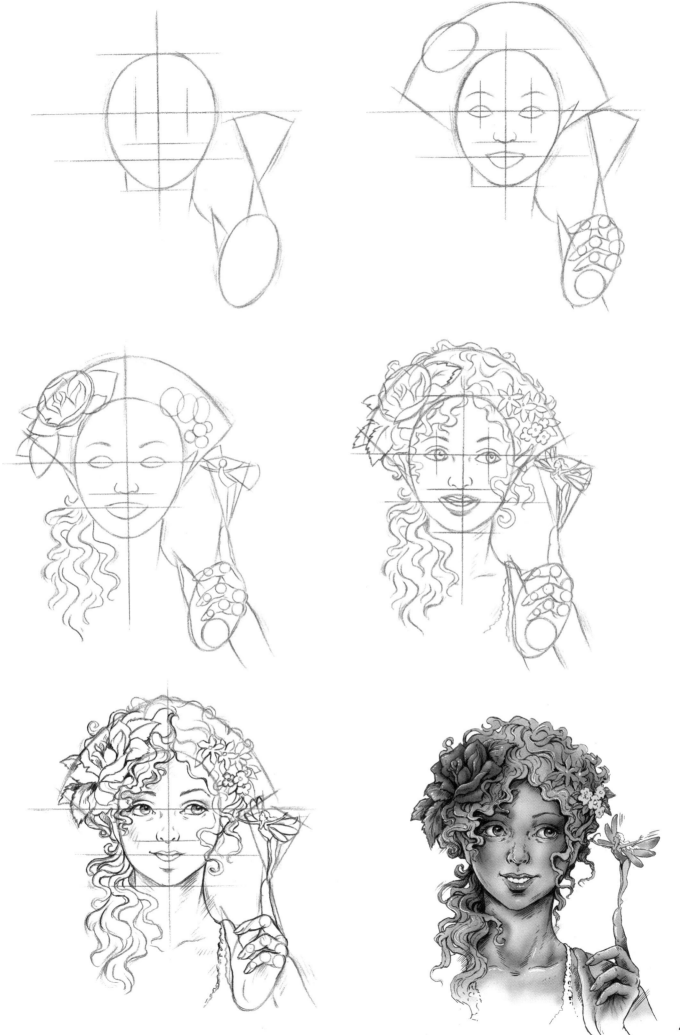

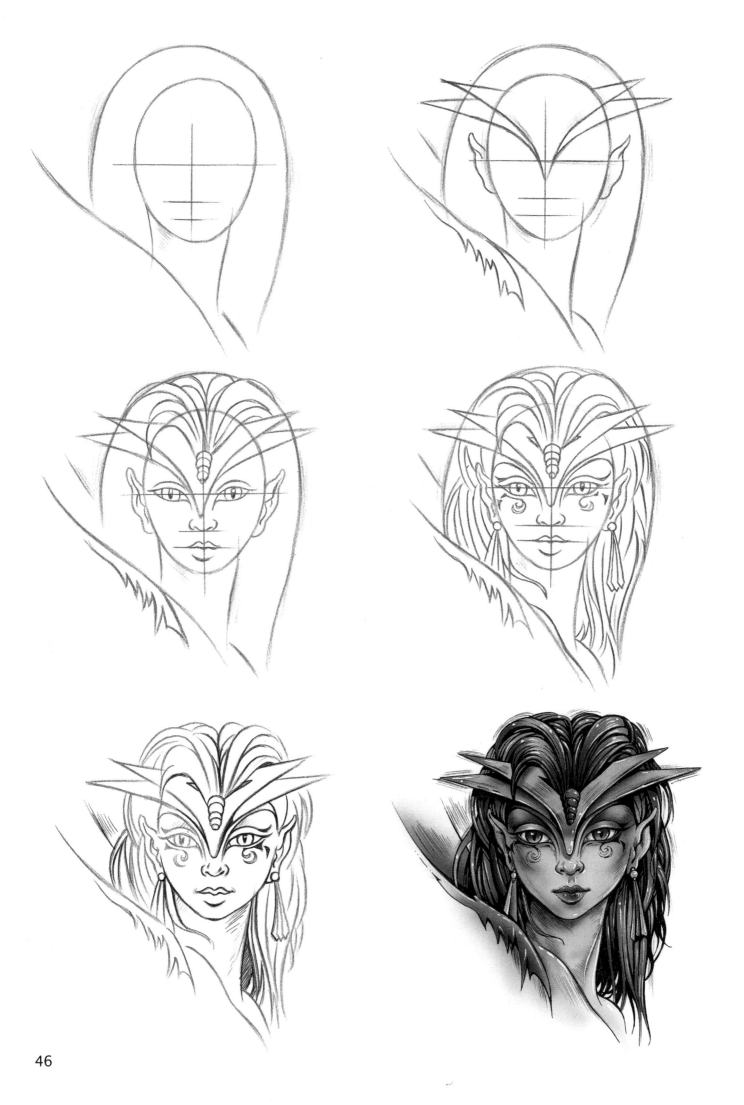

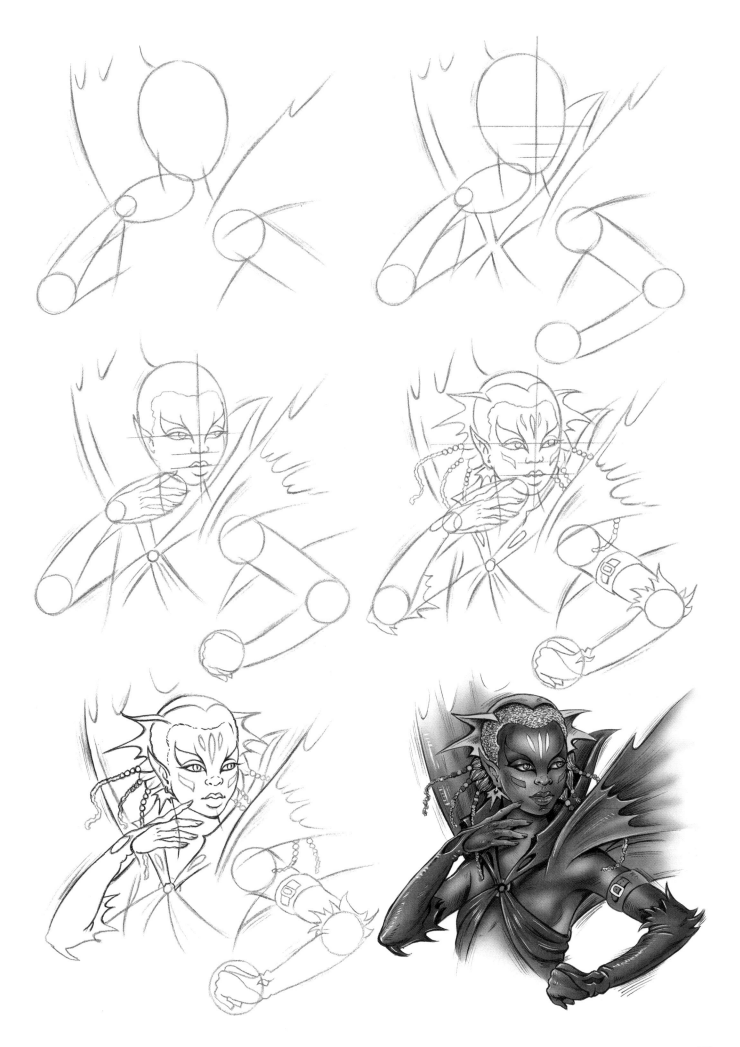

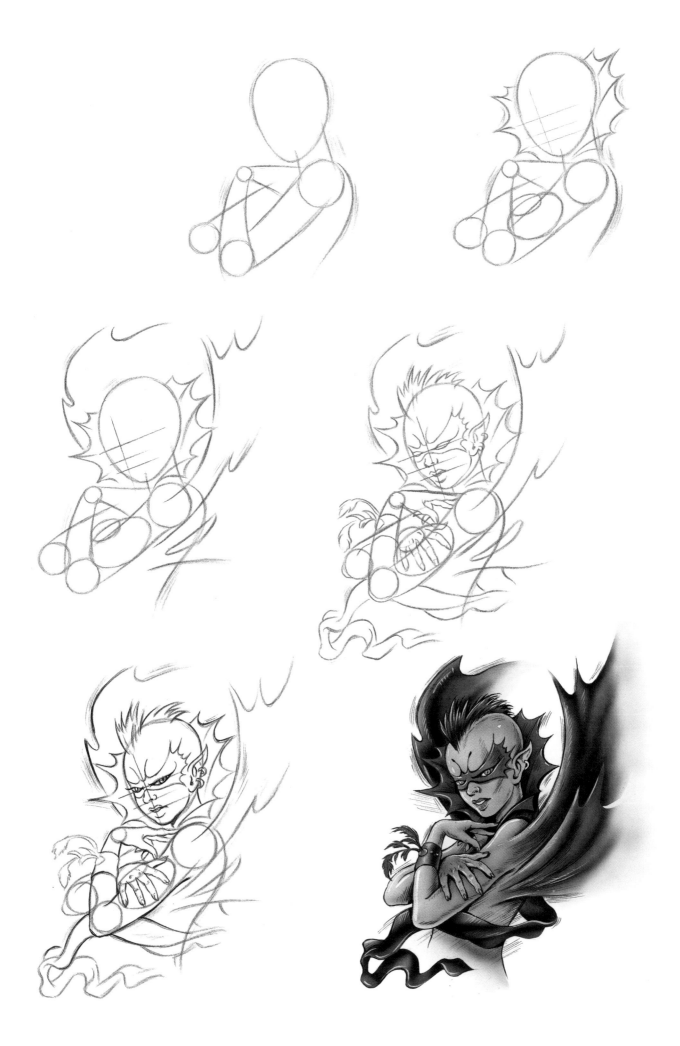

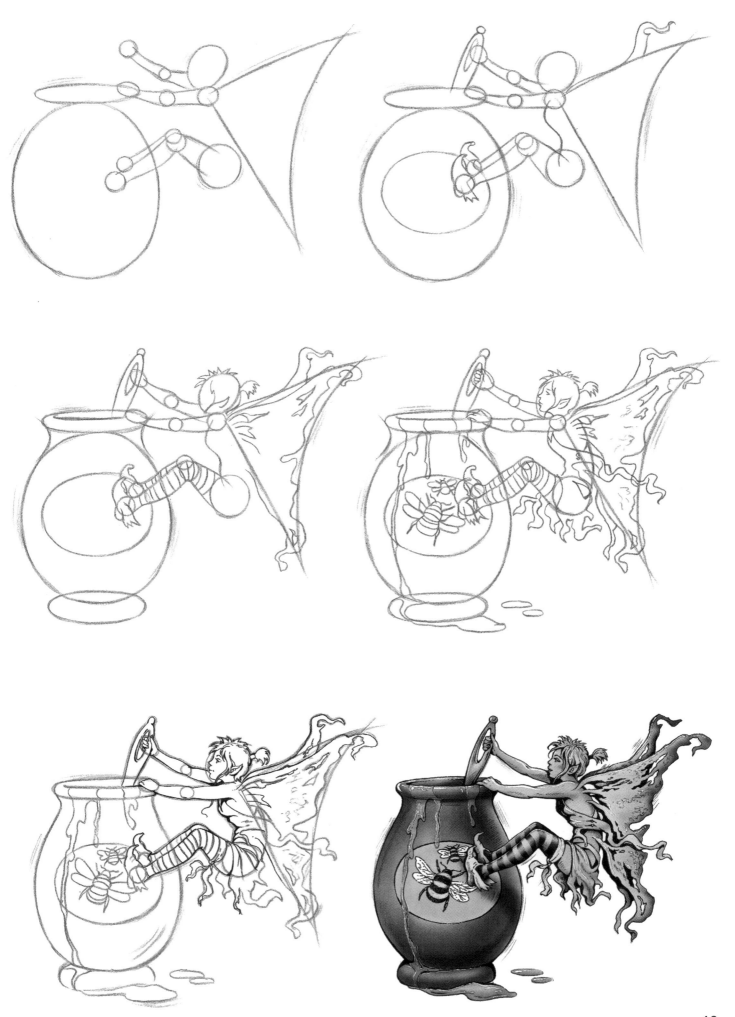

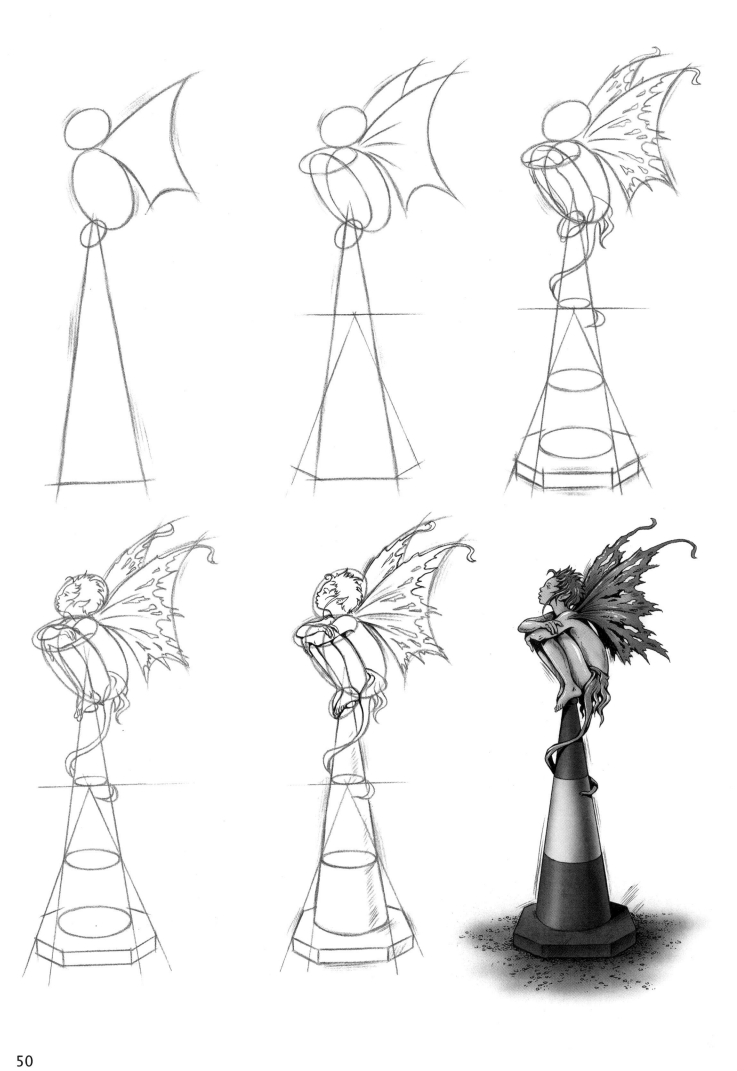

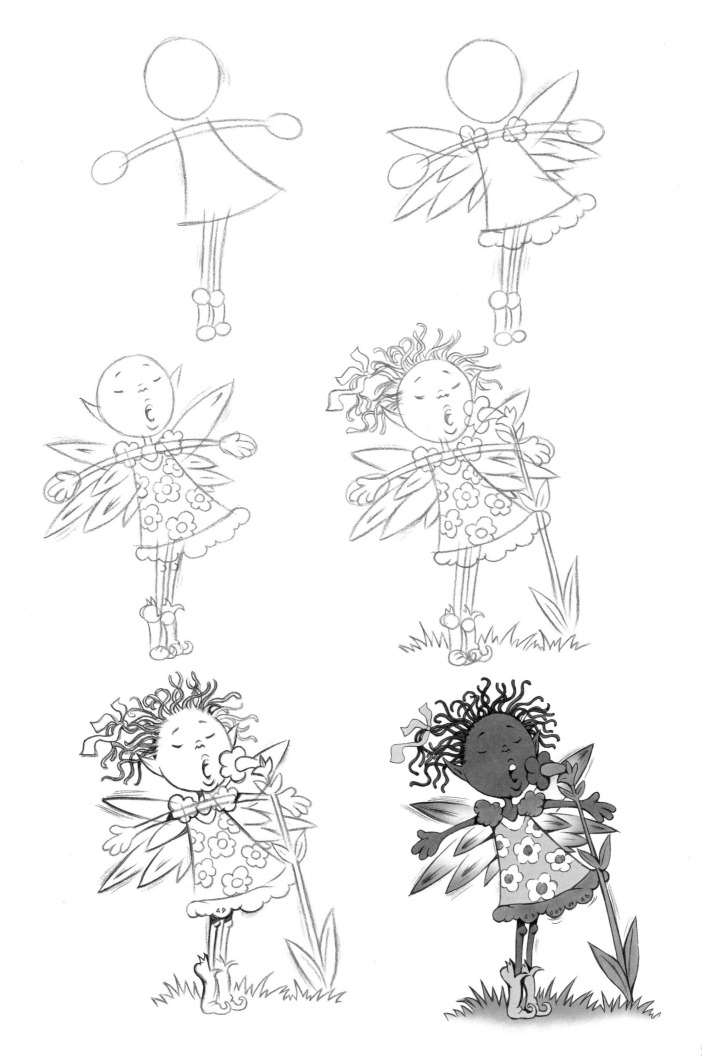

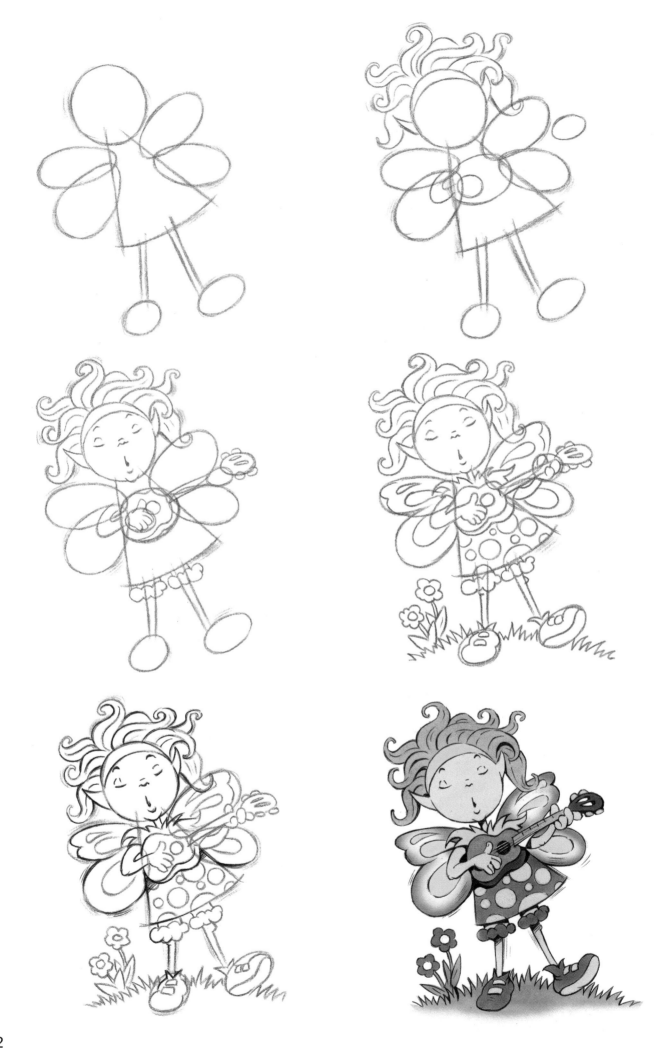

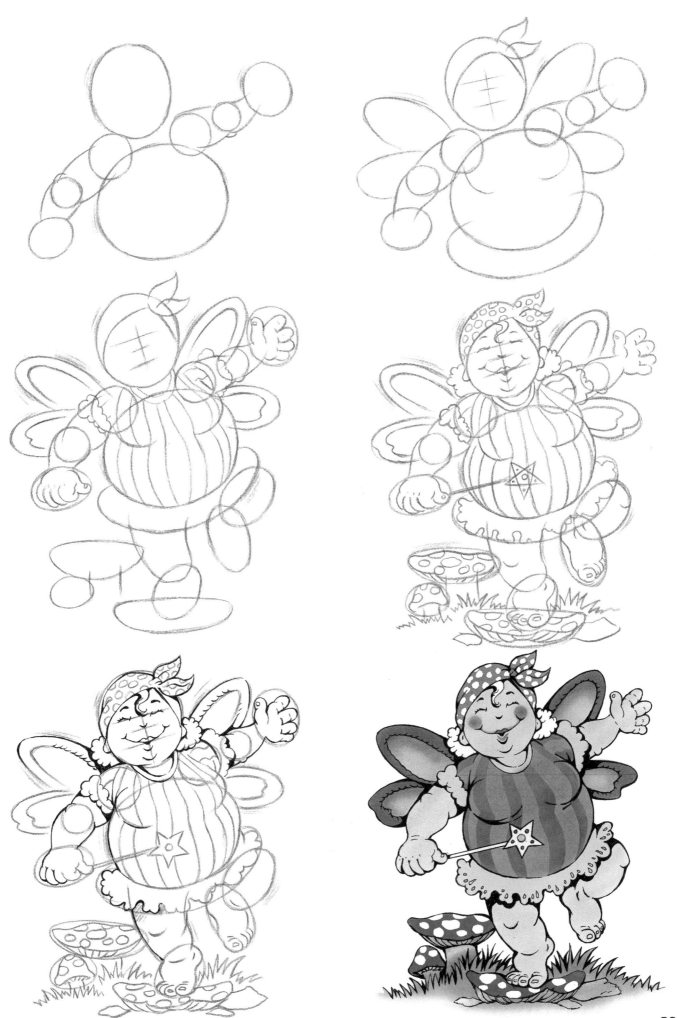

53

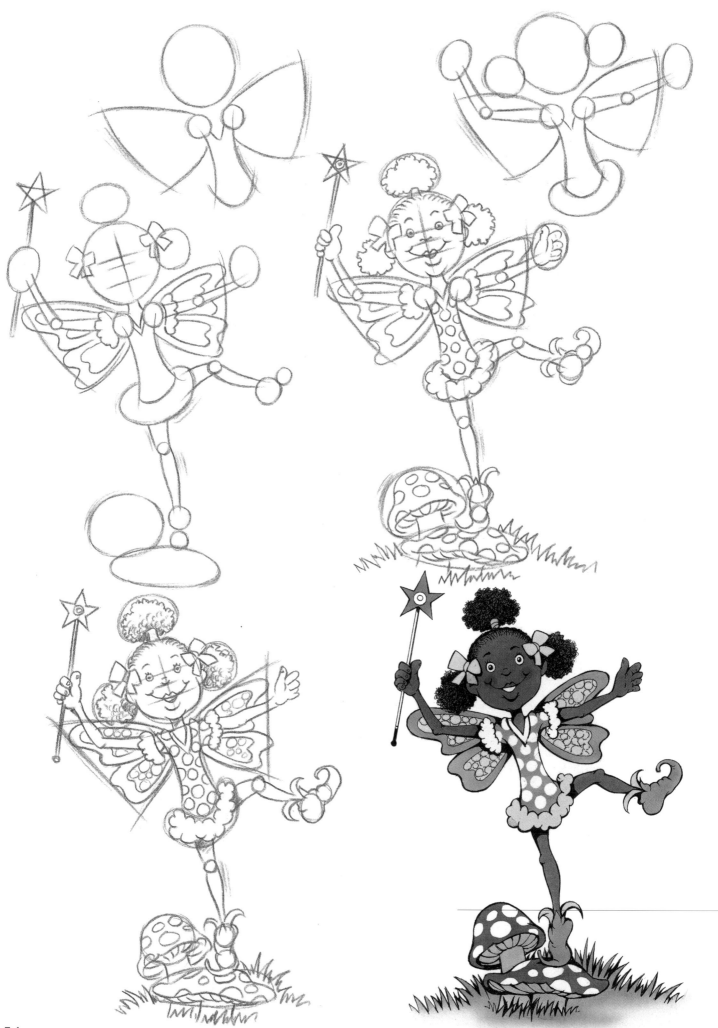

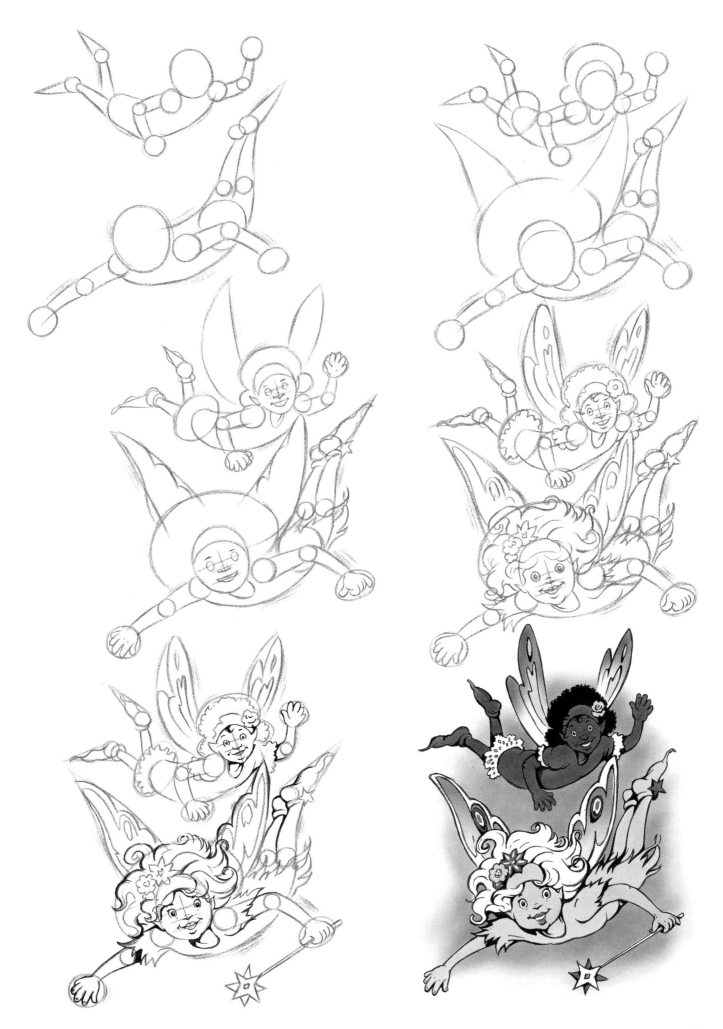

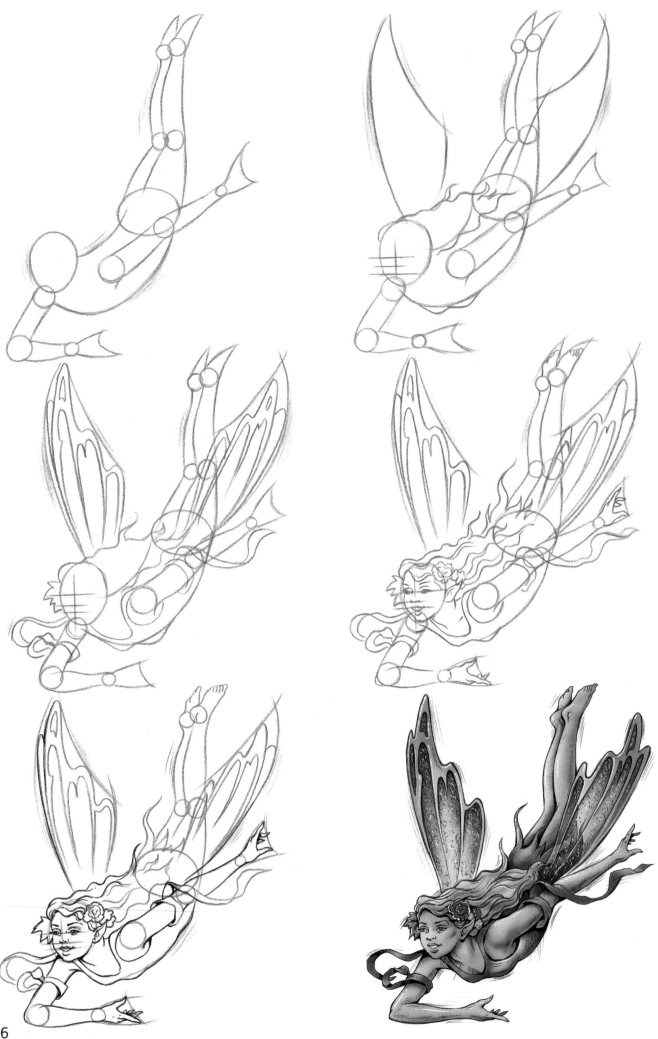

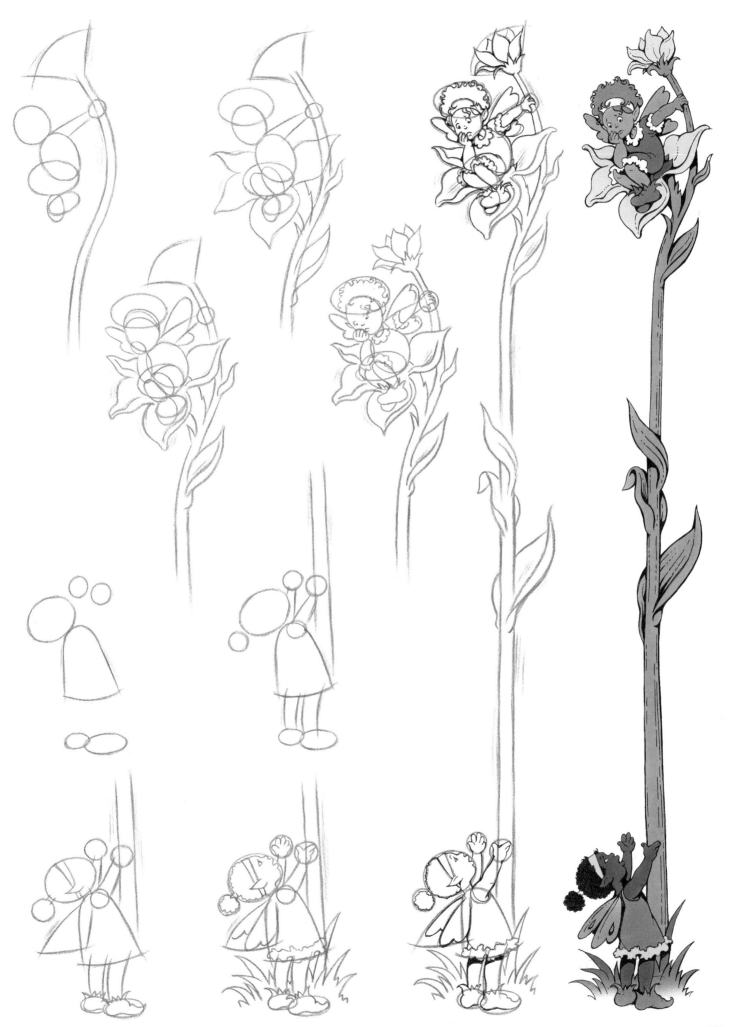

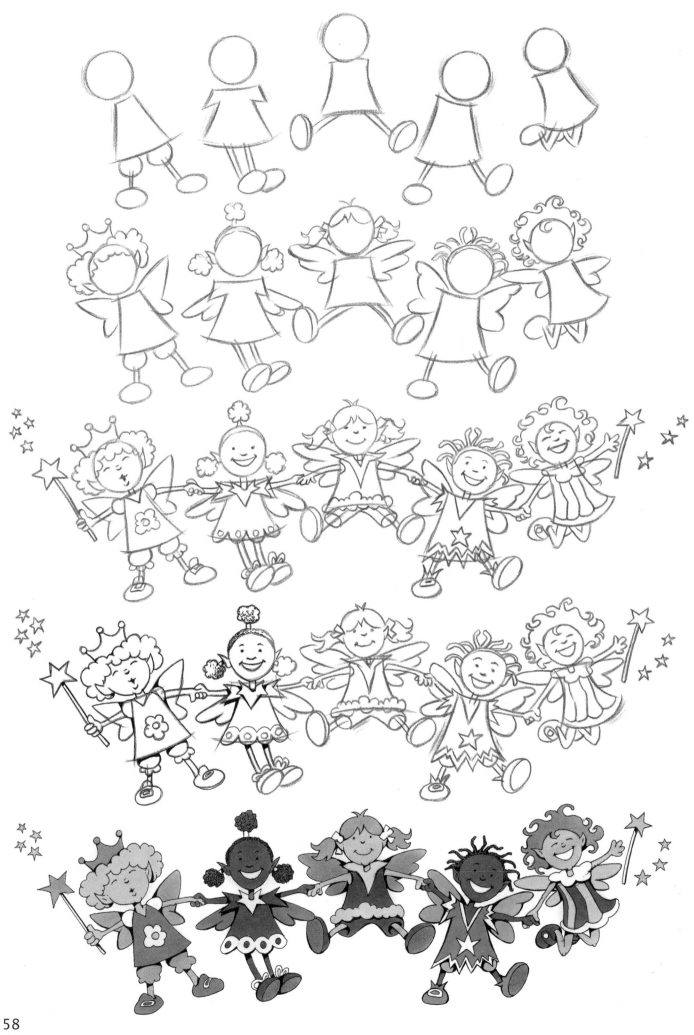

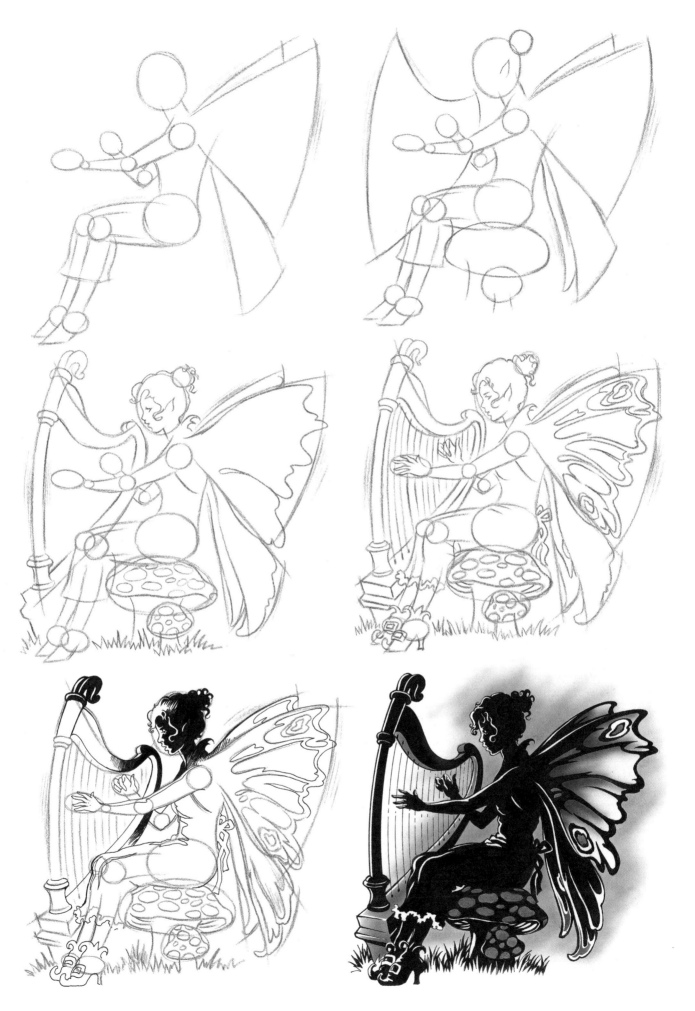

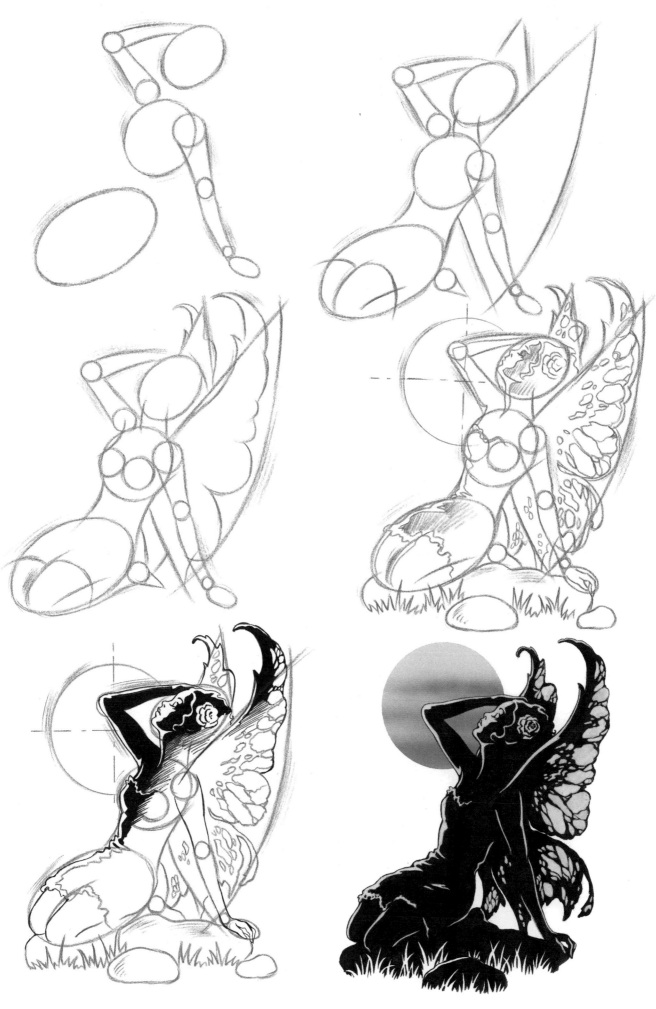

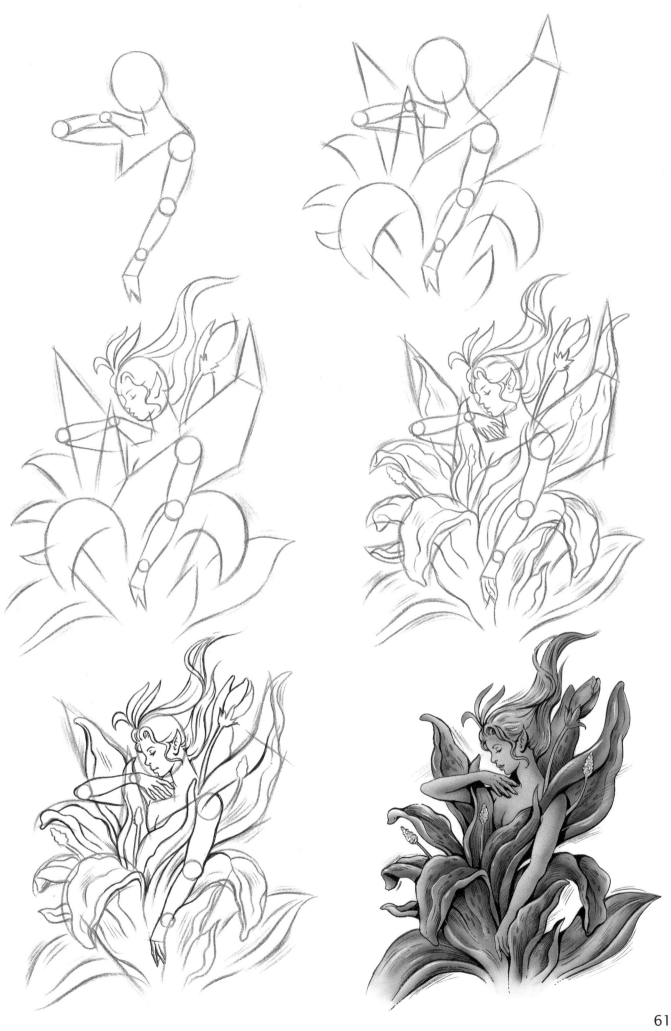

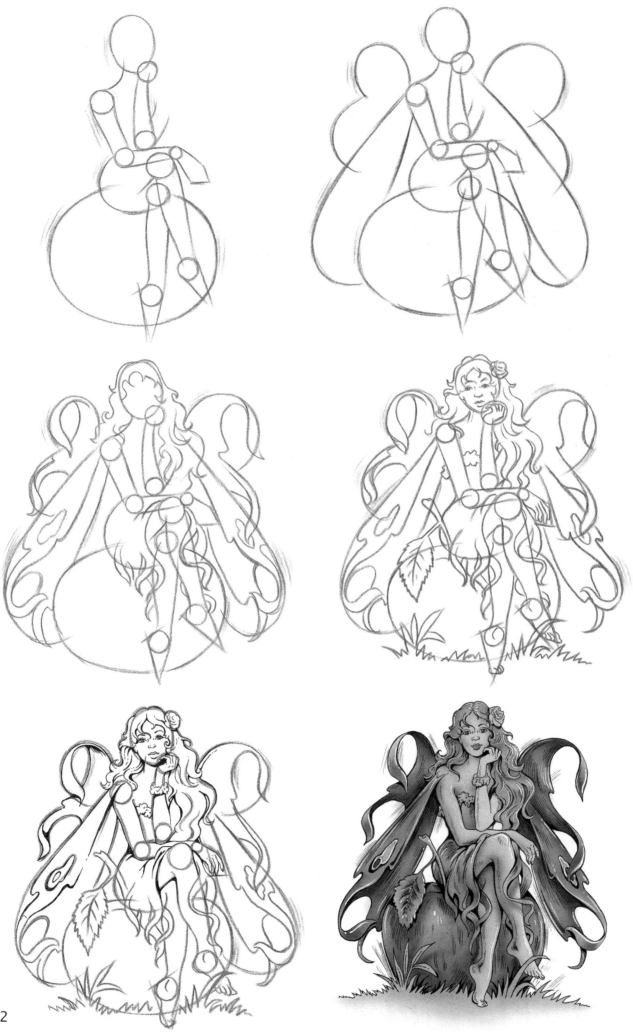

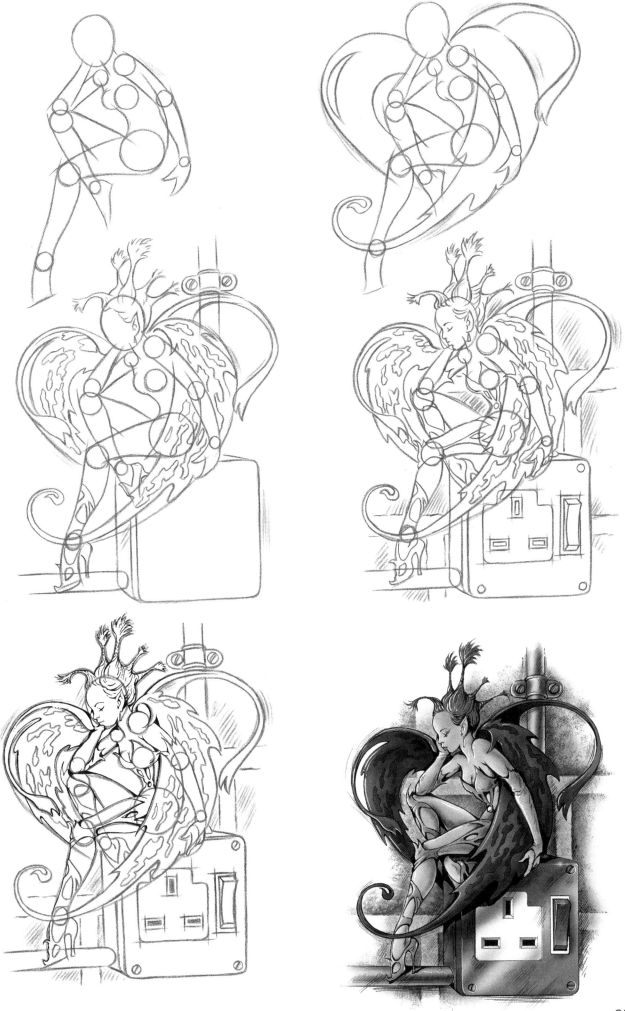

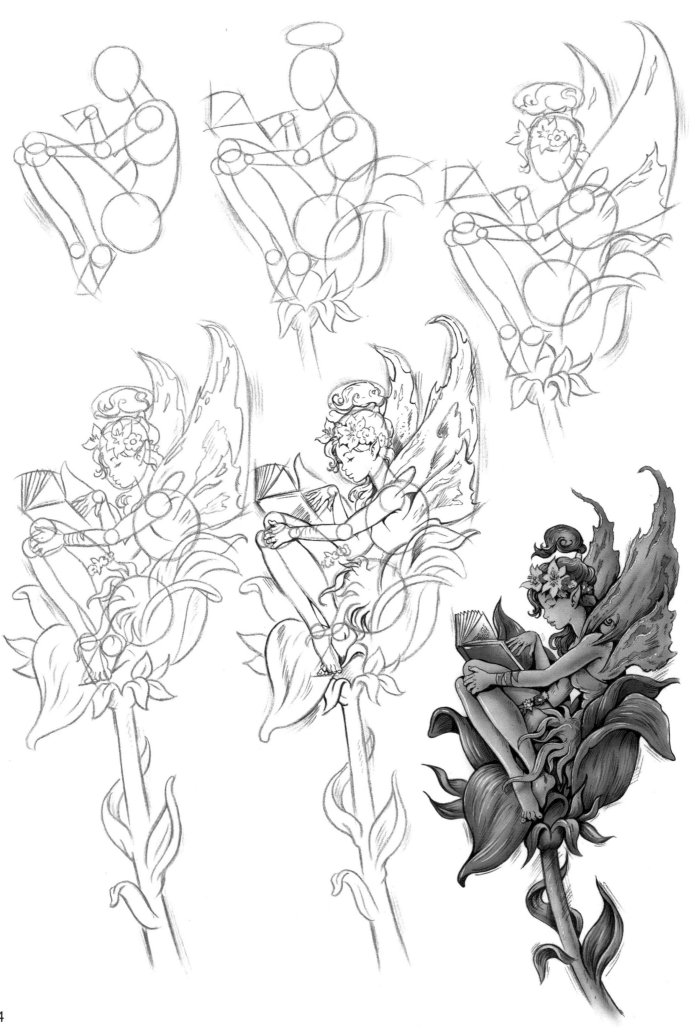

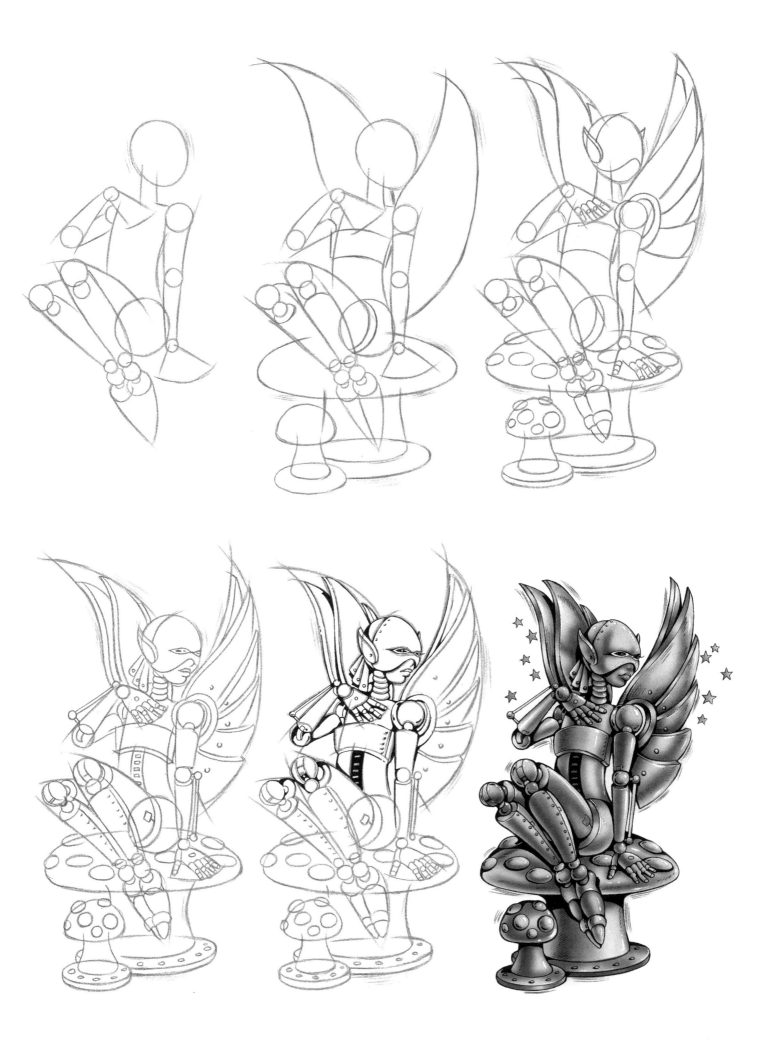

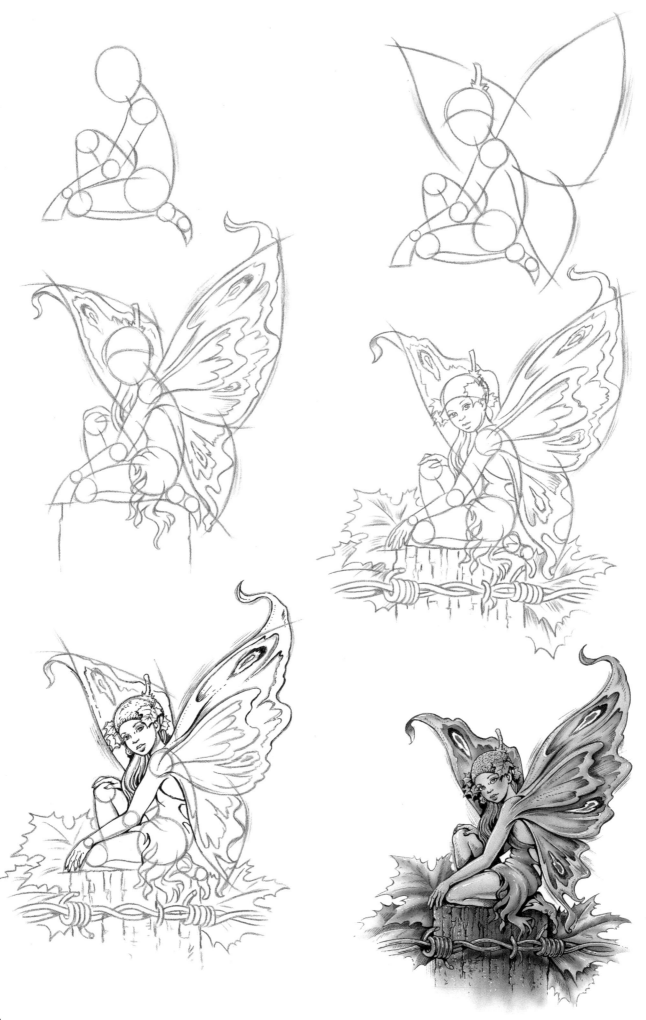

66

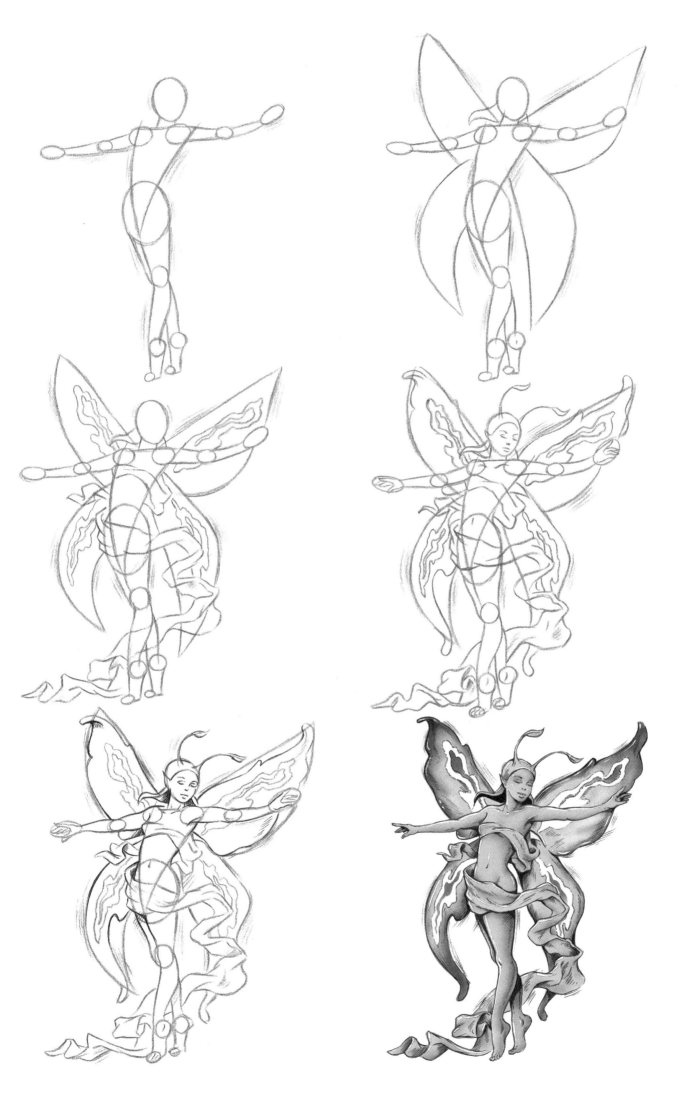

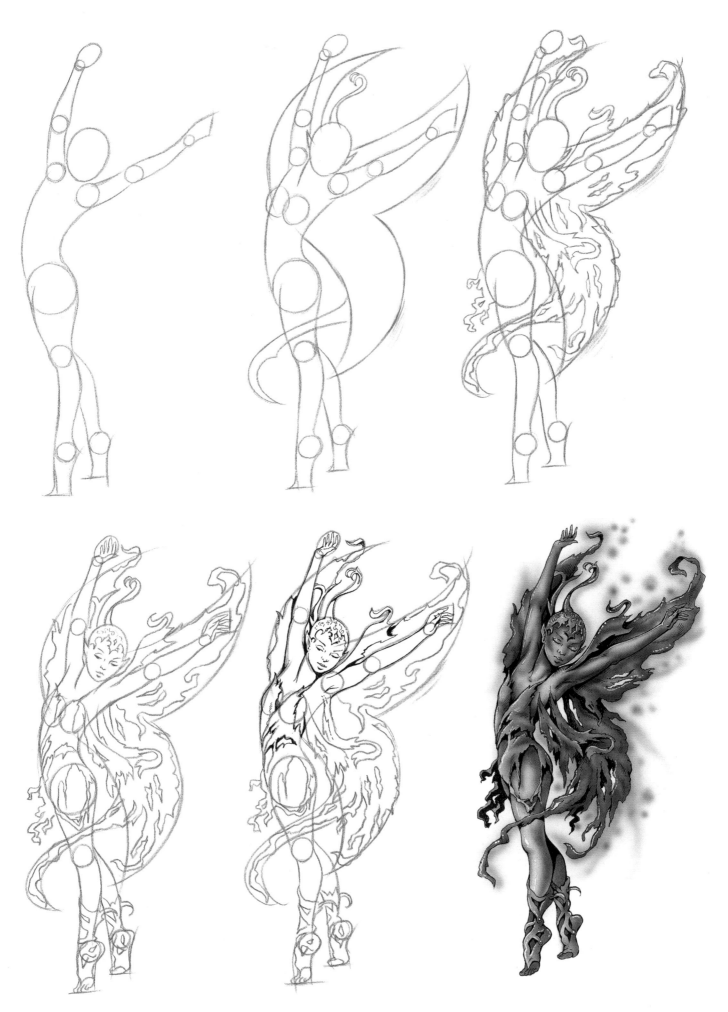

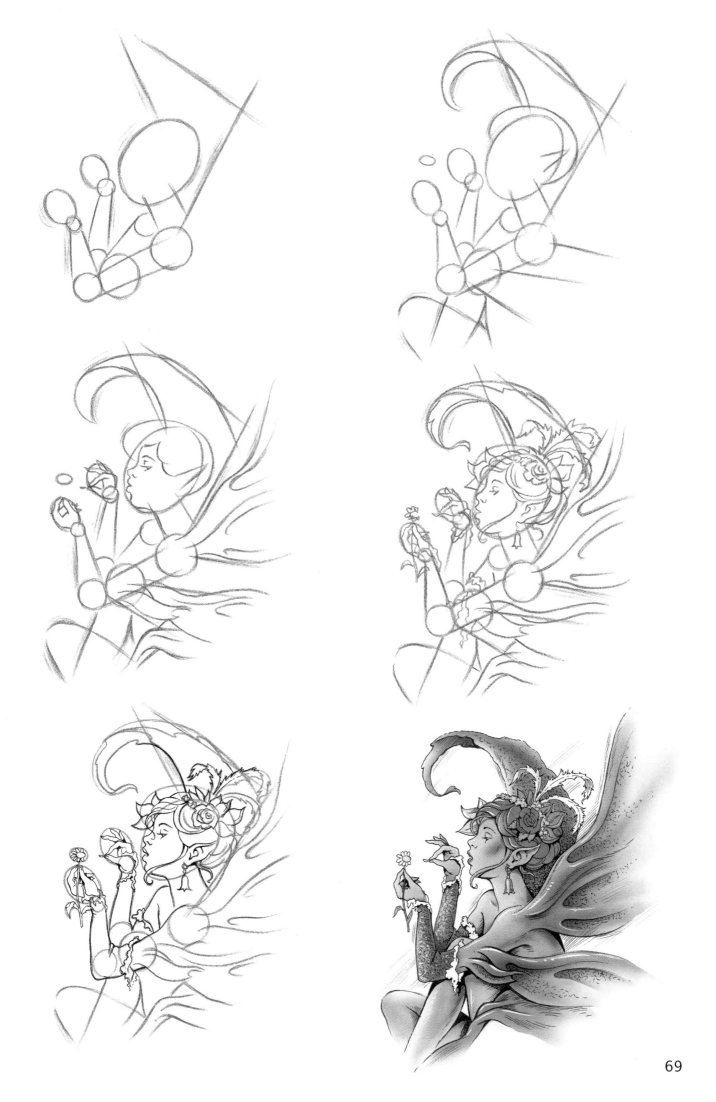

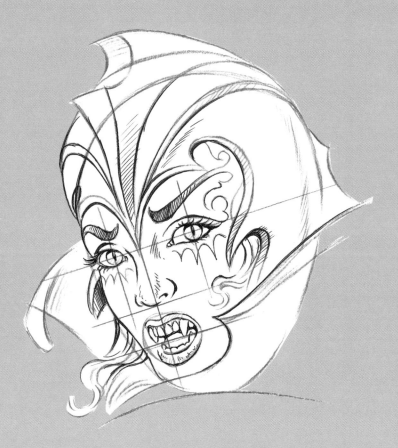

Vampires

Welcome to nightfall – when the vampires rise to drink! This selection includes a broad range of frightening and sometimes beautiful vampires in different styles, both male and female. Some feature a menacing atmosphere with bats, tombstones and castles as part of the backdrop. This type of setting can enhance a character considerably and it does not have to be complicated.

Understanding the basics of human anatomy will really help you to create your own vampires. It is a good idea to look at photographic reference for the basic figure. Magazines, mail order catalogues or photographs of family and friends are a great source of inspiration – though, hopefully, not for the fang-like teeth! An artist's mannequin is also useful for creating the foundation of your vampire drawing. Seek inspiration for clothing by looking at costumes, both old and new.

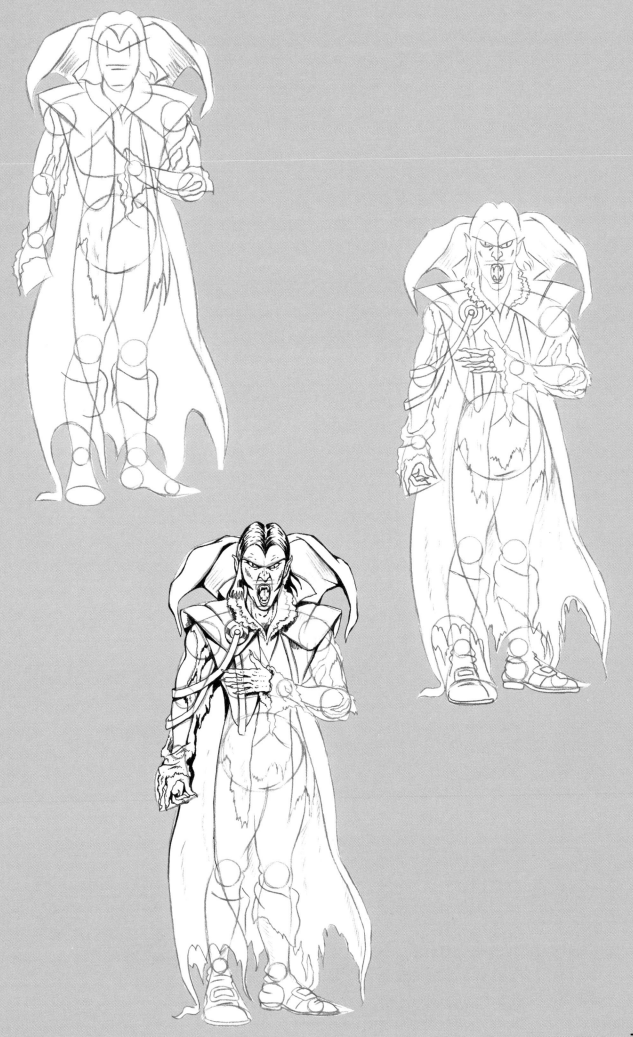

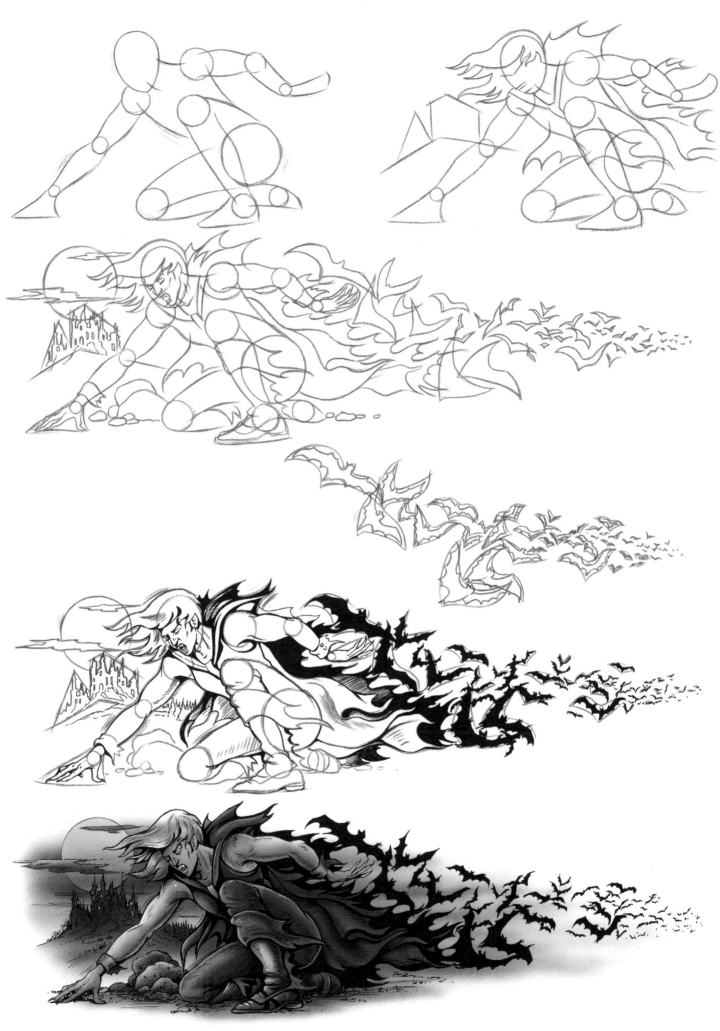

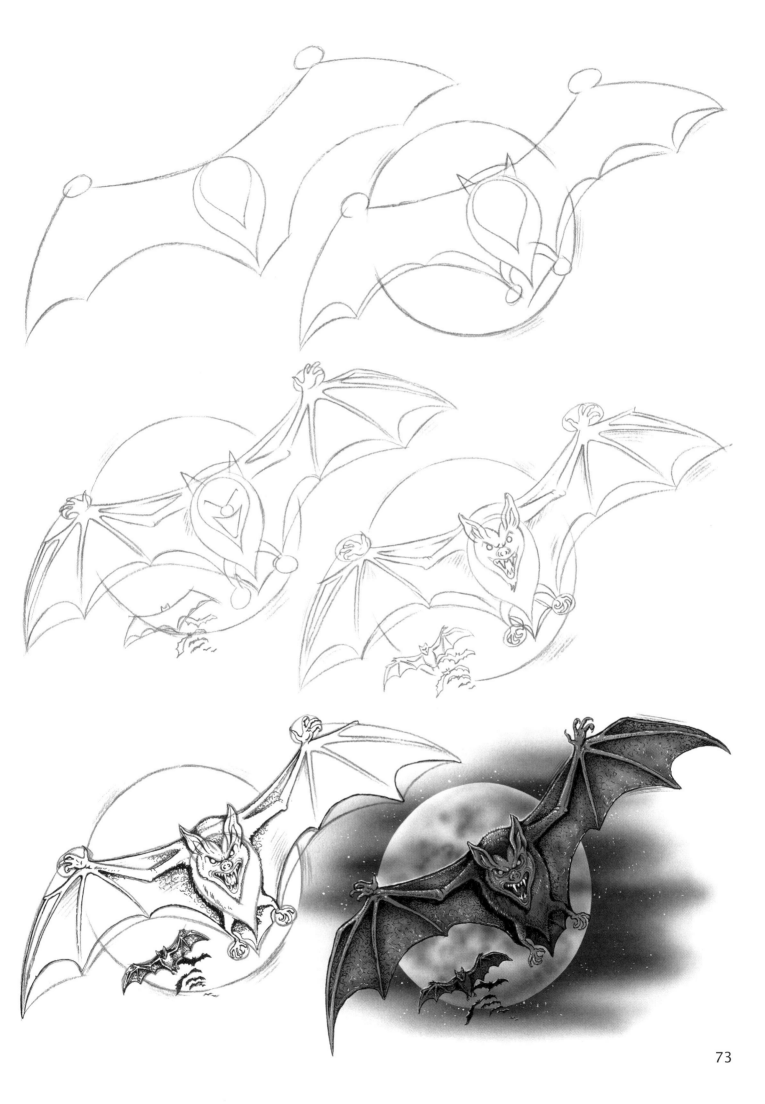

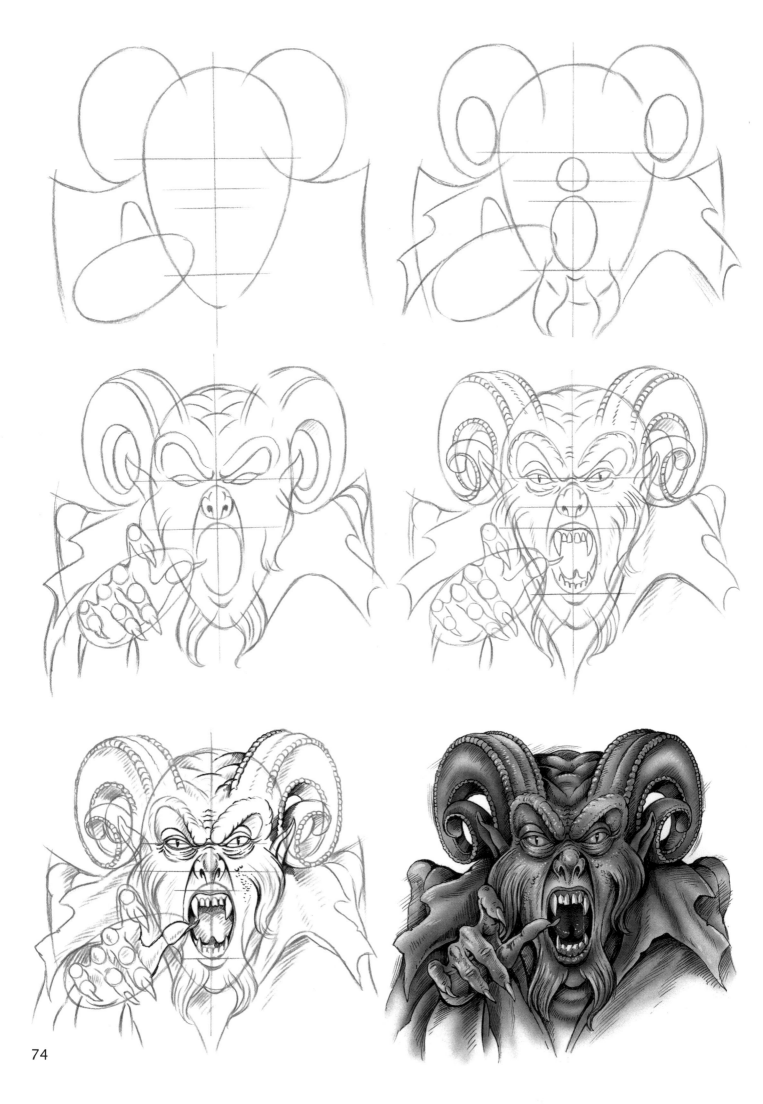

74

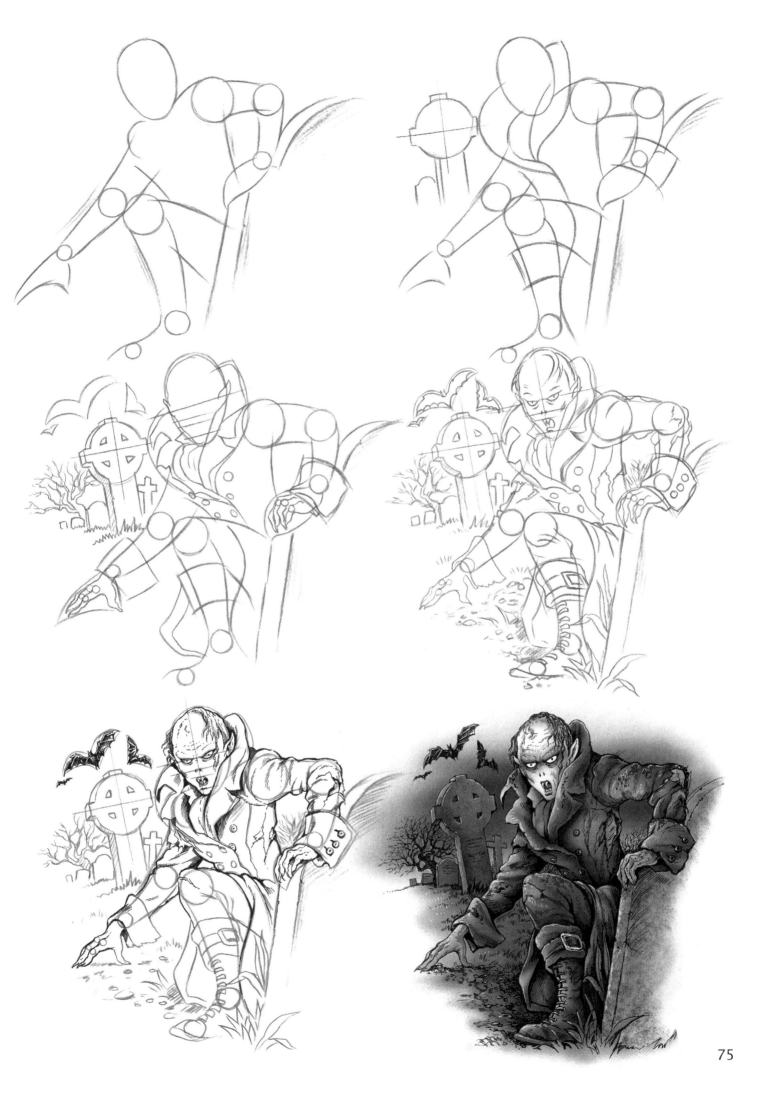

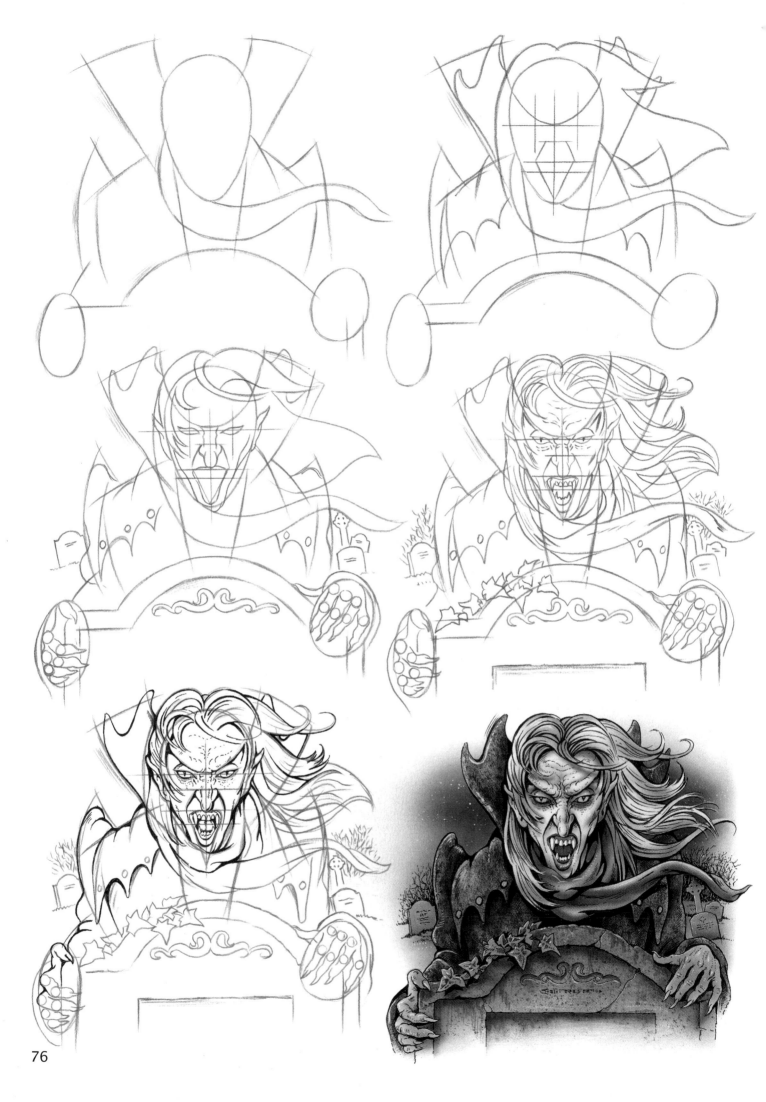

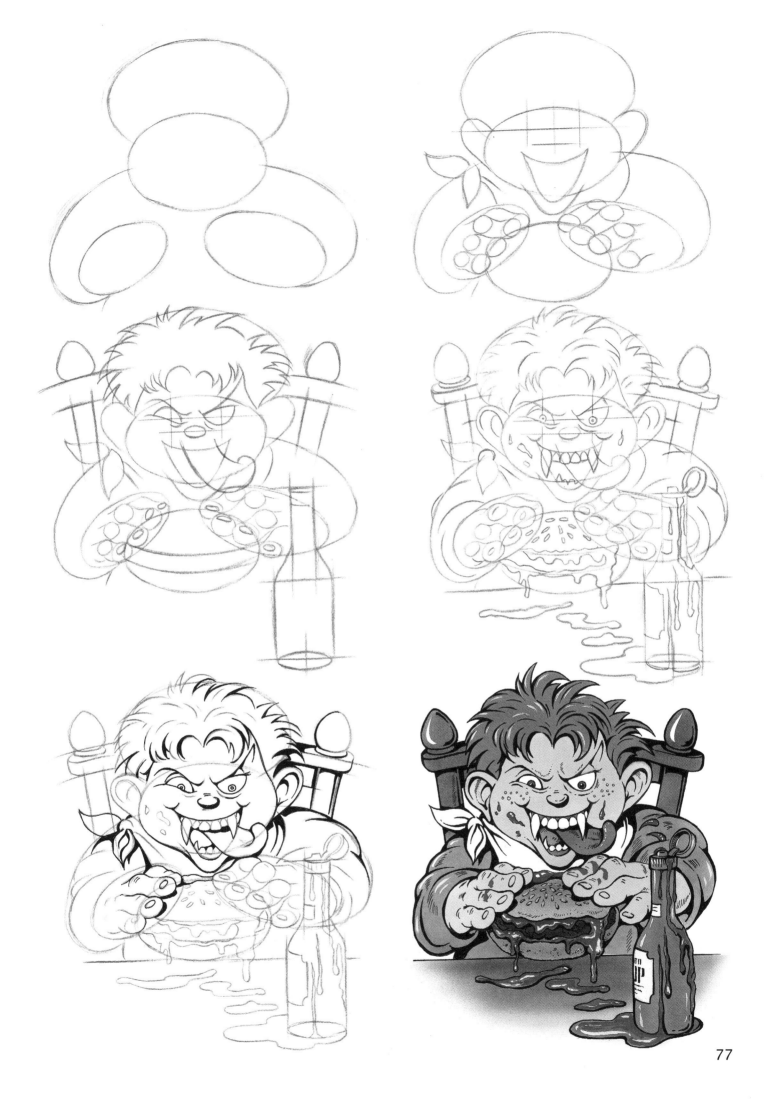

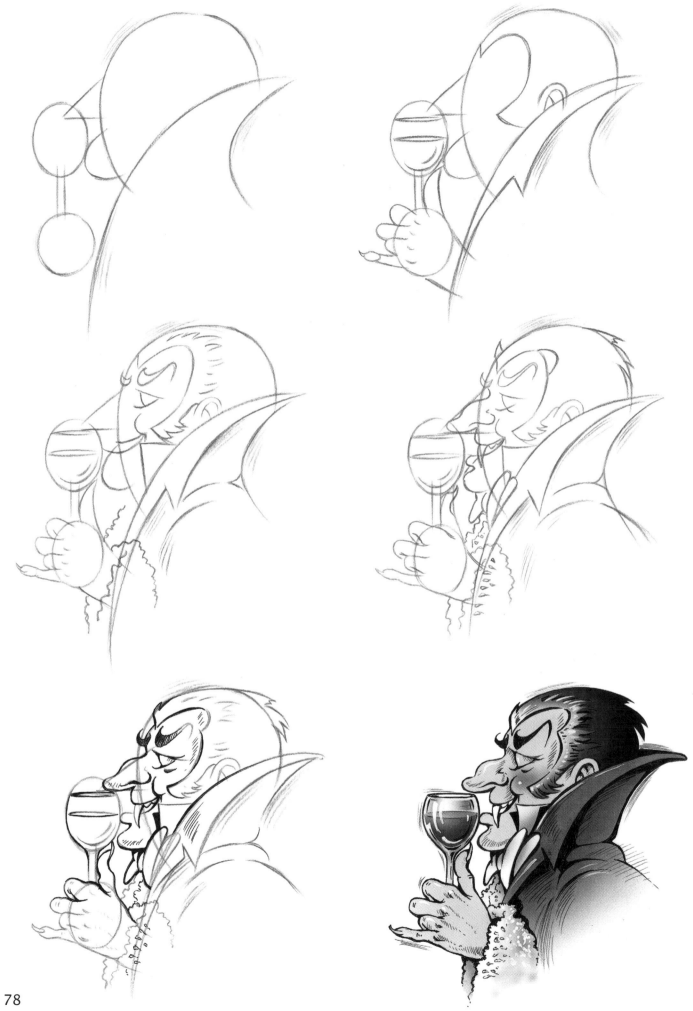

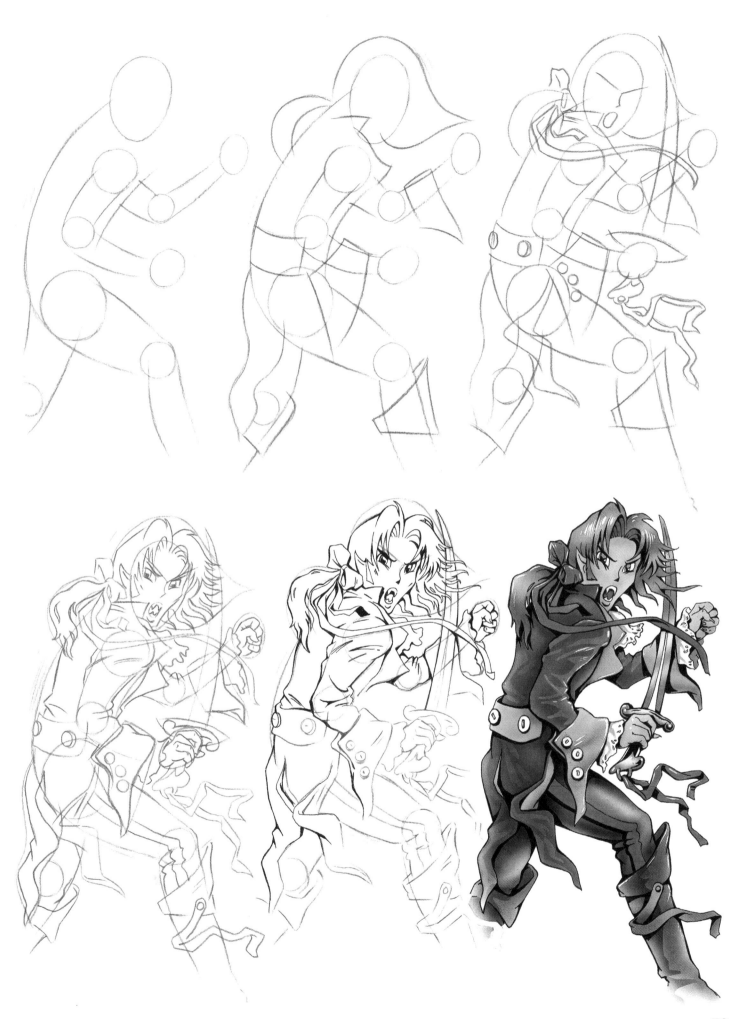

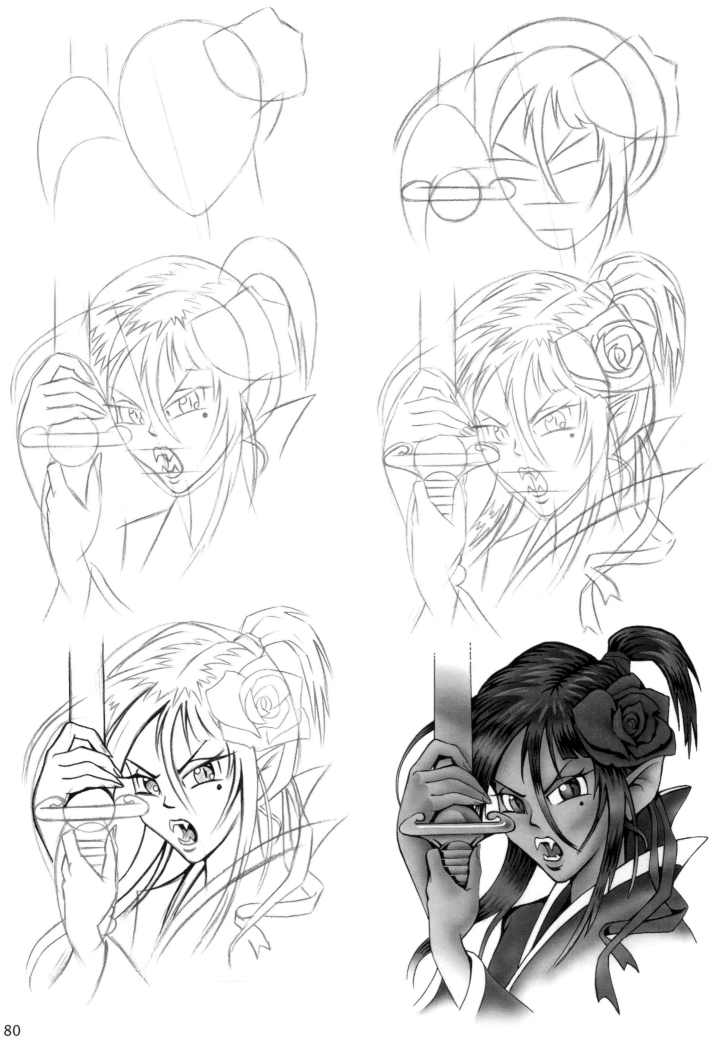

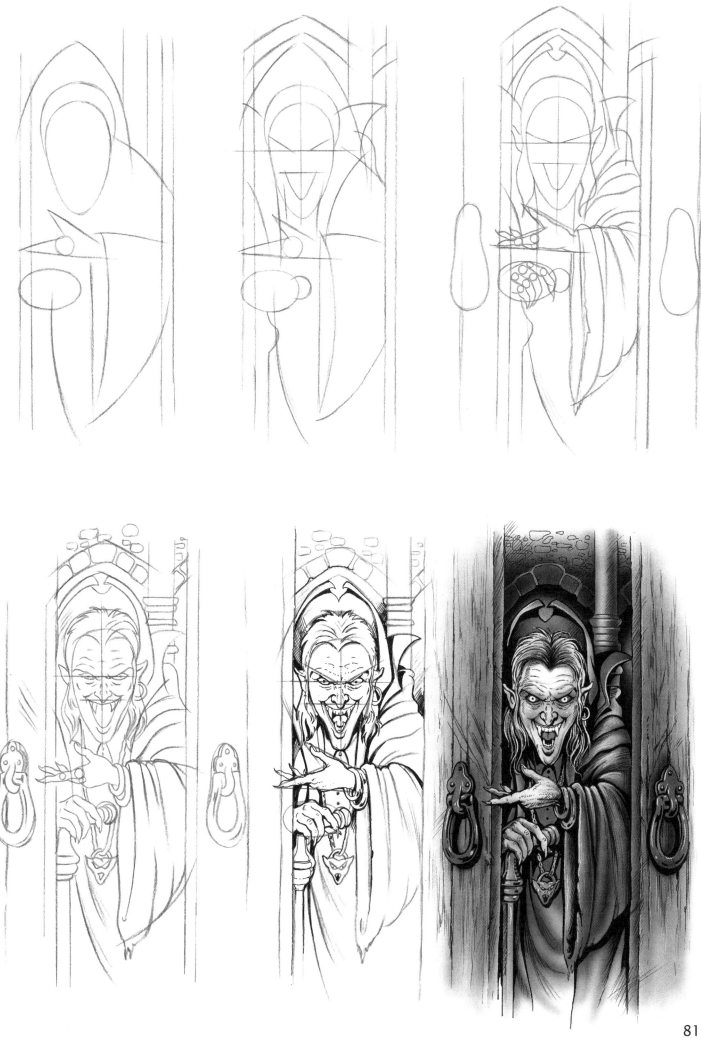

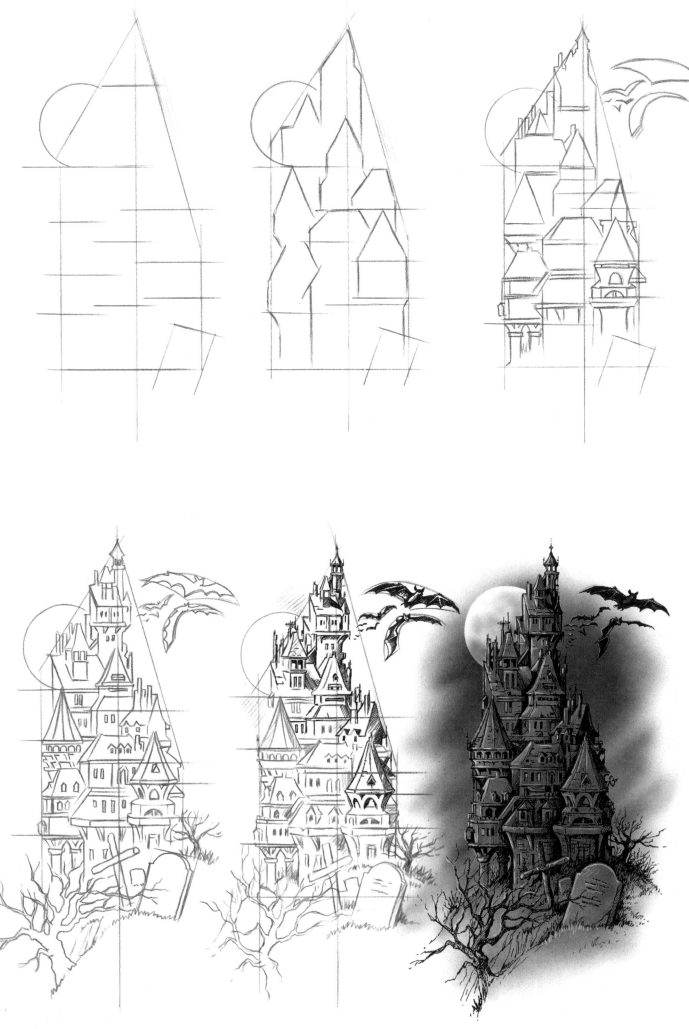

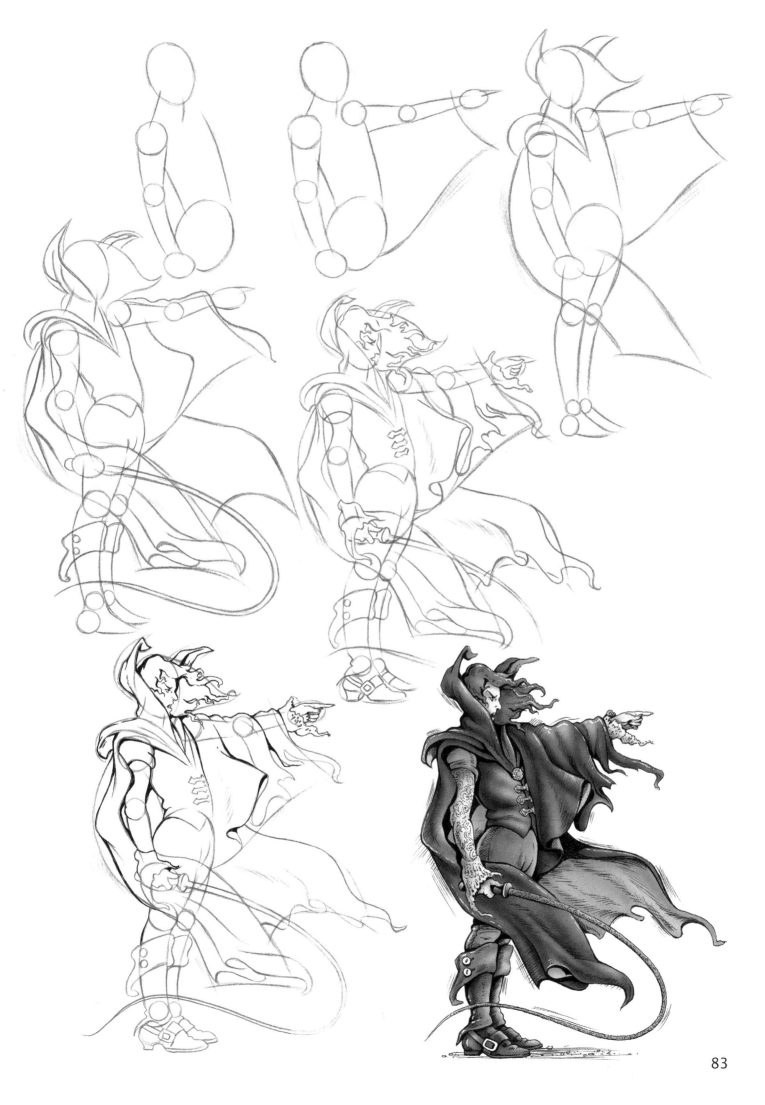

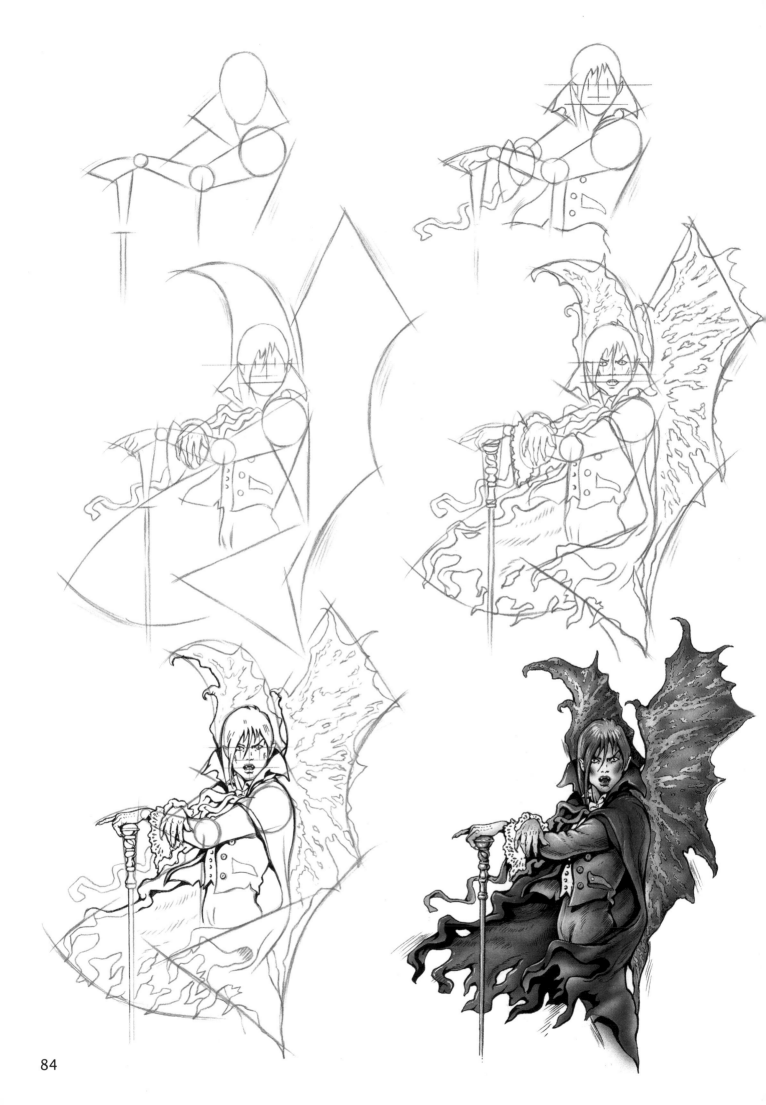

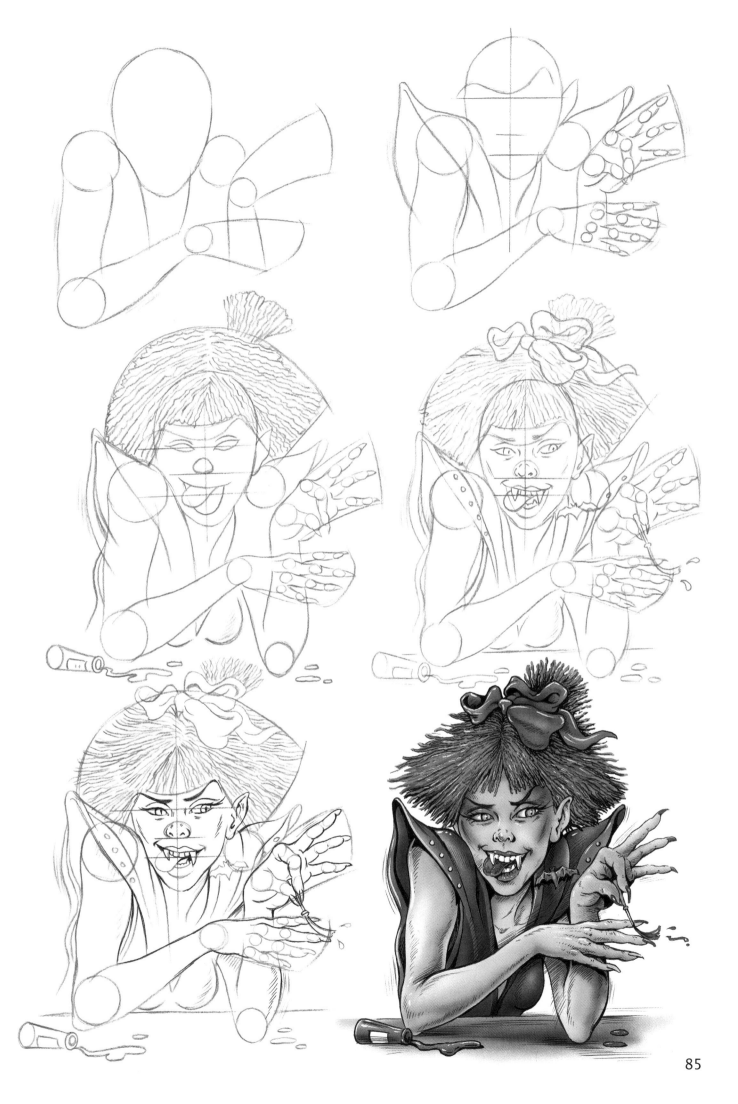

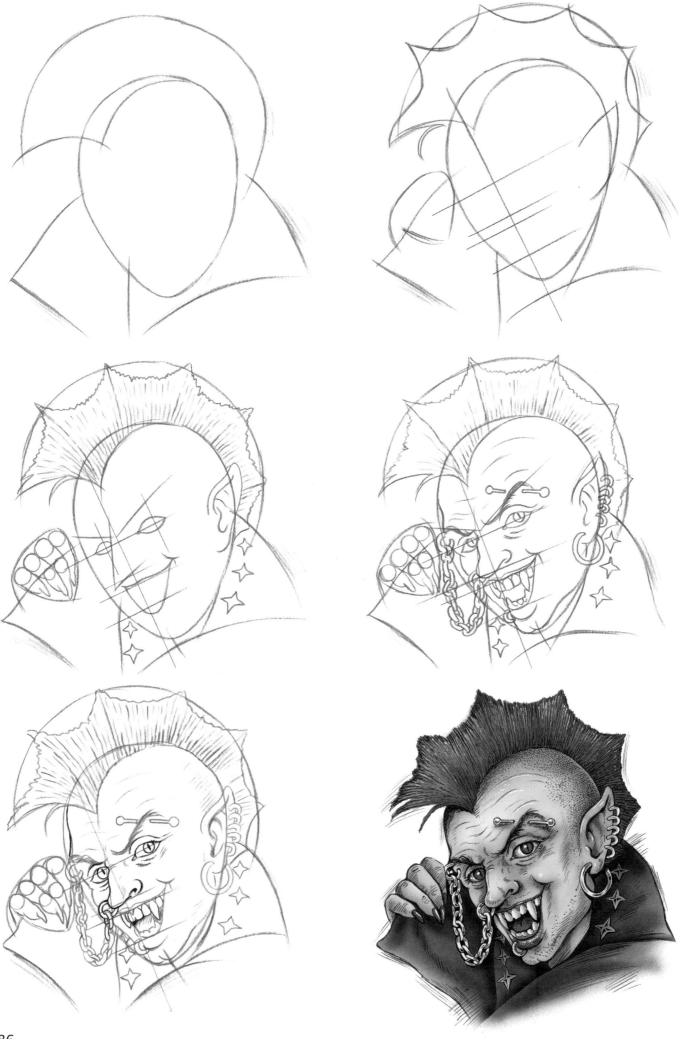

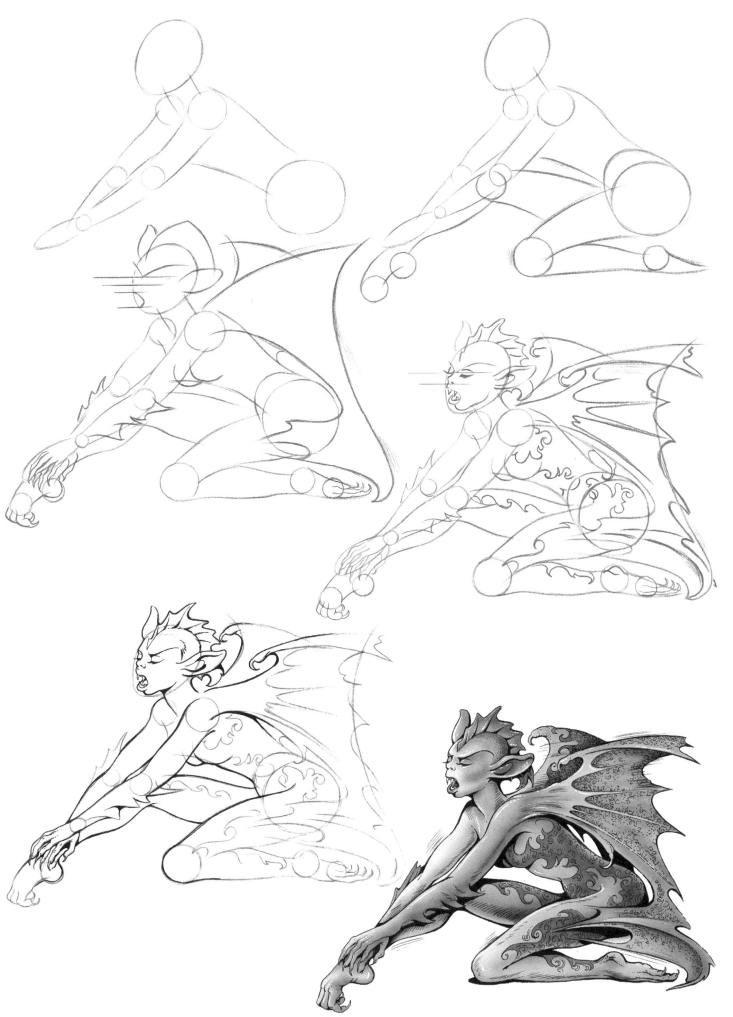

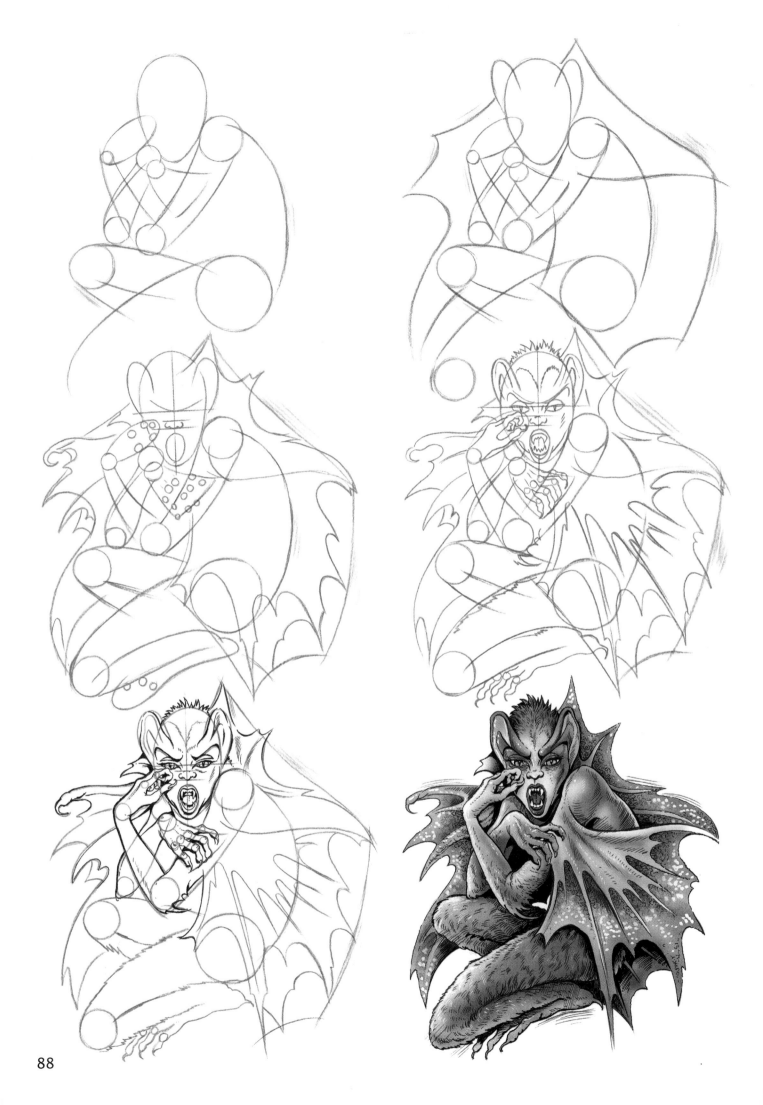

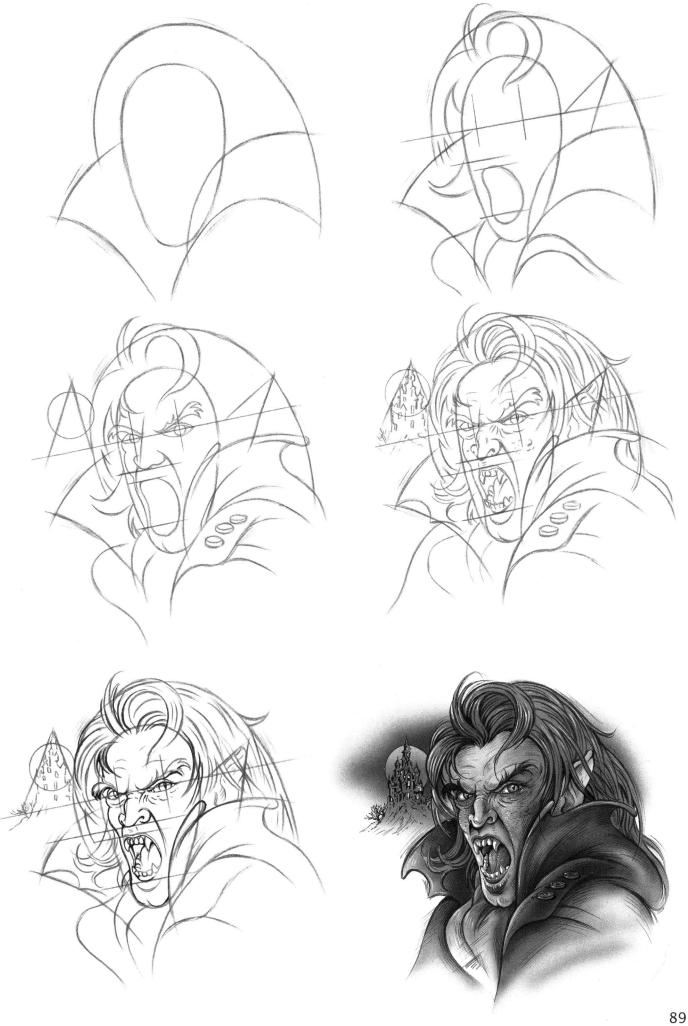

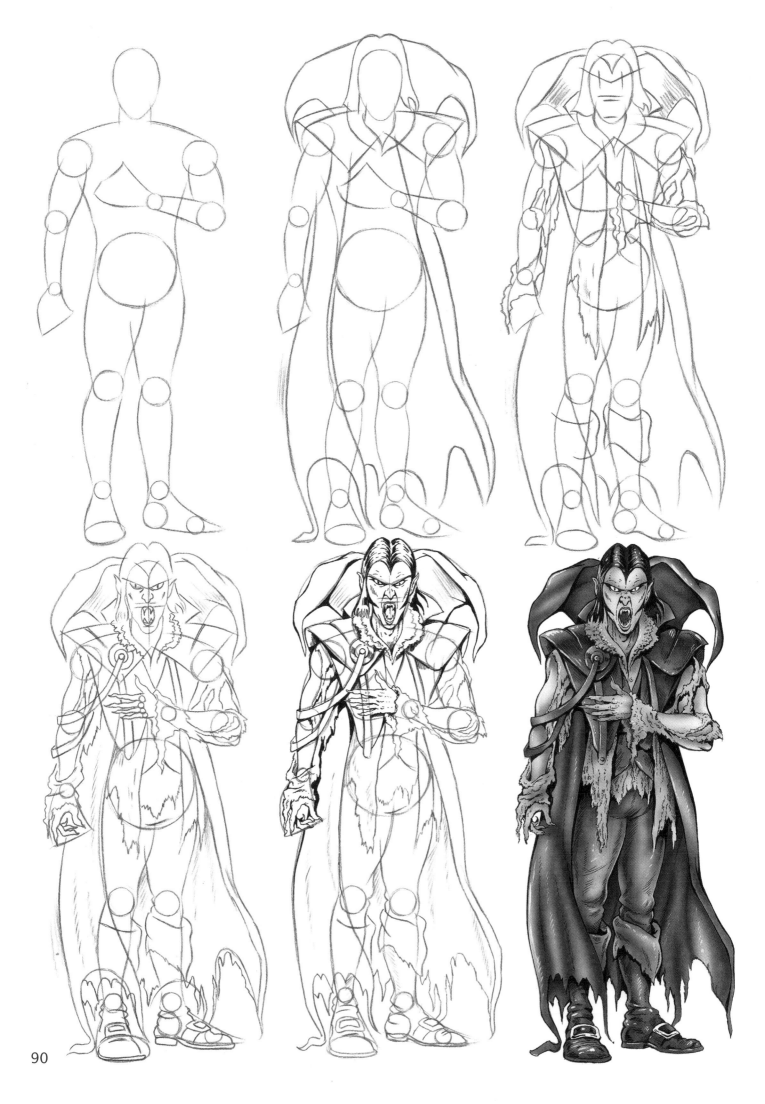

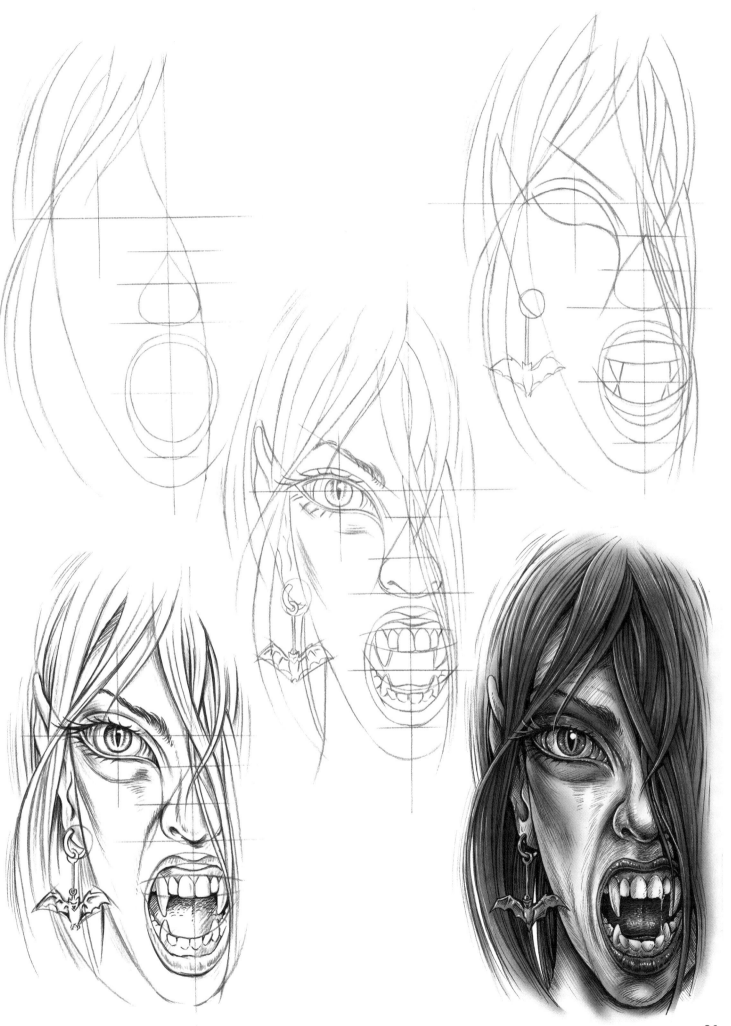

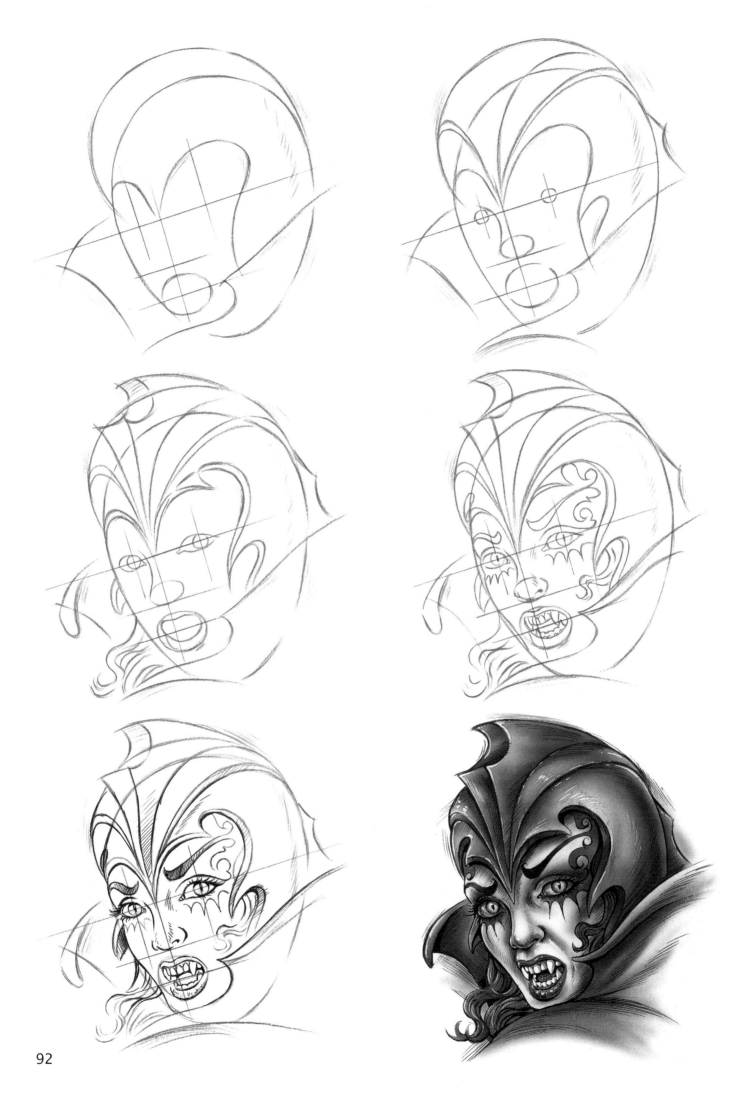

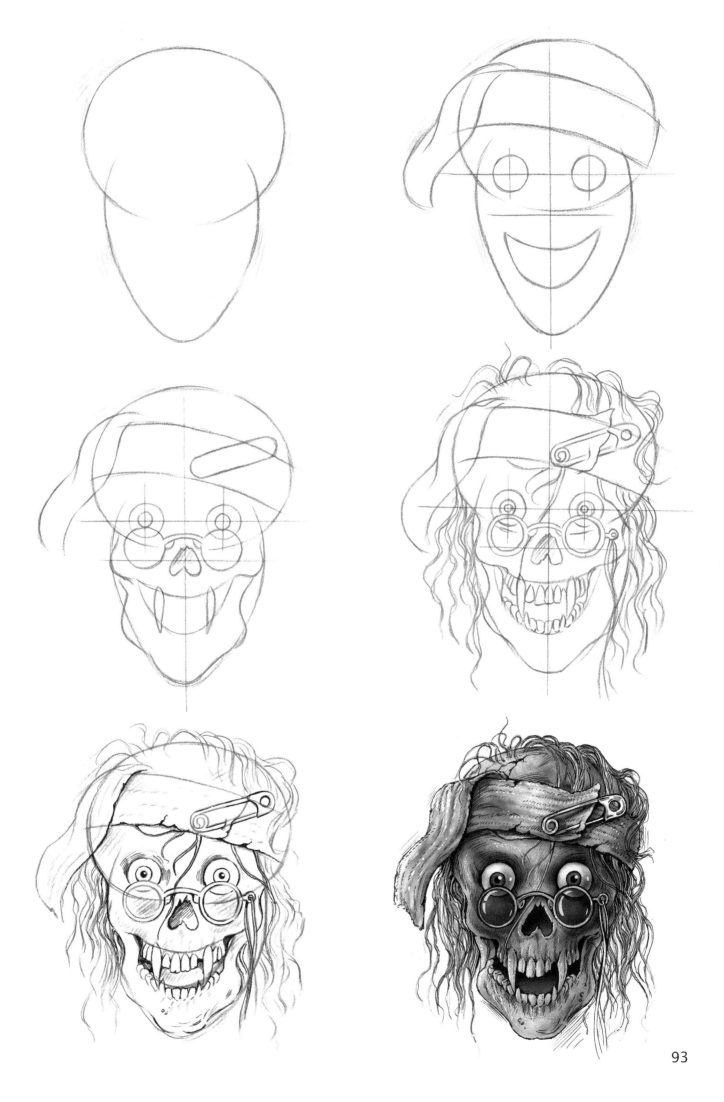

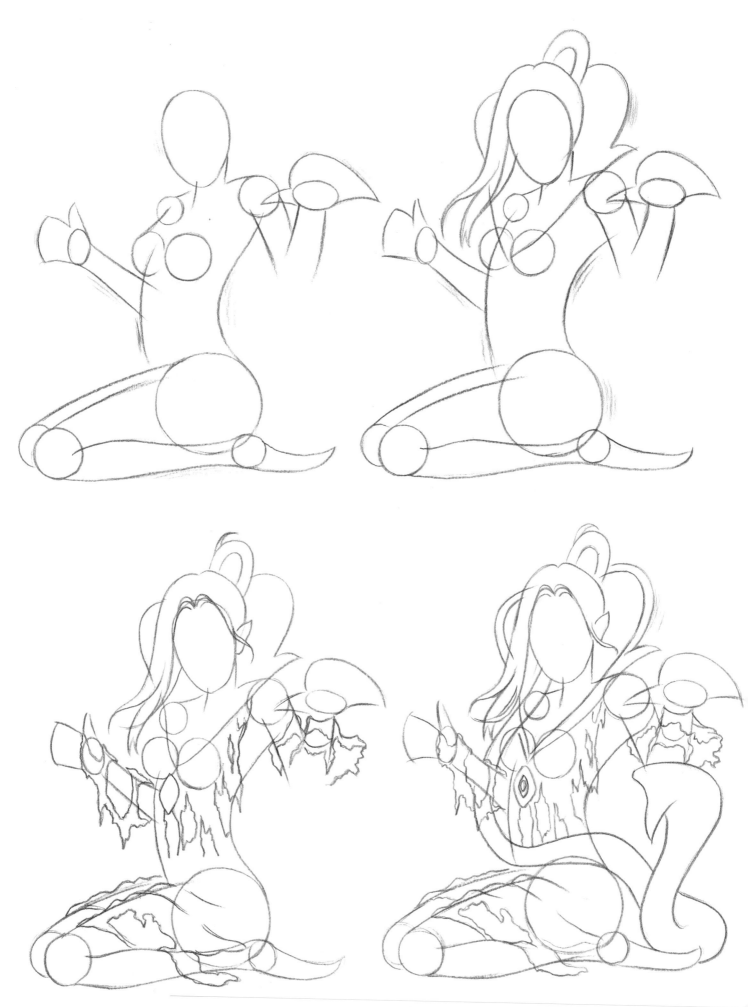

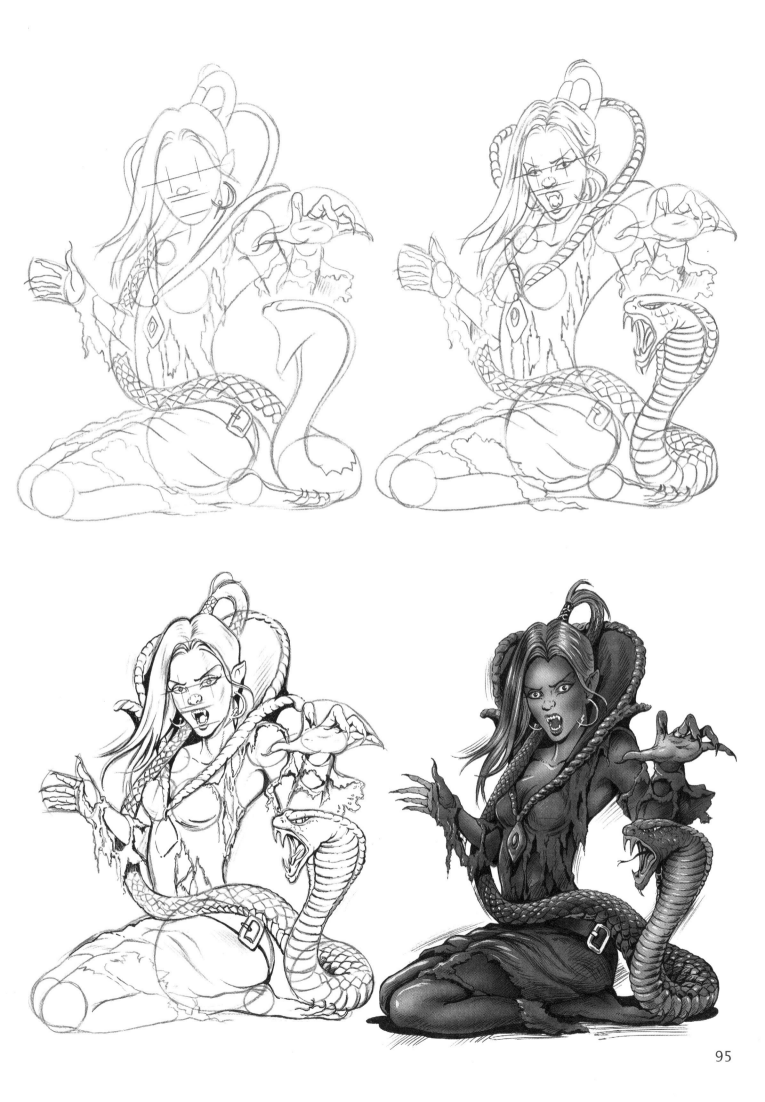

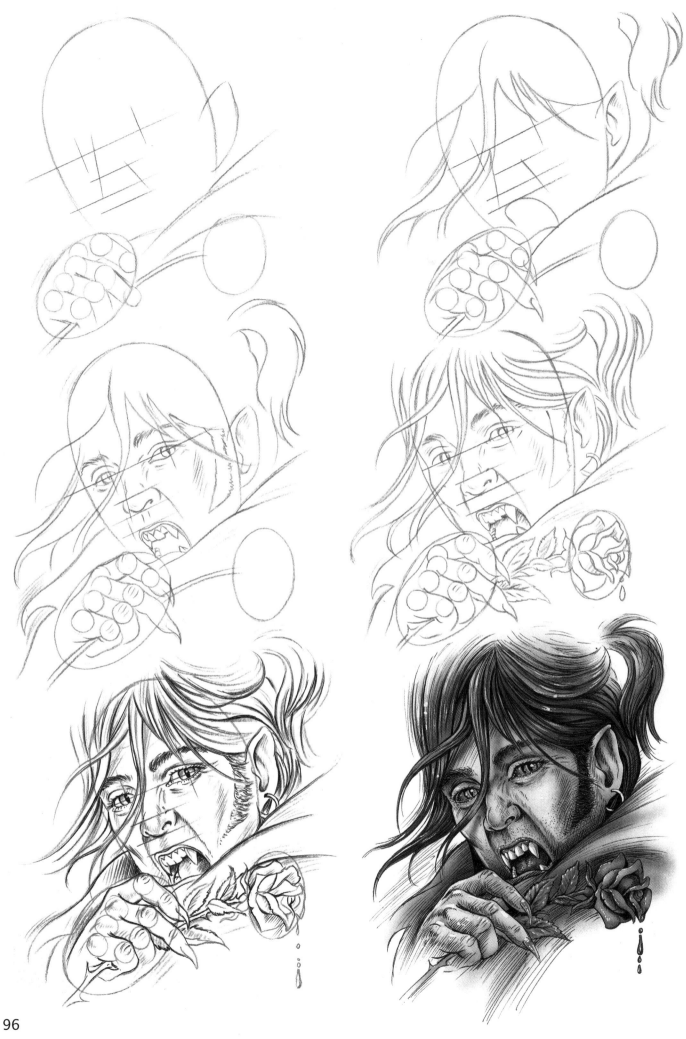

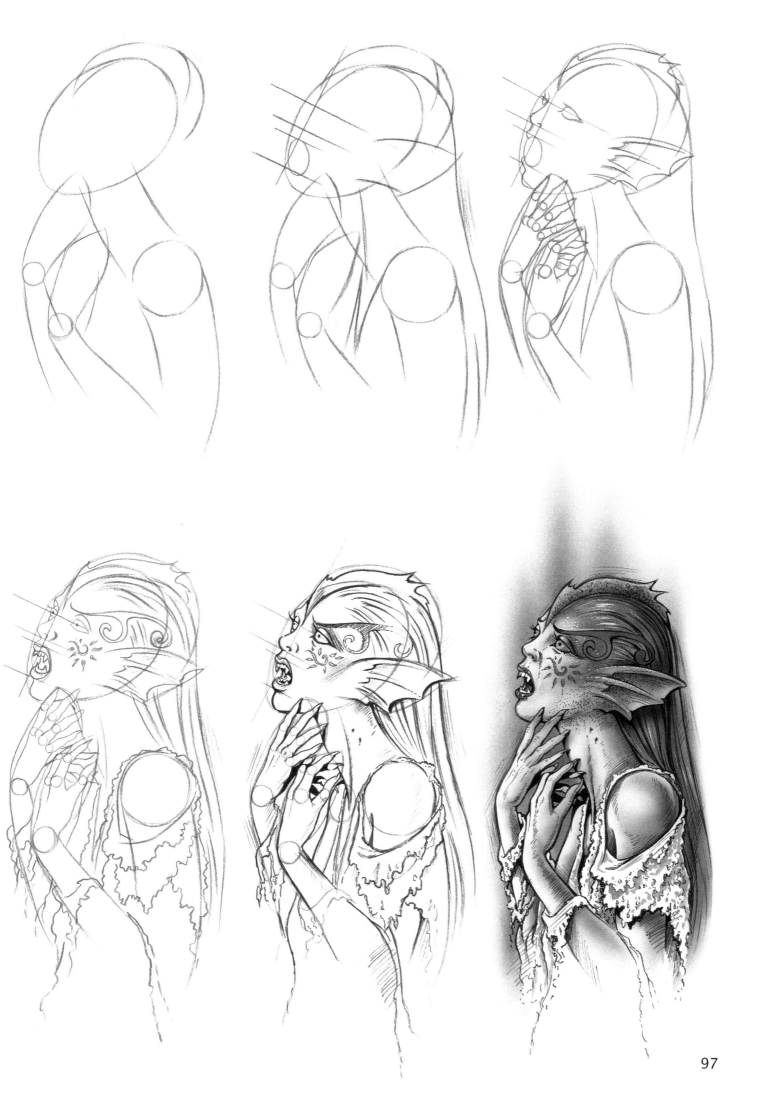

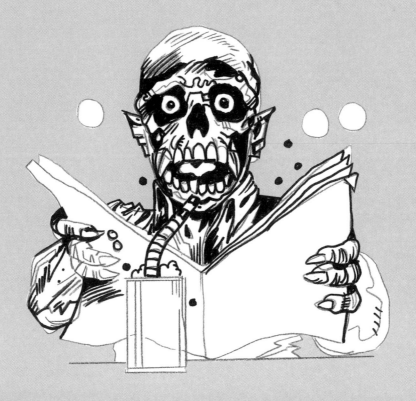

Monsters

Monsters can be scary, funky and even downright cool. There are just so many ways to draw these fun characters – you can make them cute, angry, ghostly or just plain grotesque!

When creating your own characters, remember it's all about adding monstrous features, so don't forget the fangs, big teeth, hairy tufts, strange eyeballs, menacing faces and ghoulish expressions.

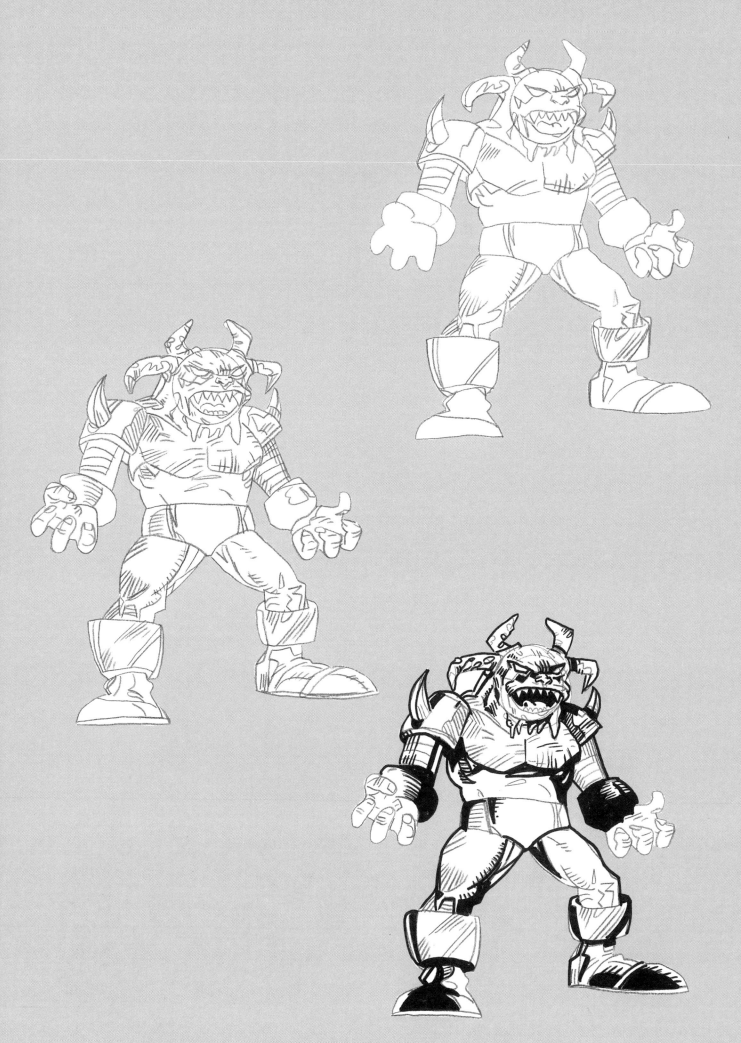

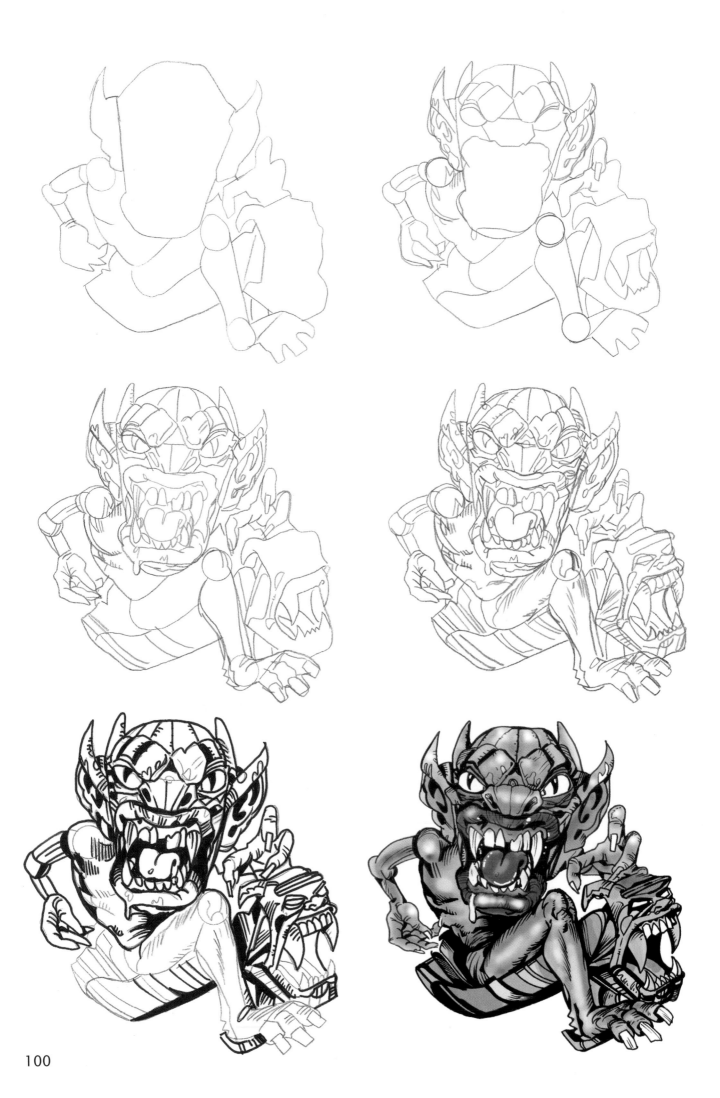

100

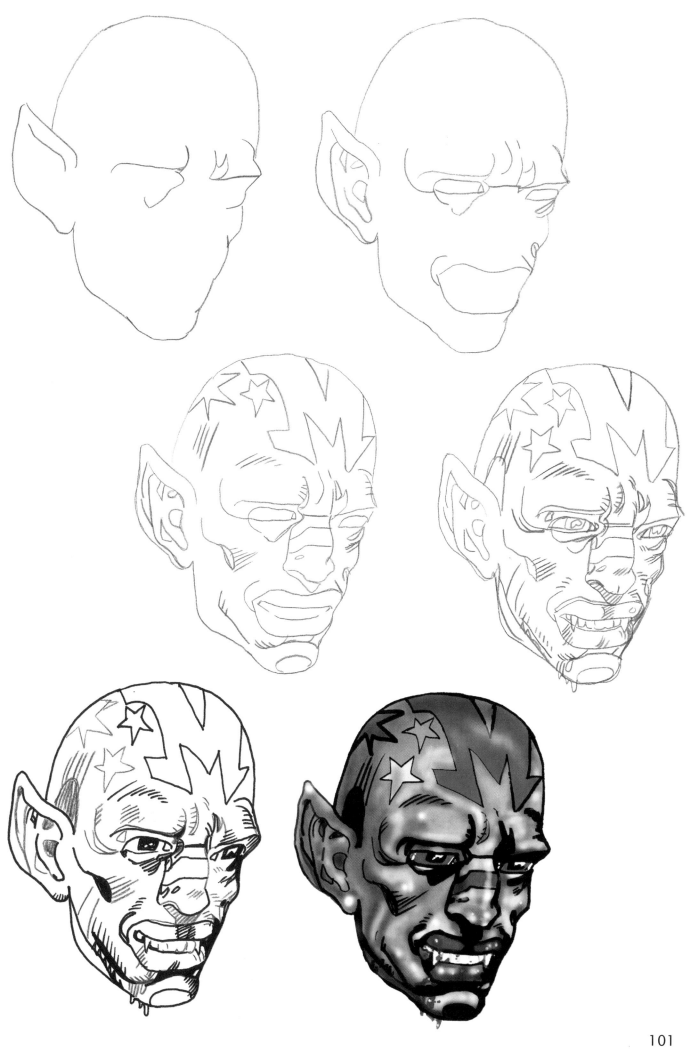

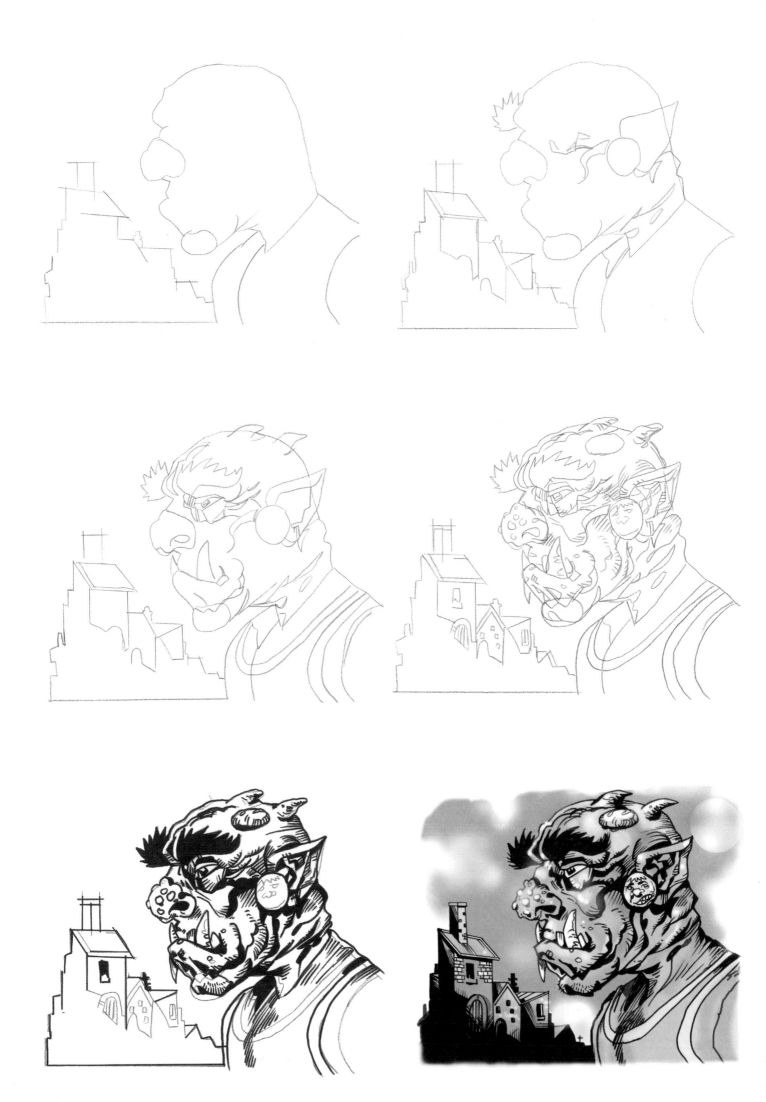

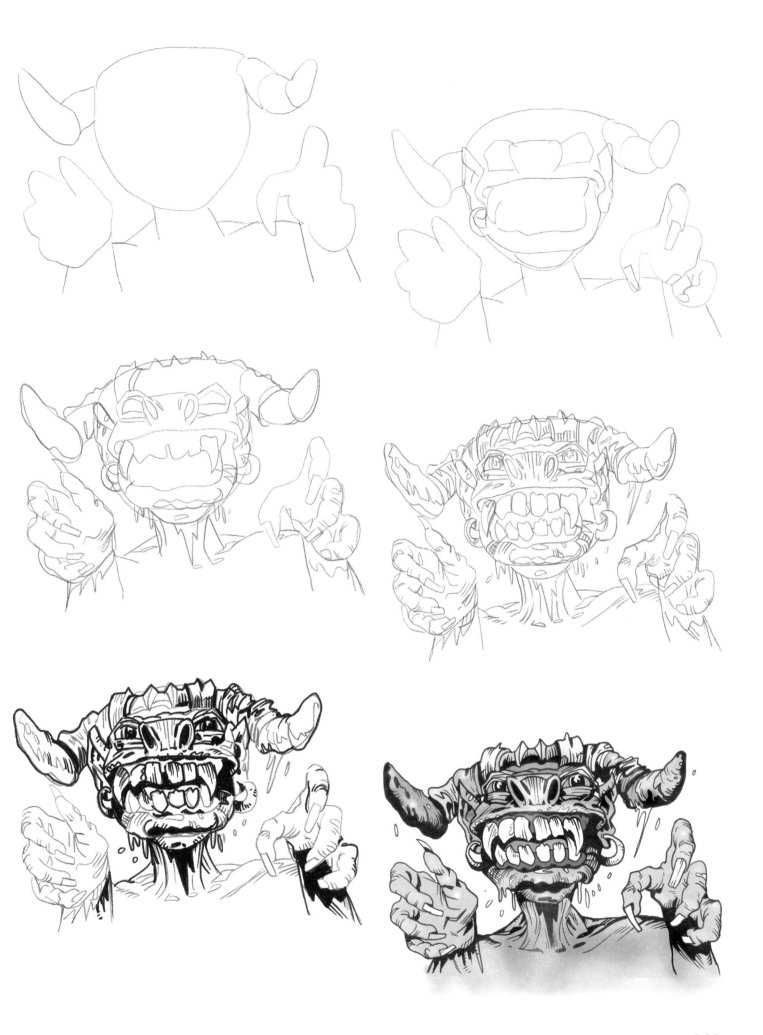

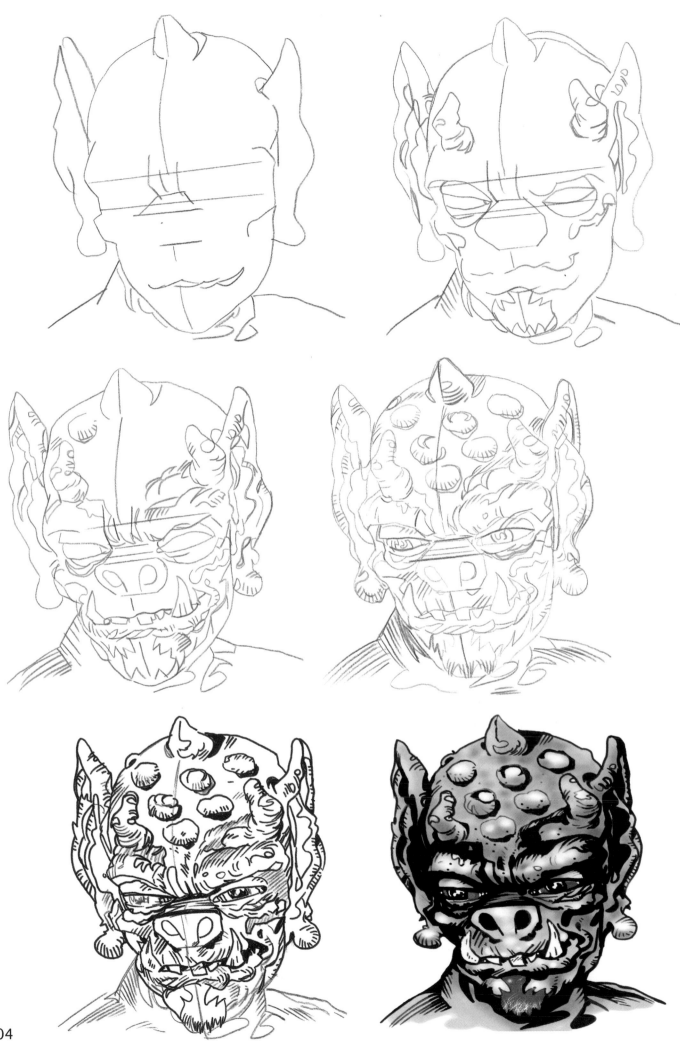

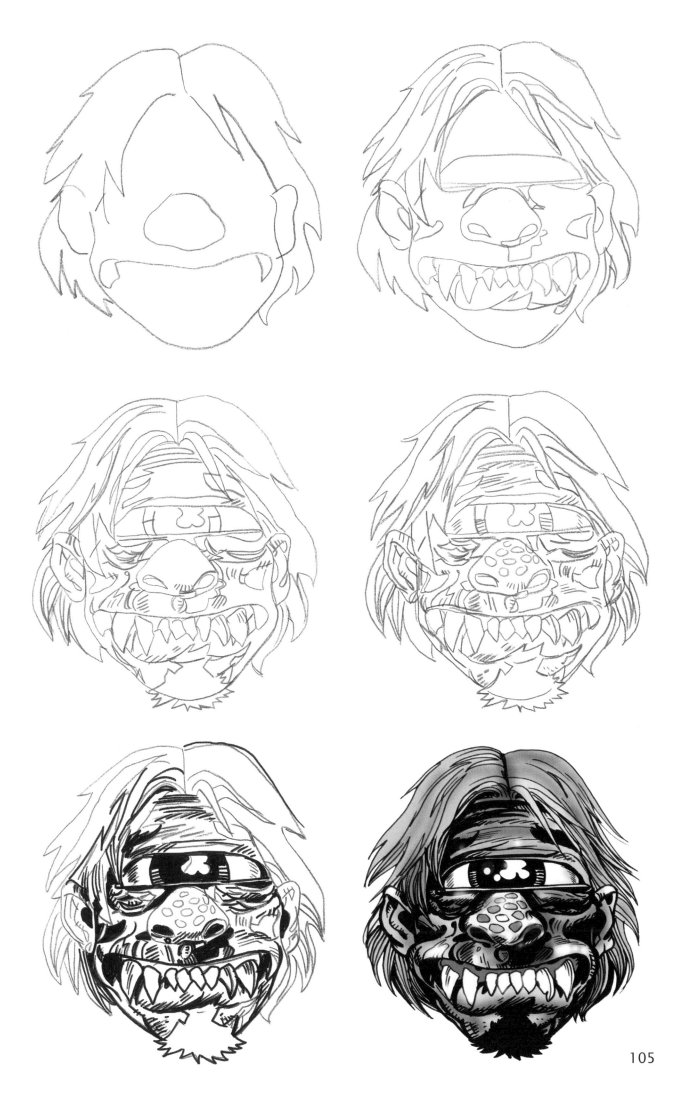

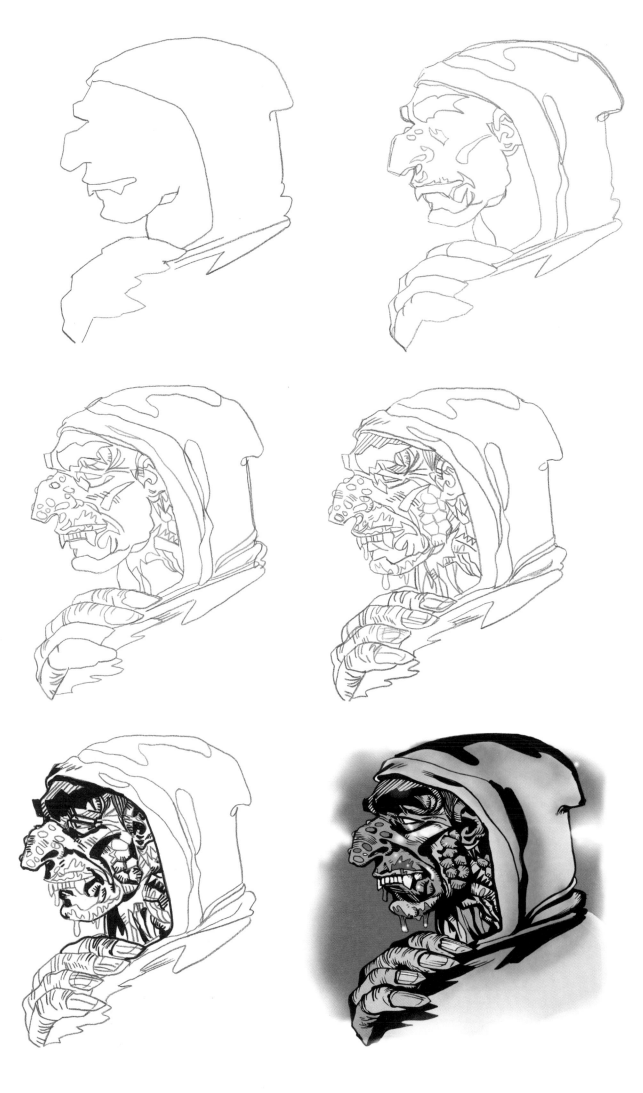

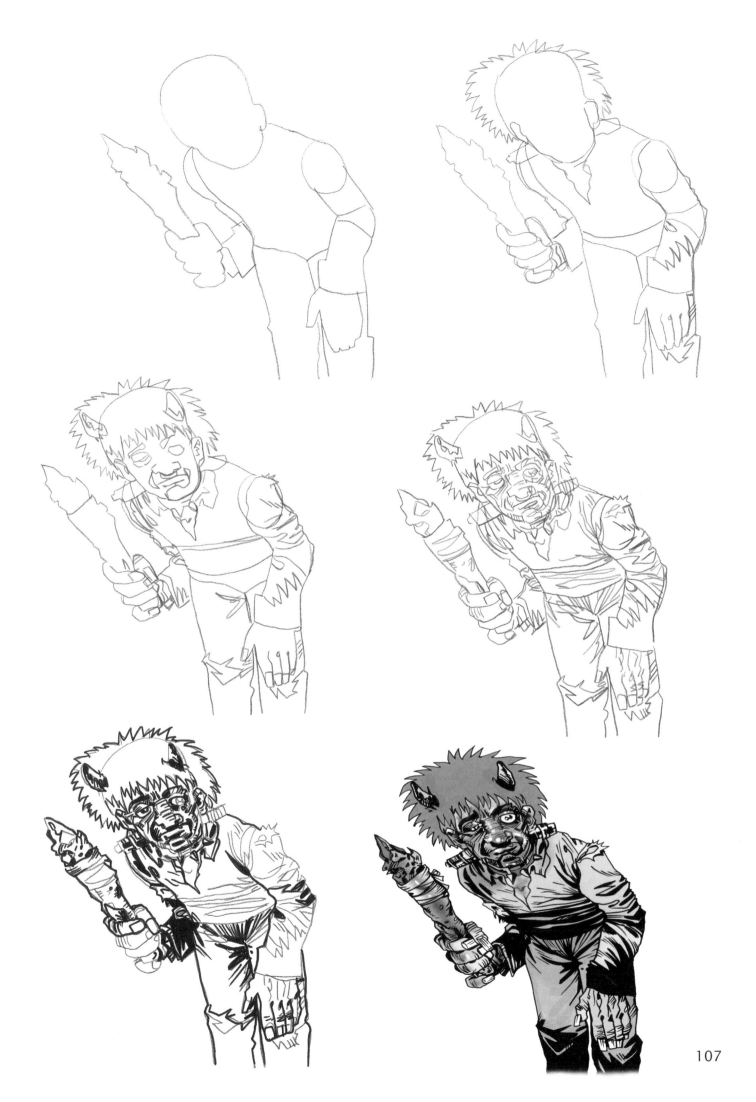

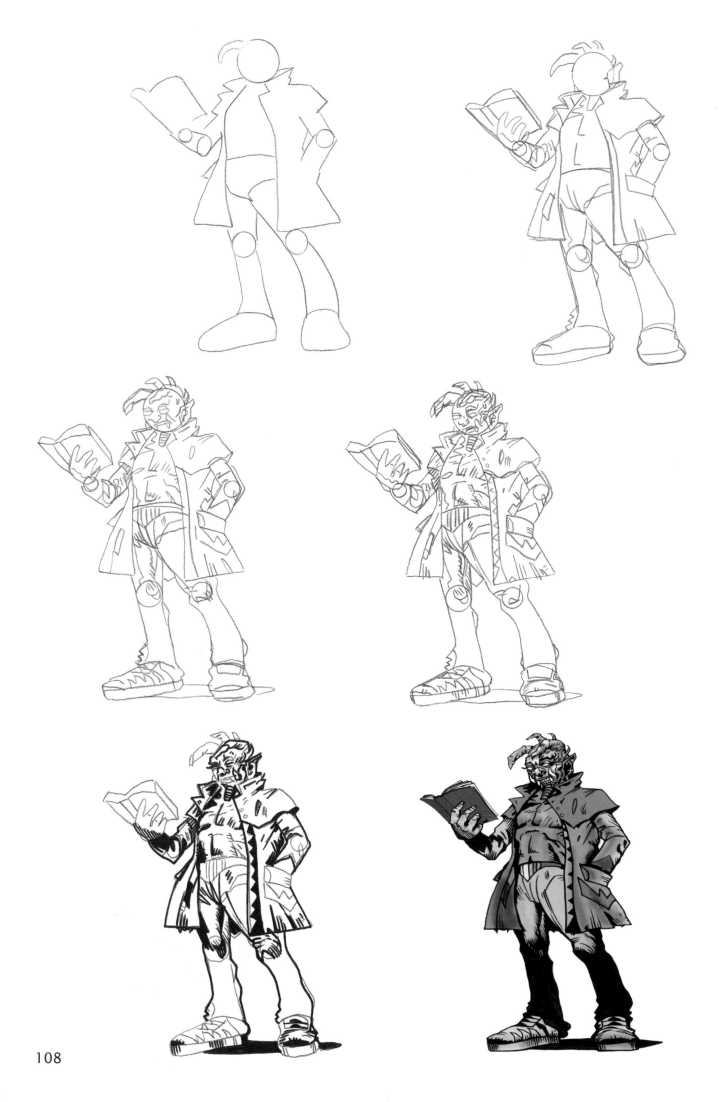

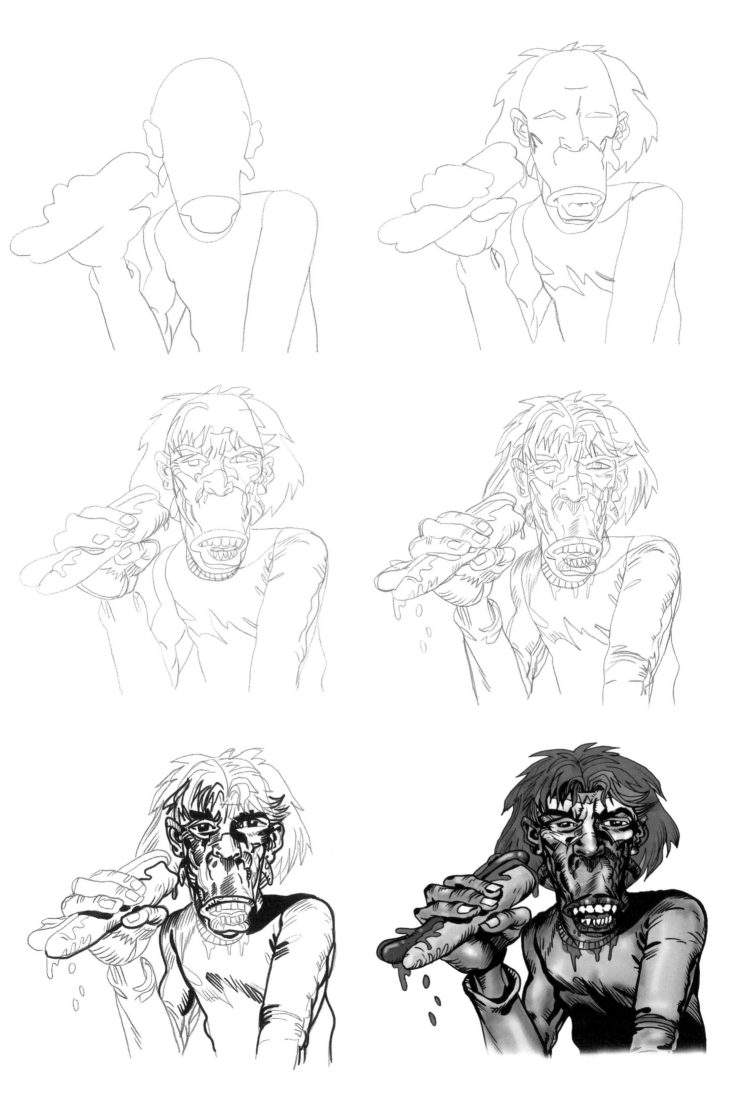

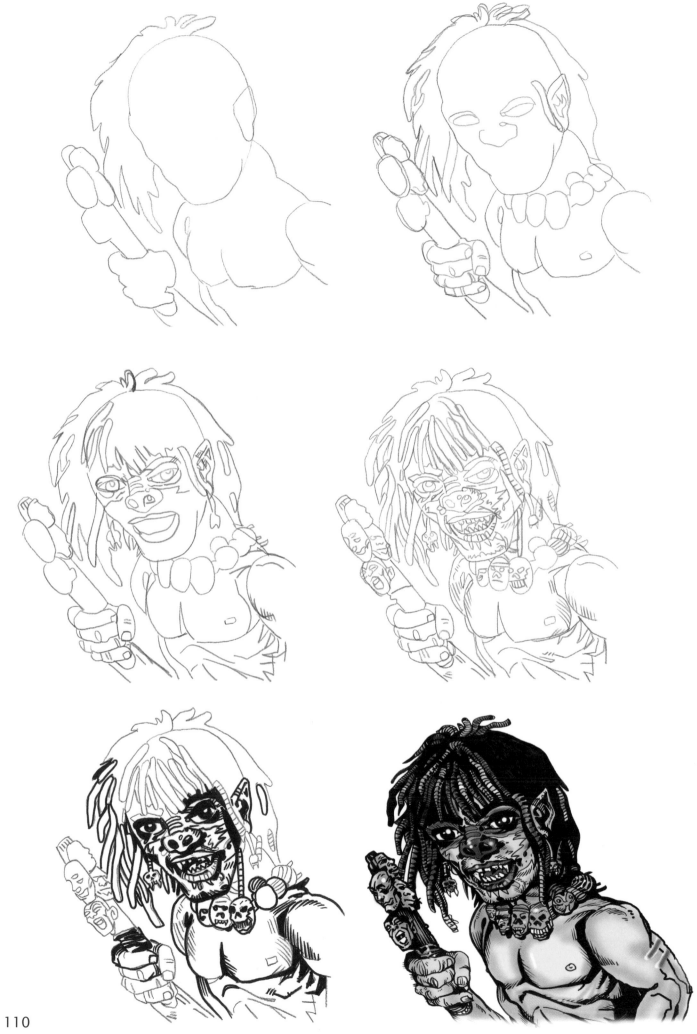

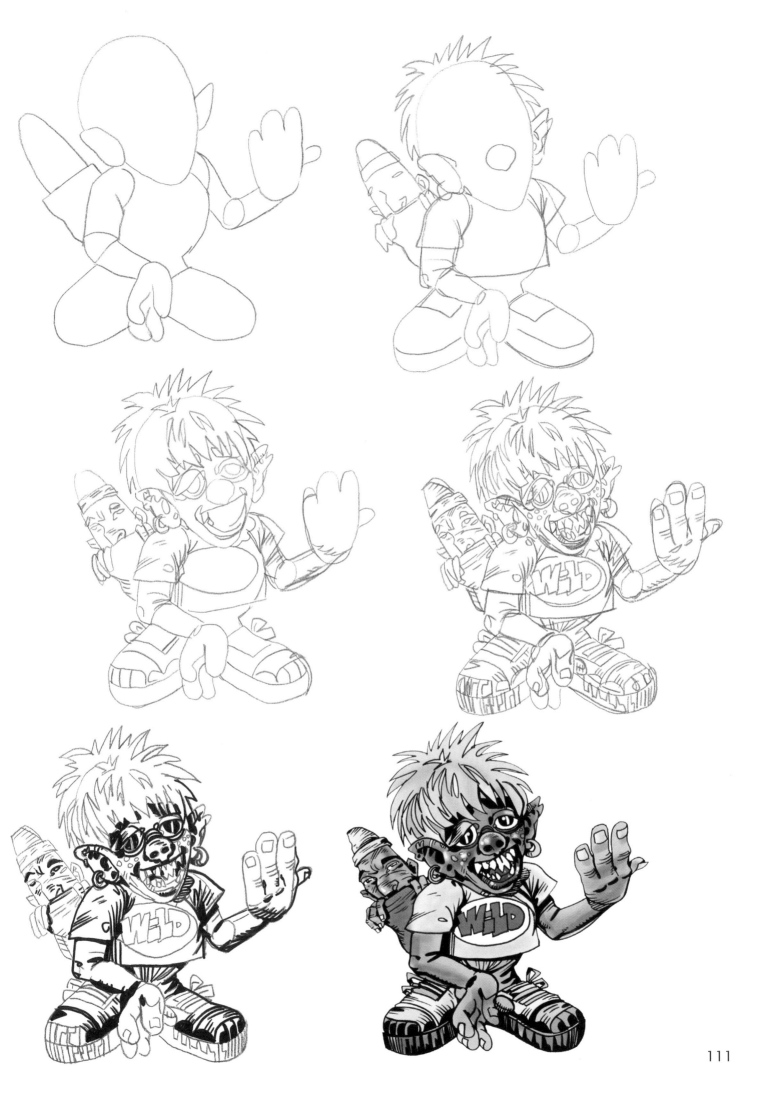

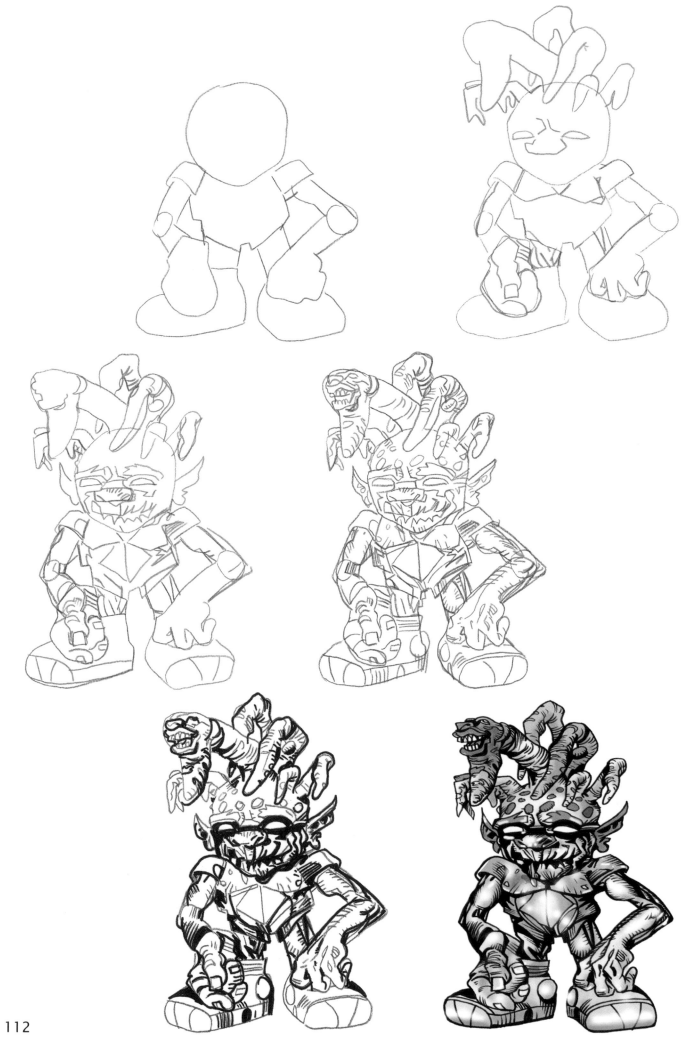

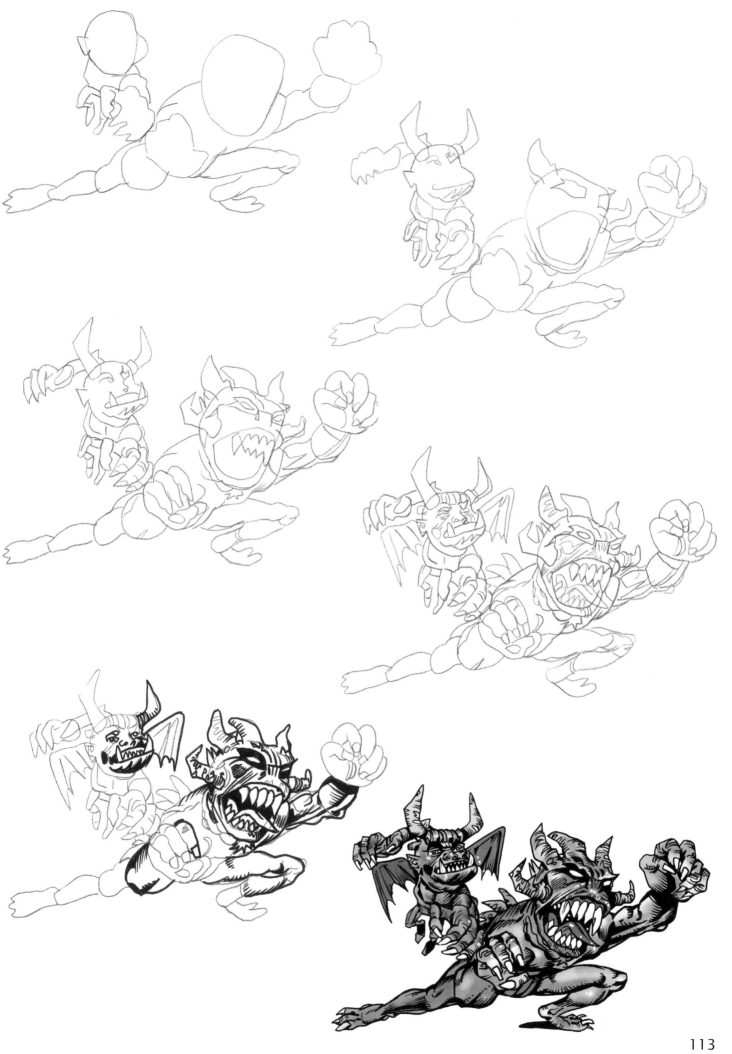

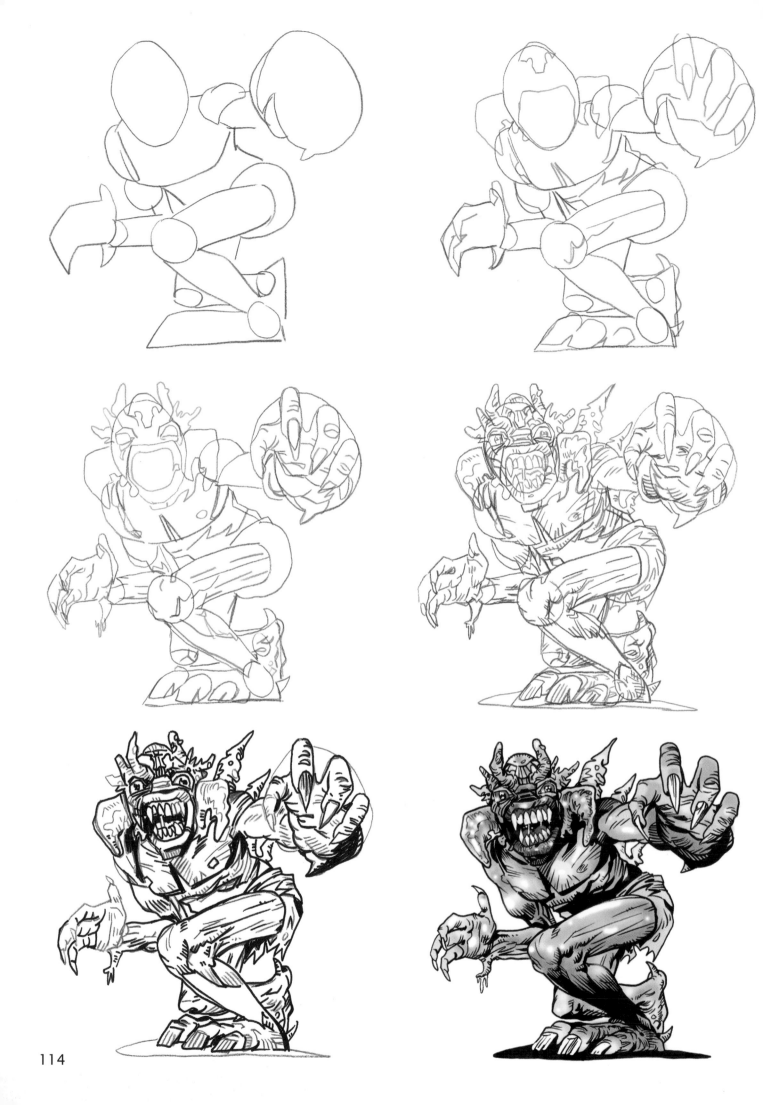

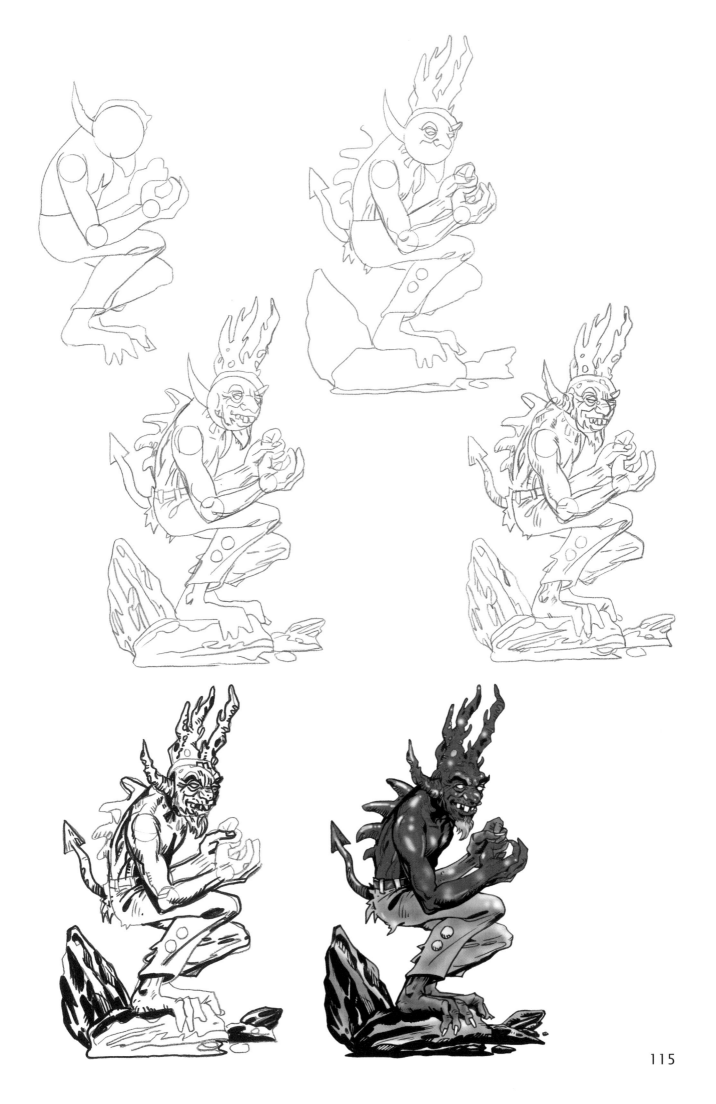

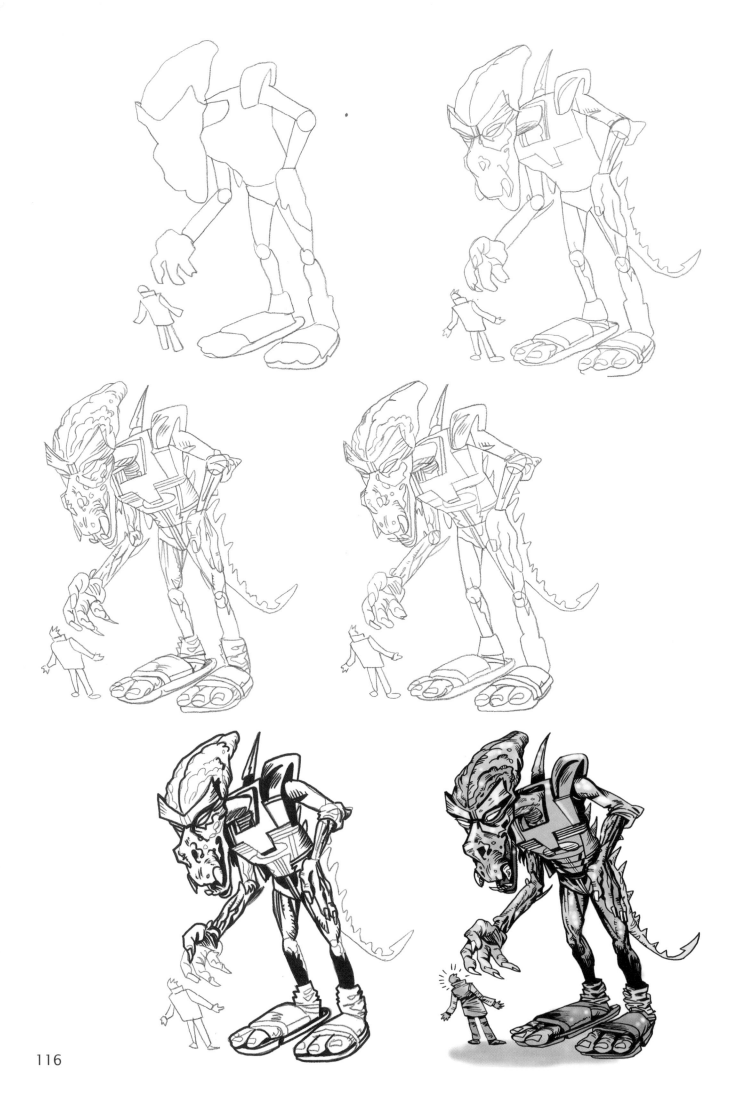

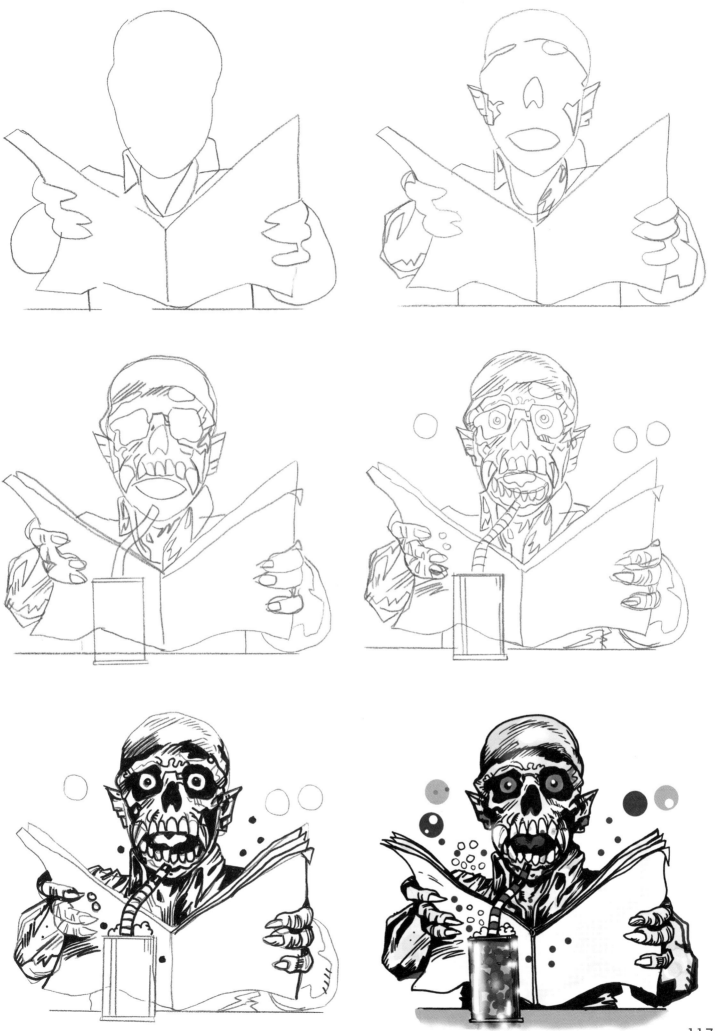

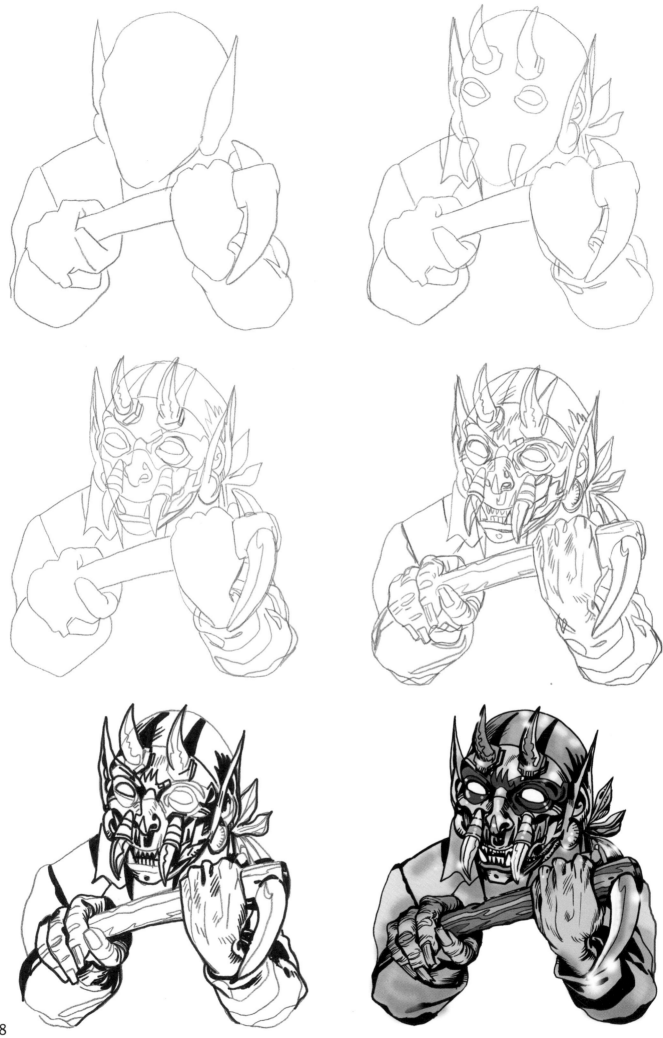

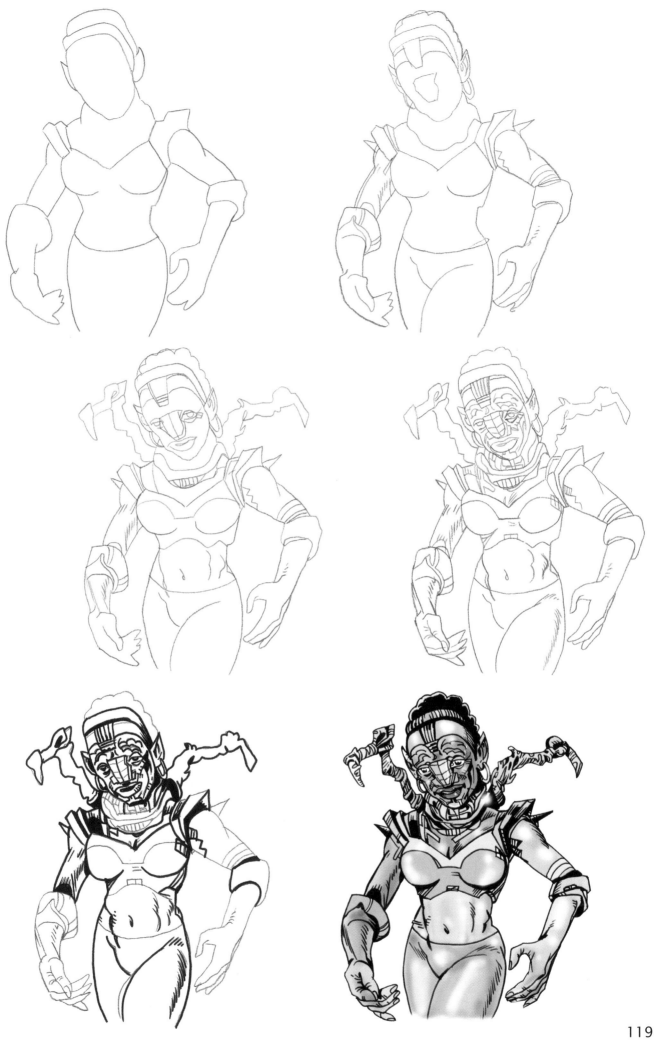

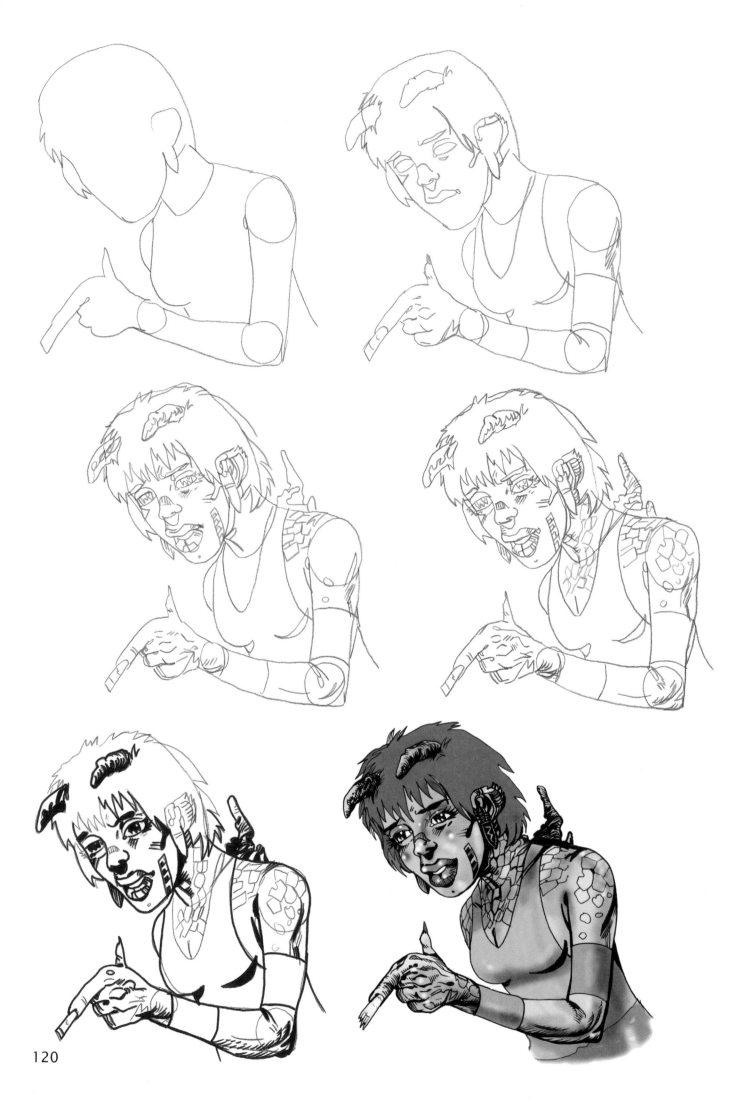

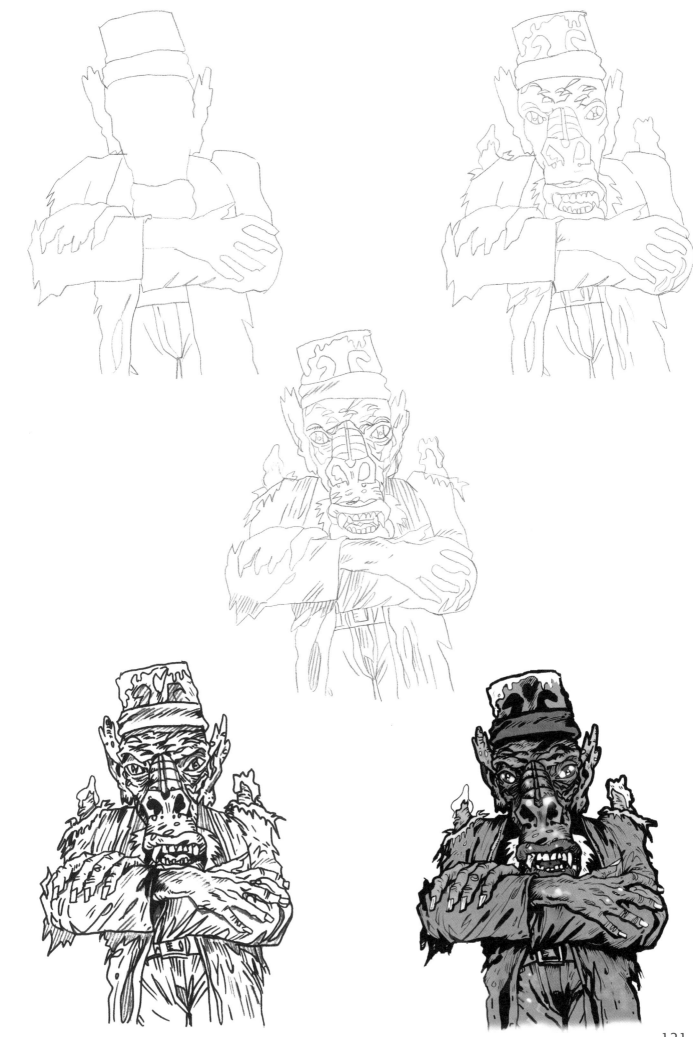

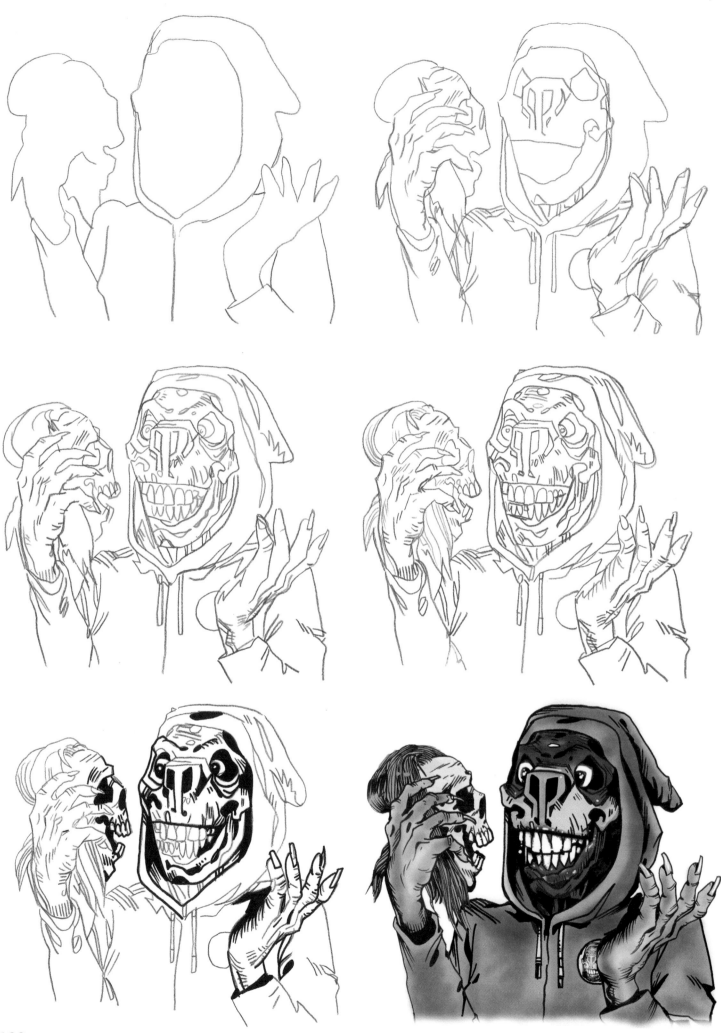

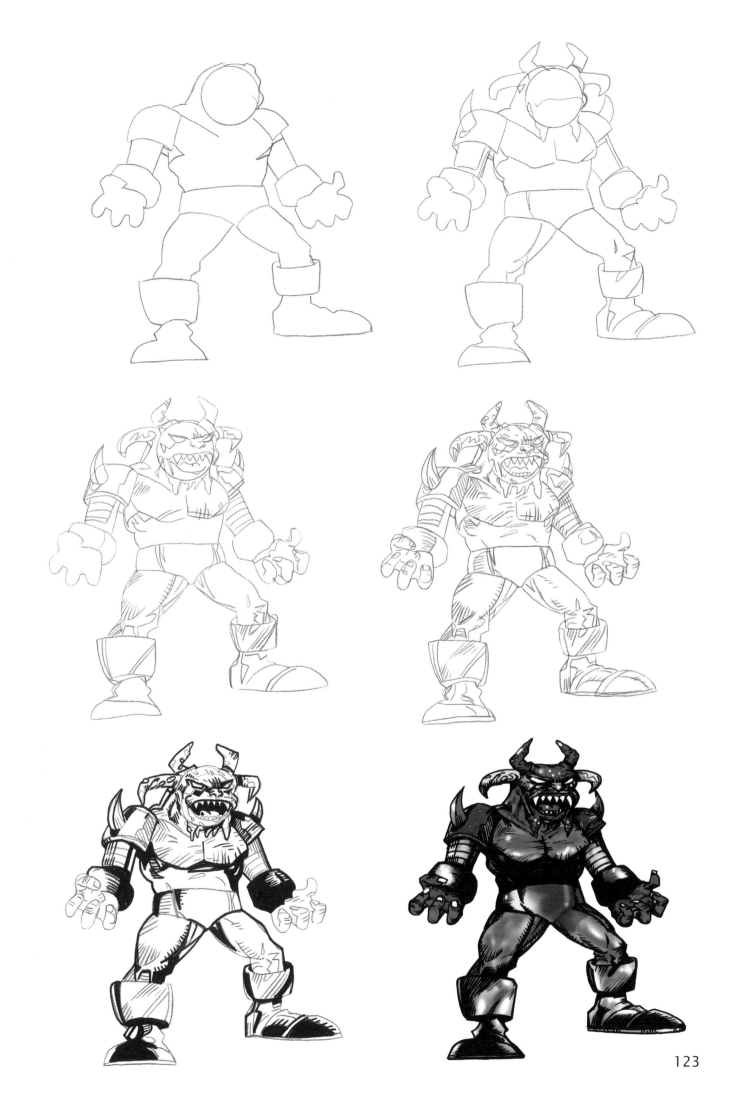

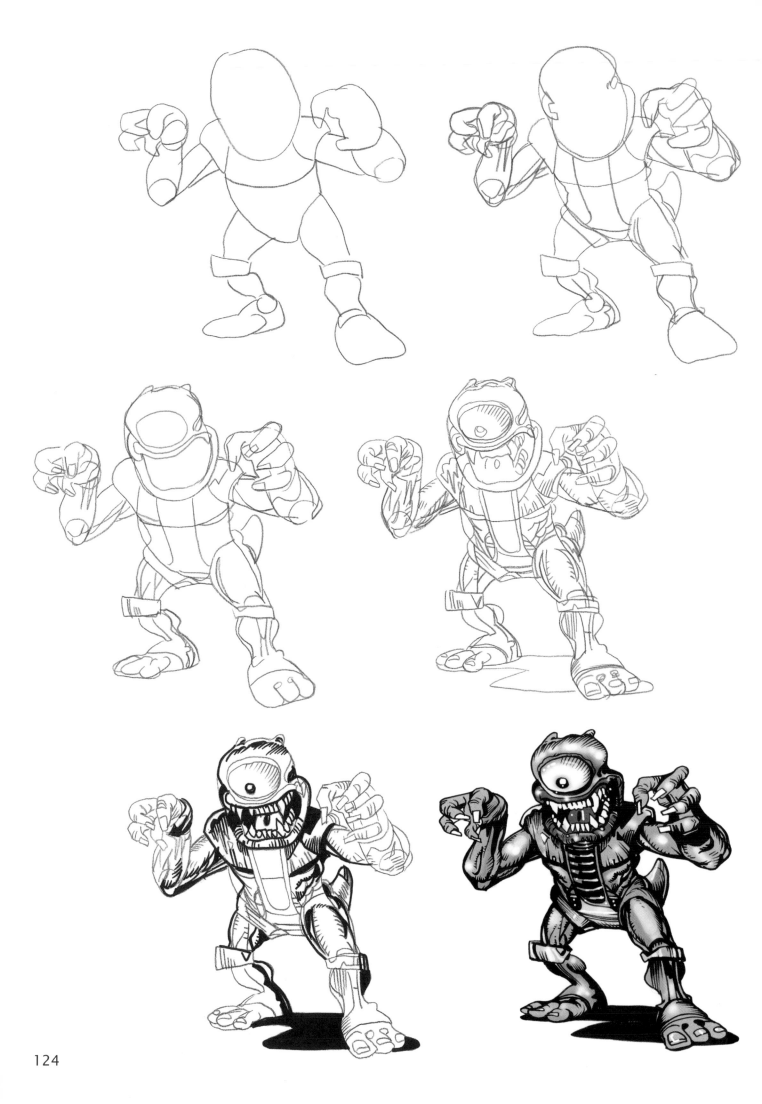

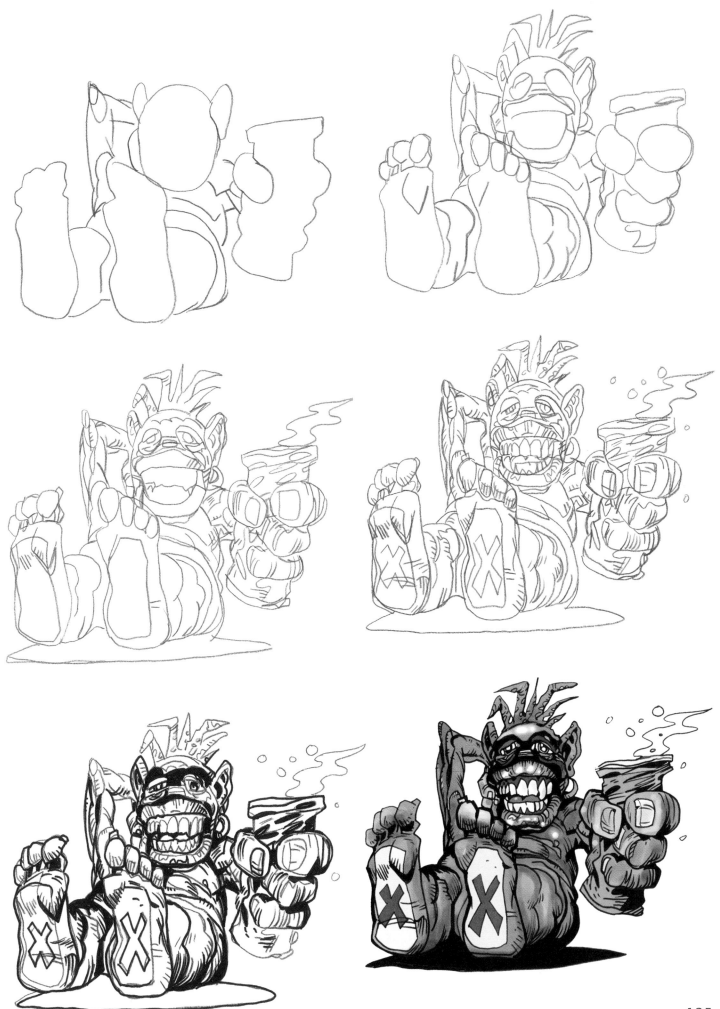

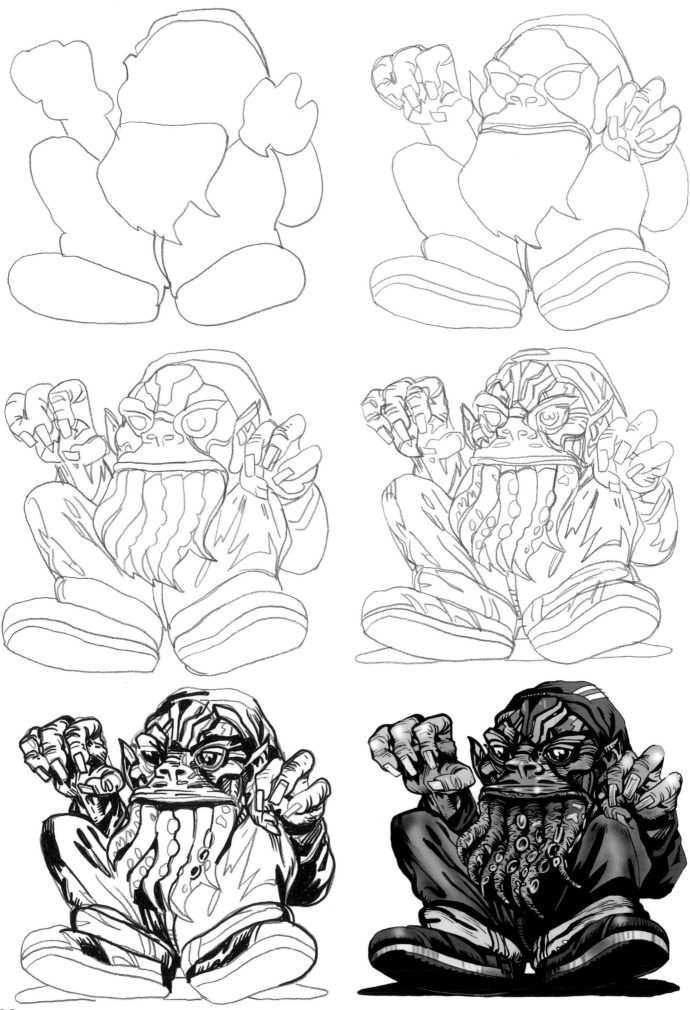

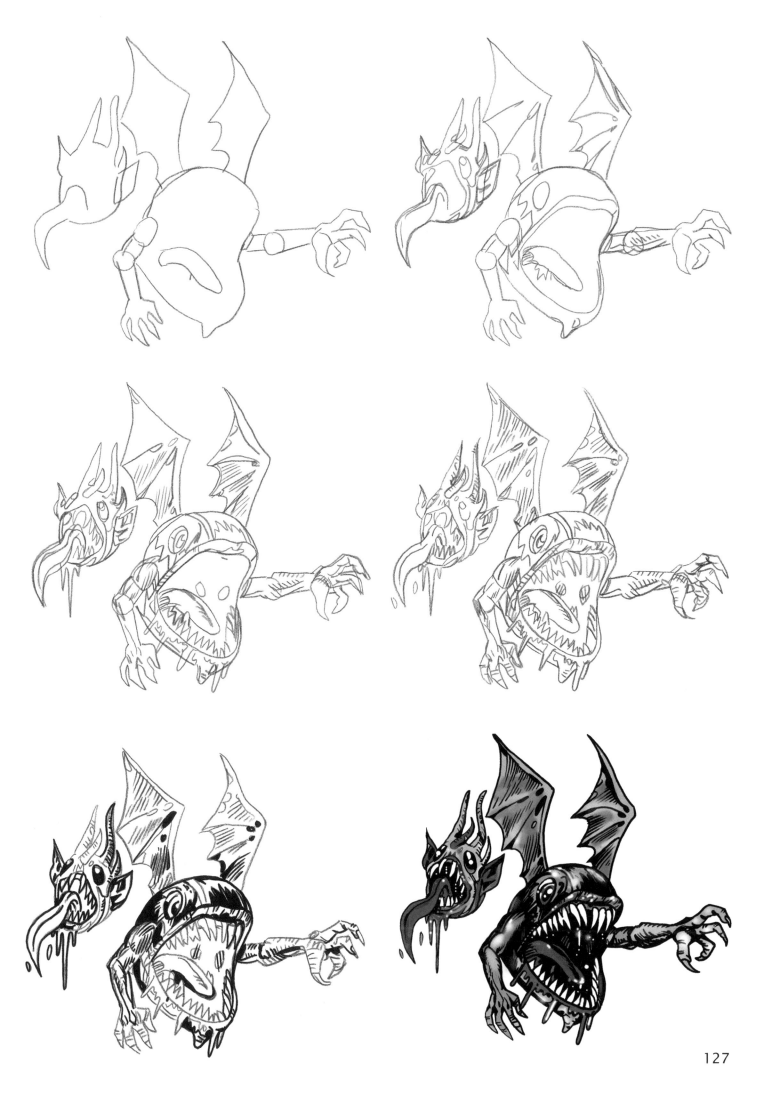

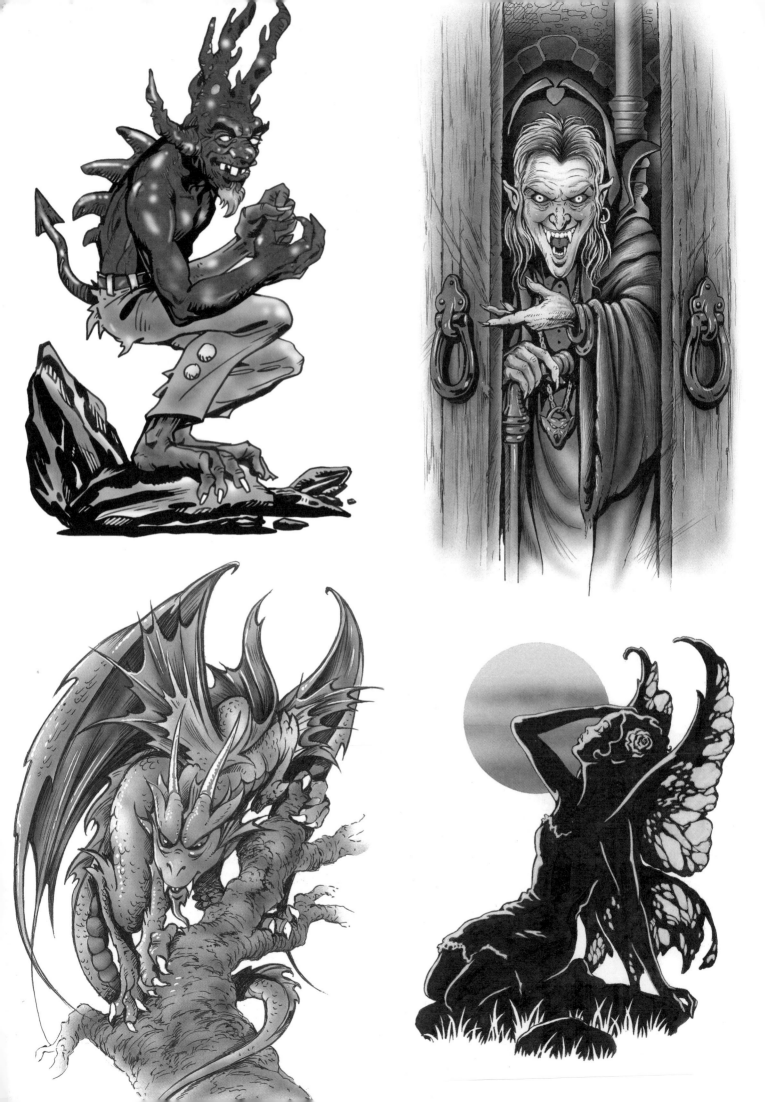